MOSES SOYER

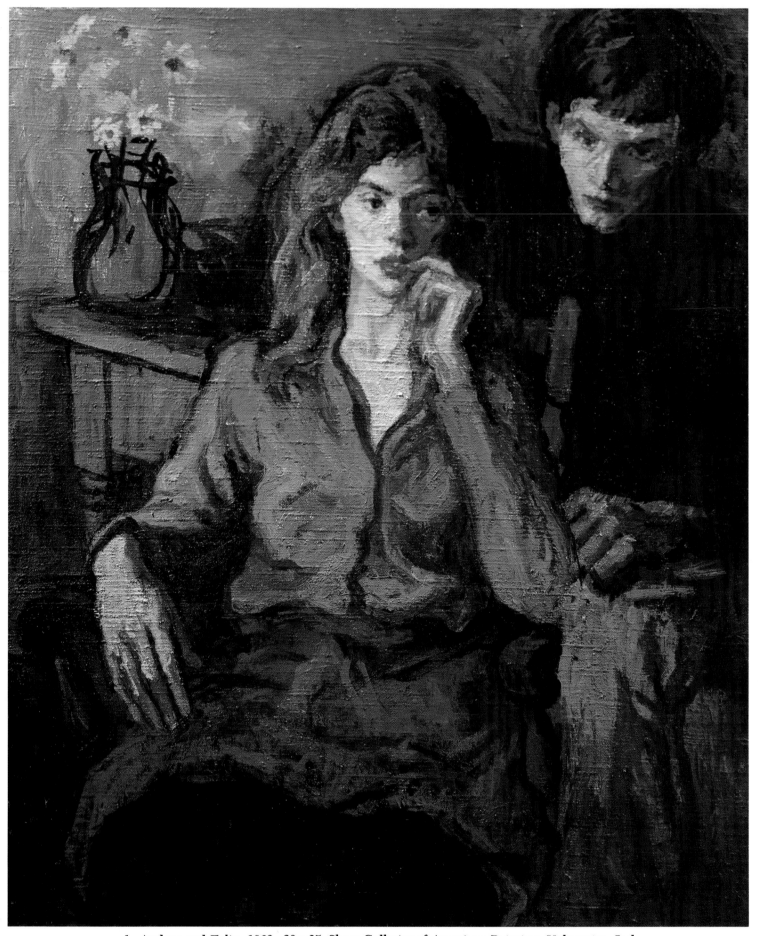

1. Andrea and Felix. 1963. 30 x 25. Sloan Galleries of American Painting, Valparaiso, Ind.

Moses Soyer

INTRODUCTION BY

ALFRED WERNER

MEMOIR BY

DAVID SOYER

SOUTH BRUNSWICK AND NEW YORK: A. S. BARNES AND COMPANY

LONDON: THOMAS YOSELOFF LTD

Library of Congress Catalogue Card Number: 67-25169

A. S. Barnes & Company, Inc.

Cranbury, N. J. 08512

Thomas Yoseloff Ltd

108 New Bond Street

London W1Y OQX, England

SBN 498 06461 1

Designed by Abe Lerner

Printed in the United States of America

List of the Paintings

1. Andrea and Felix. 1963.
2. The Artist's Studio after Five o'Clock. 1962.
3. Self-Portrait. 1922.
4. Still Life with Mirror. 1924.
5. Still Life. Circa 1925.
6. Edge of Town. 1925.
7. Bronx Park. 1924.
8. David. 1931.
9. The Tailor. 1938.
10. Backstage. 1935.
11. A Man and a Woman. 1942.
12. Employment Agency. 1940.
13. Truro, Massachusetts. 1944.
14. Conversation. 1945.
15. Ida. 1943.
16. Studio. 1946.
17. Four Dancers. 1950.
18. Eartha Kitt. 1964.
19. Nude. 1962.
20. Noemi Lapzeson. 1954.
21. Late Afternoon. 1955.
22. Girl with the Jewel. 1955.
23. Judy. 1955.
24. The Draftsman. 1962.
25. Artist and Friend. Circa 1958.
26. In the Studio. Circa 1958.
27. Flowers and Apples. 1959.
28. The Apple Tree. 1959.
29. Dina. 1960.
30. Nude with Beads. 1960.
31. In the Mirror. 1962.
32. Studio Interlude. 1960.
33. Intimacy. 1962.
34. Lovers. 1962.
35. Village Cafe. 1960.
36. Lovers. 1965.
37. Artist and Model. 1961.
38. In the Morning. 1961.
39. On the Floor. 1962.
40. Study for Portrait of Julia Evergood. 1962.
41. Study for Portrait of Julia Evergood. 1962.
42. Girl with Yellow Drapery. 1963.
43. In the Studio. 1962.
44. Keene Wallis. 1962.
45. Studio Interior with Self-Portrait. 1968.
46. Reclining Nude. 1963.
47. Dancers. 1963.
48. Rima. 1962.
49. Women. 1963.
50. Study for Apprehension No. 2. 1962.
51. Study for Apprehension No. 2. 1962.
52. Still Life with Green Apples. 1963.

MOSES SOYER

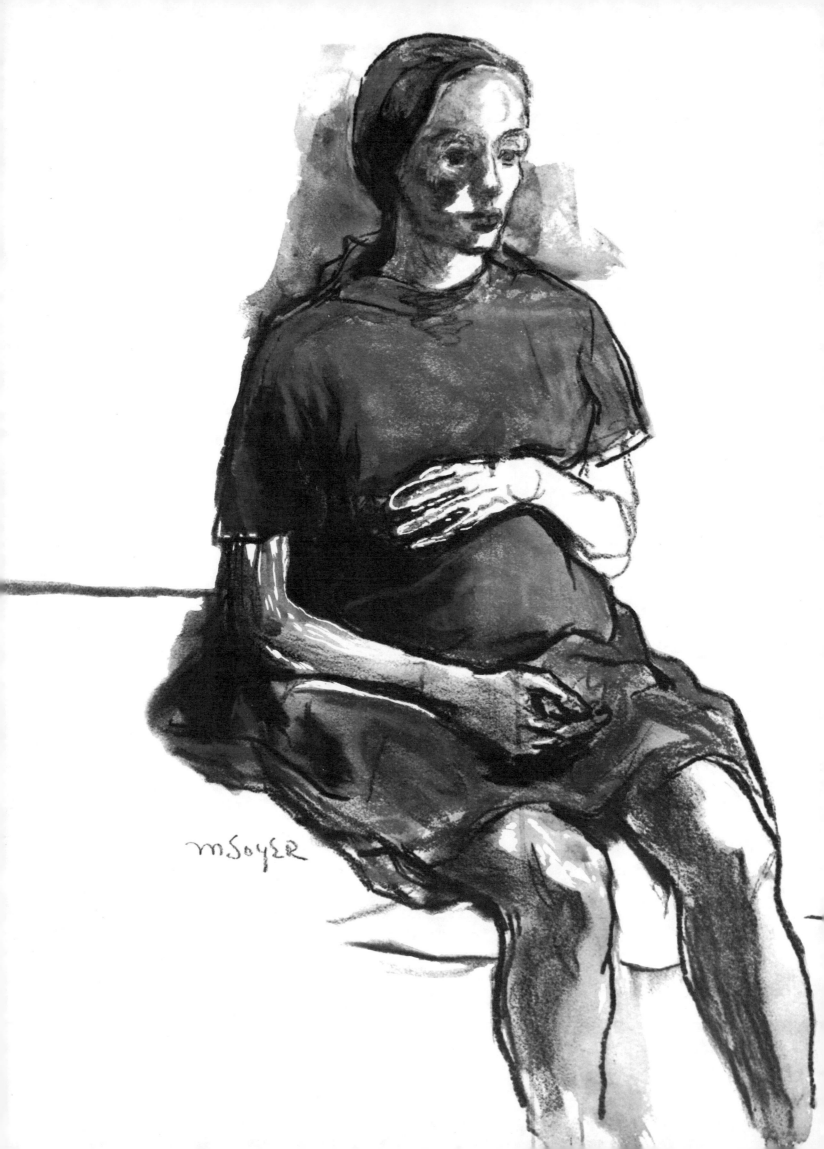

The Studio: A Memoir

BY DAVID SOYER

A LARGE, DUSTY LOFT with scattered furniture, folding chairs, a disheveled couch, canvases stacked against the wall; a graying, paint-smeared plaster cast of Michelangelo's *Slave*; one or two old three-panel screens, carelessly over-hung with heavy, musty green velvet draperies, ragged tutus and stained, once bright red or yellow skirts; a near mosaic of paint marks on the floor, marking models' feet in long-since completed poses; old and current correspondence, magazines, photographs, drawings, reproductions, exhibition announcements, catalogues and manuscripts scattered on table tops, gradually gathering a mixture of soot and pastel dust. In the center stands a large easel, and next to it a palette resting on a wheeled cart. There is the pervasive rancid odor of linseed oil, mingled with the more piercing smell of turpentine.

To one grown up in an artist's family, this is so familiar, so deep within, that no matter how far from art adulthood may lead, a visit to an artist's studio brings a sense of calm and relaxation, a feeling of belonging. Perhaps the smell of turpentine is analagous to the smell of new-mown hay in the cliché about the displaced farm boy who is drawn into a state of comfortable nostalgia when he leaves his city job for a weekend in the country.

The small works of art around Moses' studio, the scraps and fragments, photographs, lithographs, drawings, doodles, old and new, framed and unframed, hung or lying around, are from all periods of the artist's career. They include his own works and the works of others. They are like a disorderly diary or family picture album, an informal record of studio life over the years. They are, most of all, reminders of that microcosmic universe of people drawn to the artistic scene, the aimless and the purposeful, the talented and talentless, the genuine eccentric and the phony. There were those for whom this would always be a way of life and those for whom it would be a brief dalliance with bohemia before marrying that stolid doctor from Brooklyn. One is forever meeting middle-aged matrons who recall their days of posing "in the nude" or "in costume" for "the Soyers." Sometimes the recollection is accompanied by a sense of nostalgia or residual thrill. Sometimes there seems resentment at the passing years or at the different course a life has taken. Almost always there is the feeling that whatever time was spent in the studio, it was a significant time for that person.

Here are some of those small scraps of art and some of the memories, sentimental, and incomplete, stirred by them.

9

An old, fuzzy lithograph of three girls lying on a bed. Depression days, earliest memories. No money, no studio and Moses worked at home. It was a tiny apartment in Greenwich Village, with two small rooms and a bathroom (which also contained the "kitchen" stove). The living room was dominated by the double bed, a heavy oak table and an easel. On the wall above the bed hung a large, dark brown still-life of a loaf of rye bread, a knife, hard-boiled eggs and a green package of Lucky Strike cigarettes. Moses used to say, "My message is people," and he seemed to immerse himself in the syllables making up this message. The little apartment was always crowded. All were artists of one sort or another, or so they thought, painters, poets, actresses. At the core were Ida Soyer (called Big Ida, at 5 feet 4, to differentiate her from her smaller friend, Little Ida) and "The Girls"—Tamiris' dance group, the energetic and creative "barefoot girls" of modern dance. Big Ida was one of the first of the group to marry, the first to have a child and an apartment. "The Girls" gathered around her and her family, her generosity and liveliness. There was constant racing off together to rehearsal and returning noisily through the "Village" streets and hallways with their clacketing high-heeled shoes, their high-pitched voices and high spirits.

Within the apartment there was commotion and clatter, theatrical clasps to the bosom and shrill "dahhhlings," snatches of serious talk, depression, art, fascism, social consciousness, "The Dance," Martha Graham, Mother Bloor. Through the hustle-bustle, Moses (could he have seemed tall in those days?) painted—a girl entering the door, those three disheveled young women on the bed, nudes. A four-year old drew laughs in demanding imperiously of a newly arrived model (and friend and sometimes baby sitter), "Well, what are you waiting for, take off your clothes and let's get to work." The bohemian life seemed nurtured by the depression as people huddled together, drawing warmth and sustenance from each other, sharing food, ideas and space on the rough wood floor for homeless ones to sleep on. Artists lived largely on barter, trading paintings for the services of the doctor, for appliances, for hardware. Intimate days, warm days, fearful times and brave picket line times. Nights of falling asleep to the buzz of grown-up talk and laughter. Mornings of dirty glasses with disintegrating cigarette butts in the red wine dregs.

A photograph of a painting of a five-year-old boy standing with a Scottie at his feet. In an apartment near the Hudson River, with large bare rooms and pot-bellied stoves, Moses made a life-size portrait of his son with Beamish, the Scottie, borrowed for the painting from the Ben Shahns who lived downstairs. Posing was a part of life, an aching part, a tedious part. A child stood or sat, while Ida read stories aloud. One waited for freedom, for the words, "Take a rest," or, "That's all for today." One posed for Moses and for others, for sculptor Chaim Gross and for a seemingly never ending phalanx of photographers, including Walker Evans who lived downstairs with the Shahns, and also Alfredo Valente. One also stamped and kicked and refused to sit for some of the best known artists of the day.

A painting of a derelict. This was done during the time of the WPA Art Project. Moses' studio was in an ancient building off Columbus Circle that had once housed a medical school. The wide stone stairs had deep grooves worn in them from years of use, and the halls still smelled of formaldehyde and ether. On the glass door to the studio, Jake, a stocky artist and studio wit, had changed "Department of Urology" to "Department of Muralogy." The personnel of the "department" included Rudolph the derelict, bitter, red-nosed, rasping out in his whiskey voice his

classification of drinkers into "social, moderate, habitual and bottle babies." Jean, a lithe, bronzed ex-olympic swimmer looked all the more athletic next to the dumpy Jewish wife of an Irish street corner radical. Sitting against the wall or in a corner, thin, large eyed and sad, his hat always on and pushed back on his head, was Danny, a very young, very gentle man to whom a child could turn when Jake's humor became too rough. One does not remember Danny's doing anything. He didn't seem to paint or work around the studio or run errands the way Rudolph did. He appears in Moses' paintings of the period, so he must have posed. But mostly he seemed to sit against the wall with his hat pushed back on his head. Danny disappeared from the studio one day. Although the child was not supposed to know, somehow it filtered through the protective silence that Danny had committed suicide.

The official WPA business of this studio was murals for public buildings. One was of children playing, to be placed in the children's ward of a Brooklyn hospital. Another was a panoramic view of Philadelphia for a post office in that city. Months after the Philadelphia mural had been completed and installed, a priest noticed that the cross atop his church was missing from the painting. A hurry-up trip to the City of Brotherly Love, paint box in hand, and the desecration was repaired. It may have been flattering that in a busy post office someone had looked closely enough at the mural to notice such a detail.

The unofficial business of the studio was the artist's own work. Many of Moses' friends and colleagues were called social realists, and some classified Moses (and Raphael and Isaac Soyer) with this group. But in his paintings were no cops beating strikers, no fat capitalists in top hats, no lynched Negroes, no Saccos, Vanzettis or Tom Mooneys. There was just the "message of people" and since it was the depression, this was a message of people in the depression, darkly painted and somber, a heavy-breasted black woman leaning out of a tenement window, a seamstress, tired dancers, men of the waterfront. There was no need to search for themes or subjects. They were constantly around for there were always people at hand. Through the years they were to change. Where once there were bohemians, there later were beatniks and then hippies, while a rebellious off-shoot of ballet was to become an Establishment of its own—Modern Dance. But however they changed, they remained human and remained the theme of Moses' work.

A small painting, by a student, of Moses posing for the artist James Lechay. A few years later, Moses, Chaim Gross, Alex Dobkin and Raphael Soyer started the New Art School. It was housed in two large rooms (Ida had used one of them as a dance studio) in a three story red-brick building on Sixth Avenue and Sixteenth Street. These two rooms also served as Moses' studio. The announcement of the school drew a tremendous response from all over the country. Applications poured in, many accompanied by requests for scholarships. Since most of these scholarships were granted, the monetary profits of the venture came close to nothing, which was then divided equally among the four artists and the secretary.

There was, however, a different kind of profit resulting from the New Art School. A group of talented, lively young people was drawn to the studio. Many remained after the school folded, the women until marriage or careers took them elsewhere, the men until they went into the service for World War II. They were restless, varied and quick, drawn from all over the country, middle westerners, Brooklynites, southerners and New Englanders, bakers' sons and ministers' daughters. For some reason there always seemed to be a small town minister's daugh-

11

ter drawn to a life of art and artists, perhaps seeking a freer way of life than she could pursue at home.

In the unstable atom of studio life, the mature artist was the nucleus, circled by an inner ring of electrons, the students closest to him. They in turn were circled by fast moving, more peripheral individuals who would break away frequently, to be replaced by others, while the inner ring remained steadier, changing only slowly as the years passed. Ken was for some time in the inner ring. A tall, slim Hoosier with curly blond hair and even features, he grew a red beard eventually and looked less the clean-cut, all-American boy. But he exuded chic and grace in everything he did, from the way he dressed (he later became a successful expatriate fashion designer) to the way he baked a pumpkin pie. He lived, illegally, in the studio and shared it with a high-cheekboned, piercing-eyed, blond crew-cut van Gogh-like young pacifist named Fred. There was a smoldering violence and talent in Fred. Ken once woke up in a fright, unsure as to whether or not Fred had been standing over him with a hammer raised. This violence Fred later turned against himself. He too committed suicide before he had a chance to develop his talent.

Others in the inner ring included Natalie, a bouncy Great Neck grandmother; beautiful, blond Jeanne whose peaches and cream, buxom, toothy, country-girl freshness almost obliterated the sexless, fragile mannikins a fashion magazine once brought to the studio for photographs; the dark, Semitic, strong-willed Sylvia, Jeanne's opposite in type, but equal in attractiveness; and Nell, the painfully sensitive and talented southern girl, tall, gawky, flat-chested, delicate of feature and southland manner.

Were these students? They attended no classes but were constantly in the studio. They lived Moses' life with him, sharing his career, absorbing his humanistic point of view that the most important subject of art is man. He was important in their lives, yet he needed them as they needed him. Their admiration buoyed him, their greater worldliness and practicality helped him organize the studio. They painted it, cleaned it, made and fixed the furniture. They kept him close to the ethos and rebelliousness of youth as he moved through middle age. They took his dictation when he wrote, washed the coffee cups, and answered the phone. They posed for his paintings. If he was their model, they were his models.

The artist-model relationship goes deeper than the observation of a body's surface by a recording eye. When Moses paints, the studio is still. The radio plays music. Conversation is quiet, sporadic and intense, as the hours go by, session after session, painting after painting, and the artist gradually gets to understand the model. The talk grows intimate. The model describes the man she is sleeping with. One pregnant woman tells her well-nested pleasure, another smirks defiantly as she anticipates the shock to her par(enemies)ents when they see the complexion of their grandchild. One young dancer leaps in spirit as she reports a tiny role in Martha Graham's ensemble, another sags on the verge of depression as her body thickens and "the break" does not come.

The tension of each pose is broken by the words, "Take a rest." Sometimes the rest is forced by the intruding ring of the telephone and even when it is not, Moses often uses the time to make a call. Every day the two brothers are in New York, sometimes twice a day, sometimes more, there is the staccato, predictable, nearly toneless telephone conversation with

Raphael: "Hello . . . What's new? . . . Talk louder . . . Who have you seen? . . ." A brief exchange about the paintings each is working on, who is posing, some art or family gossip and then goodbye until the next call: ". . . What's new? . . . Talk louder . . ." There are also several daily calls to Ida. What time did she get up? How was the coffee? Any mail? What is she doing today?

That large, double studio was a center of activity. The whole building was occupied by artists. Upstairs were Sol Wilson, Jim Lechay and others. There were tremendous parties, with crowds of people. Ken and the others would decorate the studio and prepare the refreshments. One affair, to raise money for a wartime cause (paint supplies for Dutch and Russian artists), drew hundreds of guests, with many of the artists and students in uniform. Amidst the noise, the dancing, the shouting, the drinking, moved the majestic black presence of Paul Robeson, erasing from at least one memory all other impressions of that hectic evening. He seemed to fuse into a single powerful, regal being all of the physical, intellectual and artistic traits an adolescent could admire. To a young mind, both dimmed by wine and whipped by excitement, it seemed that the waves of people parted in awe as Robeson moved graciously through the studio.

A small, harsh profile of Moses, painted by Joseph Stella. The older generation of artists was welcome in the studio. Moses always felt a filial respect for them, growing out of his sense of being rooted in the traditions of art. There was Walkowitz in his strange quest for immortality when he had 100 portraits of himself painted by 100 artists. The successful Max Weber, gentle and silver-haired, talking in a high-pitched voice about the days when he washed his own socks or how he put out a fire in his studio with his "precious hands." Burliuk was often there, vigorous, forceful, with rasping, accented voice, constantly sketching and talking, tales of Mayakovsky, Arshile Gorky, life in Russia and Japan, travels to Europe, Africa, Australia and all over the United States. He was a troubadour artist, painting wherever he lived or traveled, communicating through his paintings whether or not he spoke the language of the country. (Moses' accent would seem stronger after he had been with Papa Burliuk and old friend Nicolai Cikovsky, for he would speak Russian with them. Toward Burliuk, Moses would use the respectful "you" form in Russian, while Burliuk would use the "thou" form in return.)

Joseph Stella seemed old, with sagging, gray features, steadily complaining about his bifocals and the buzzing in his ears. At times he'd suddenly come to life to tell, in a grand and eloquent style, stories of another studio building, this one in Paris, where he, Modigliani, Pascin and Soutine all worked. He often told how on one cloudless spring morning he went to the window to soak in the beauty of the day. His rapture was interrupted by water trickling from above and onto his head. He looked up to see Pascin playfully dripping water upon him. In a rage, he ran upstairs, picked up the smaller man and dropped him to the floor.

Stella seemed to be producing little toward the end of his life and seemed forgotten in the fashions of art. In his last few years, he spent many days in Moses' studio, talking, sketching, posing, dozing, bitter and sad. He died before the shift of fashion came and he was "rediscovered" as a forerunner of much that is "modern" in American art. Moses' paintings of Stella show him in these last years, but Moses also owns a self-portrait by Stella as a younger man. He is shown in profile. He is bull-necked, imperial and scowling, as he might have been on that spring day in Paris.

This filial respect extended also to other artists of the past and present. In talk and in writing, the spirits of Rembrandt, Corot, Degas were always present. Robert Henri, his teacher, was seen by Moses as his inspiration to become a professional artist. Thomas Eakins was respected for his straightforward honesty and Hopper for steadily, if harshly, portraying man and his world.

A painting by Moses of a heavy, mustached fully-clothed business man sitting on a couch and eyeing a semi-clothed young woman. Within the stream of humanity constantly flowing through the studio were those who were not themselves artists but who were always bubbling on the periphery of the art world. They might be honest, sincerely interested, close friends trading their services (as dentist, accountant, physician) or their goods (hardware or books) for drawings or paintings. Long days were spent with these friends, often starting in the studio, continuing with visits to galleries and museums, lasting through dinner and a movie or an evening of good talk about art or other subjects.

There were also the "goniffs" (thieves) whom one had to watch to be sure that while they were bargaining for one painting, they were not stuffing another one under their coats. They rummaged through the studio, looking around the walls, blowing the dust off the drawings lying on tables, turning stacked canvases around to be seen. The talk was of the marketplace, not of art: "Moses, I could get you a Grosz of the Berlin period, wouldn't cost you much. . . ." or, "Throw in the Elshemius over there and . . ."

Another group included the collectors who preferred to buy directly from the studio rather than going to the gallery. Some may have felt that they would get bargains, or they may have seen a studio visit as an offbeat kind of entertainment for a Sunday afternoon. One collector might stand impassive as painting after painting was displayed before him. Another would grow enthusiastic, singling out one or two paintings he liked and continually going back to them, building up a sense of attachment to the work of art he liked. A young couple, perhaps a former model and her new husband, might buy a small painting on credit at a much reduced price. A business tycoon might offer to buy the entire contents of the studio at one shot.

Over the years, the studio's location changed, but the pattern of studio life continued. One group moved on, to make their careers or marry, or disappear or die, while others moved in to take their places, a new group of young students, a derelict, the hangers-on, the dancer-actress models, old bohemian poets and new beatnik poetesses, businessmen, doctors, collectors, fellow artists, photographers. Some faces are the same (Chaim Gross grows gray, Isaac Soyer white), some are different. A career passes, made up partly of people who have moved through the studio, many of them caught on canvas or paper, some vaguely remembered, some forgotten.

Moses now has a twilight studio, dark and quiet. There is one cool splash of light near the large window, and one small square of light under a skylight in the center of the long loft room. The rest of the room is dusky, the walls graying white-washed brick. It seems stripped to essentials: the model and artist working near the window, the radio, a bottle of whiskey in the kitchen, the low-keyed phone talks with Raphael and Ida. The hangers-on are gone, the collectors go to the gallery, the older generation of artists, those who are still alive, cannot climb the studio stairs. There are no students, for they might detract from the business of painting.

14

I do not visit often. When I do, it is for a few minutes, a quick look at the latest paintings and a glance around at the still accumulating record of an artist's life that has been so familiar. When my son and daughter visit with me, I sometimes wonder what they will remember, what it will mean to them. Can they have the sense of being "home" that I feel? They have spent so little time there. Perhaps the paintings old and new, the photographs, the drawings, the books and catalogues, will bring to them a sense of the life and history of the studio. Perhaps there will be passed on to them a certain feeling for people that has been so much a part of it. Perhaps this feeling can span the generations.

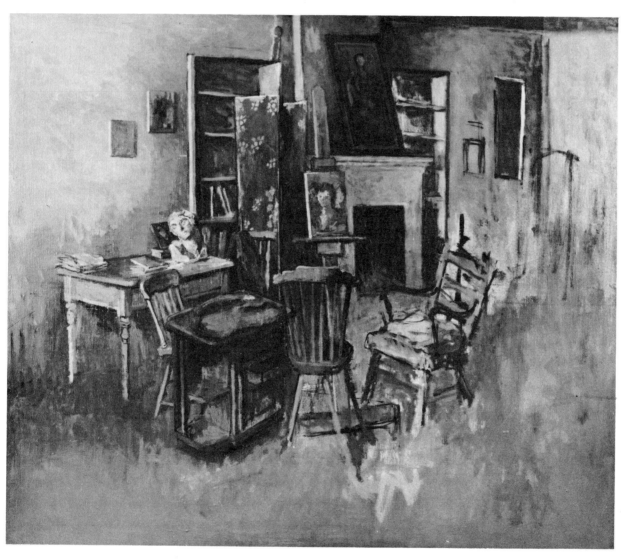

2. The Artist's Studio after Five o'Clock. 1962. 36 x 42. ACA Gallery

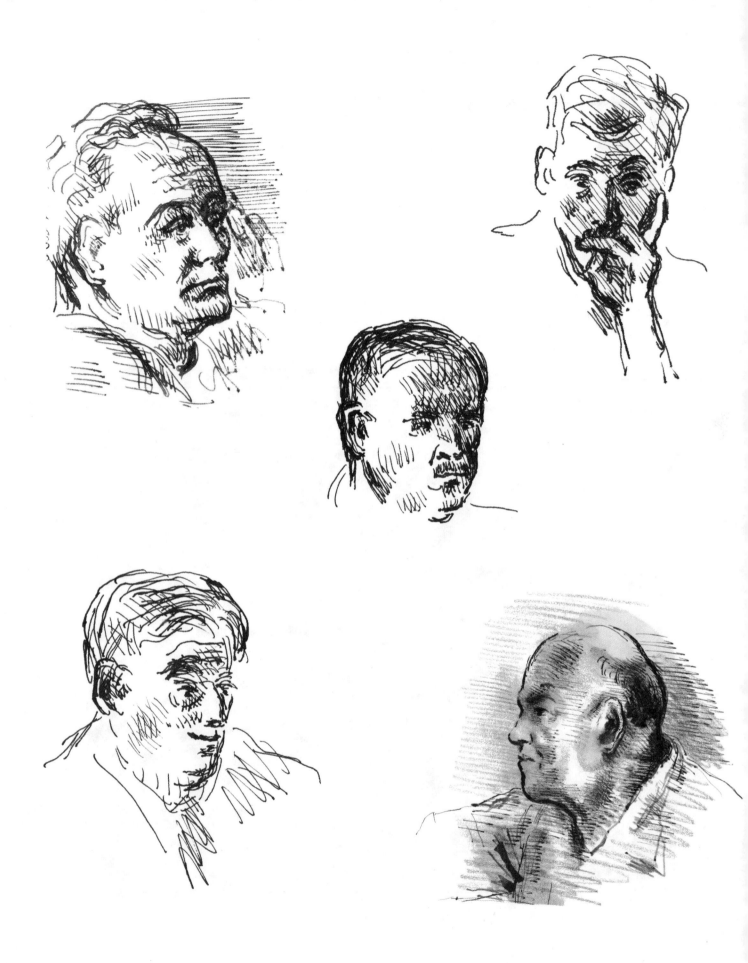

Thumbnail sketches by Moses Soyer of Peter Blume (upper left), Karl Fortess (upper right), Niles Spencer (center), William Gropper (lower left), and David Burliuk (lower right).

Moses Soyer

BY ALFRED WERNER

IN THE VAST HOUSE OF ART there are many mansions, and in them coexist artists of many schools and philosophies who, despite their differences, share a common goal: to pour their souls into the shapes fashioned by their hands. One of these philosophies is well represented by Moses Soyer, who has been painting indefatigably for nearly half a century. He belongs with those artists whose feelings crystallize in the image of man, beginning and ending with the human form. Steadfastly, he has remained an observer of the world, a describer of its people, a reporter concerned with accurately rendering his most personal response to nature.

Soyer's work can be found in some of the major public collections in the United States—among them the Metropolitan Museum of Art, the Museum of Modern Art, the Whitney Museum of American Art, and museums in Philadelphia, Washington and Detroit. Still, the intrinsic merit of his *oeuvre* has yet to achieve the full recognition it deserves. Soyer refuses to cater to fickle fashions in current taste and remains true to himself.

Moses Soyer's story should intrigue those who wonder how and why, seemingly from nowhere, the urge to create visual images seizes hold of a particular individual. In the Soyer family, three of the four sons—Moses, Raphael and Isaac—became artists, while Israel and the two daughters, Fanny and Rebecca, turned to school teaching. A factor that makes the Soyers' achievements even more significant is their background, for they belonged to what social historians call an underprivileged group. The family was part of the wave of Jewish immigrants who fled Tsarist Russia at the turn of the century, and from whose numbers scores of brilliant artists emerged. This is surprising, since proletarian and lower middle-class Jewish homes were usually devoid of objects that might spark esthetic contemplation, and Biblical law and tradition discouraged the making of images. The Soyer household, however, was atypical, as we shall observe.

Soyer's story is not only that of one Jewish boy from a small town in Russia who became an artist. It is also part of the American saga, if this term is understood to signify the humanistic philosophy postulating that differences in race, religion or ethnic origin are no obstacle to acceptance into the intellectual segment of society. When Marc Chagall settled in Paris as a young man, he had to overcome much xenophobic, anti-semitic prejudice before achieving recognition by that nation's art establishment. Eventually he was given French citizenship, but he never became a true Frenchman. Although he lovingly painted the vistas of Paris—"my second

17

Vitebsk" he once wistfully called the metropolis—his pictures are often filled with the outsider's nostalgic memories of his native town, his *shtetl*.

Soyer, in contrast, is very much the American, having quickly and deeply rooted himself into the American soil. But then, he was only thirteen when he was brought to the New World, while Chagall was already twenty-three when he arrived at the Gare du Nord and had already studied for years at art schools in St. Petersburg. Yet even people who are quite young when they are transplanted onto French soil are rarely accepted as fully French. Soyer, however, soon shed his immigrant identity and adopted the American vision. Indeed, his canvases are strikingly American, not a bit European. Even Jewish subject matter is as conspicuously absent from his work as it is markedly present in that of older artists such as Abraham Walkowitz or Max Weber.

Nor is there anything particularly Jewish about the profound sense of compassion often found in his paintings. The fact that Moses Soyer was one of several dozen Jews among the era's social realist painters should not be misinterpreted. Within the ranks of the protesters, no distinction was made between gentile and Jew, black and white, native American and immigrant. They formed a fraternity of people filled with the same desire—to give plastic expression to the genuine dissatisfaction rampant in a period of mass unemployment, strikes, and riots.

Being very American, Soyer's art is stimulated as much by the prosaic as by the poetic. His outstanding qualities are directness, clarity, simplicity—even a dash of naïveté; his pictures come straight from the heart, unaffected, plain-spoken and at times even unflattering. A true democrat, he would heartily agree with Emerson's endorsement of the common, "I explore and sit at the feet of the familiar. . . . Give me insight into today, and you may have the antique and future worlds." Soyer would also concur with Walt Whitman's "Never was average man, his soul, more energetic, more like a God."

18

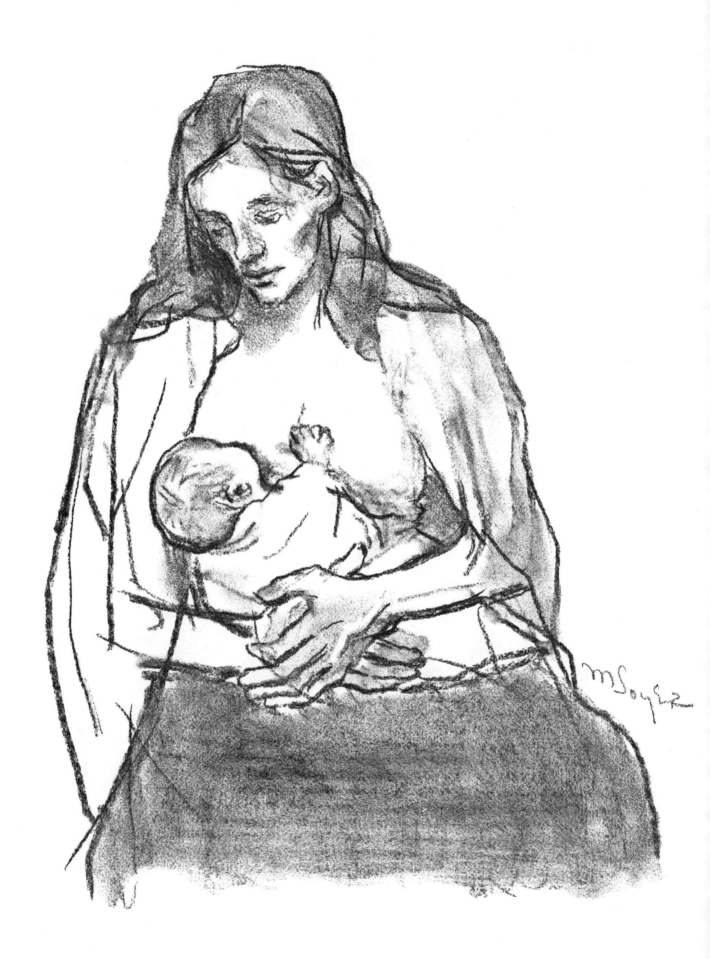

It is significant that, as a child, Moses, like his brothers and sisters, knew a good deal about America—even though he was separated from it by thousands of miles. Soyer's father read about the U.S.A. and often talked to his brood of its vastness, richness, and democratic form of government. "Who knows," he would say dreamily, "perhaps one day you may be citizens of that great republic and contribute your strength and talents to its growth."

George Washington and Abraham Lincoln took their place alongside Peter the Great and Alexander Pushkin as the youngsters' heroes. They read translations of *The Adventures of Tom Sawyer, Uncle Tom's Cabin,* and *Hiawatha.* On weekends and holidays their mother would cover the large round dining table with a shiny oil-cloth on which, in barbaric red and green, was printed a picture of the Brooklyn Bridge spanning the East River and joining the skyscrapers of Manhattan with the tenements of Brooklyn. The Statue of Liberty and the Singer Building were also clearly discernible.

From a picture that Moses Soyer painted in 1937, we know the father Abraham Soyer as a small, sad-eyed, bearded intellectual. Earlier, in 1932, Raphael Soyer had painted his parents seated at a table in a relaxed yet thoughtful mood. They are no longer young; they look worn out by too much work and too many worries. But Moses remembers when they were full of life and zest, when they were about the age his own son David is now.

The family's original name was Shoar (possibly derived from the Hebrew word for sentinel). Abraham Soyer (1867-1940) was too big a man for provincial Borisoglebsk, where he lived until the age of forty-five. Maxim Gorky, in one of his books, describes this small town, located southeast of Moscow, as a poverty-stricken, muddy and hopeless place. There, fifty Jewish families lived among a total population of about fifty thousand. A noted Hebrew writer, Soyer taught this ancient language to the Jewish children who attended the public schools. Significantly, the superintendent of the city's schools, a bearded ex-general, would often come to sit at the back of the room and observe Mr. Soyer teach the language of the Old Testament. The relationship between the city's Christian majority and the tiny Jewish minority was relatively good.

Moses and his twin brother Raphael were born on December 25, 1899. They went to the same elementary school, but attended different secondary schools. At his *gymnasia,* the drawing teacher, a former Cossack general, liked the gifted young Moses—so much, in fact, that he tried to convert him. He once told Moses a story with a moral about a Jew who, falling out of a window, screamed, "Jesus Christ, help me!" and thus reached the ground completely unhurt. The teacher also took the boy to weekly Sunday services in one of the Greek Orthodox churches. Mr. Soyer raised no objections, only remarking, "But never forget that you are a Jewish child."

Luckily, Moses came from a family far more enlightened than that of either Chagall or Soutine. Hostility toward the plastic arts was absent. Even the paternal grandfather, Moses Shoar, was something of an artist; in his leisure time he cut decorative patterns in small stones and nutshells with his pocket knife. Another relative had carved an intricately wrought large Torah shrine for the synagogue at Lutzin, near Vitebsk. Once the pride of the *shtetl,* the shrine is now in a Soviet museum.

Despite the family's artistic leanings, the environment provided precious little esthetic fare for the sensitive and precocious Soyer boys. The small city had of course, no museum; the synagogue consisted of one dank, dark room; nor did the town's main church, a red building with onion-shaped cupolas, have any artistic importance (even so, young Moses was impressed by

21

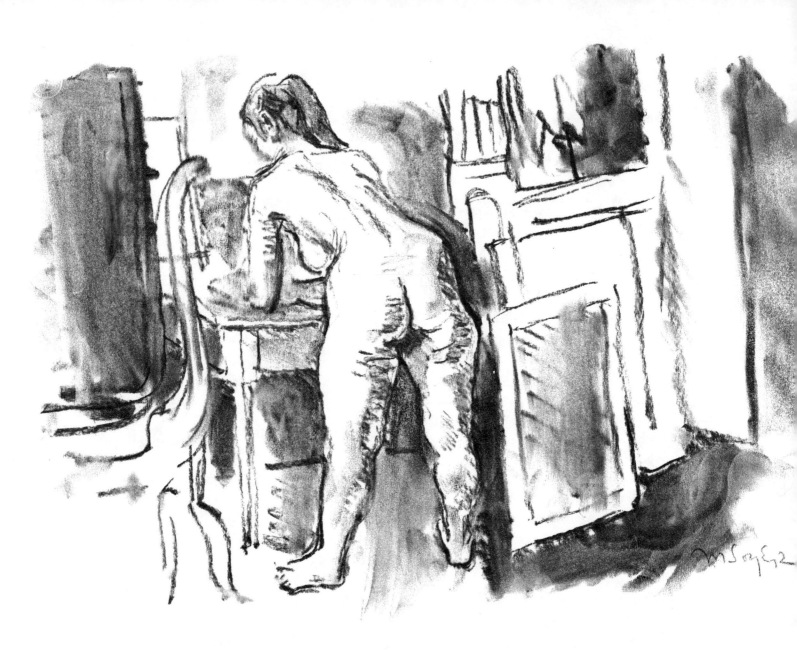

the steeples that seemed to pierce the sky). Thanks to their father, however, the children got their quota of early art appreciation. Although raised in a strict Jewish home, Abraham was un-inhibited by the Second Commandment's taboo on the making of images. He adorned his own dwelling with postcards and with small reproductions of old master works, and he told his children about Michelangelo, Raphael, and Rembrandt. He himself loved to draw human profiles and horses walking or galloping.

His wife was also gifted in many ways. Yet, despite her excellent mind, and although the man she married became important enough to be listed in several encyclopedias and other reference works, Bella Schneyer Soyer had no higher goal than to be a devoted wife to Abraham, and a good mother to his children. This quiet, reserved woman was an artist of sorts who loved to embroider illustrations of Russian fairy tales on linen, using brightly colored yarns. With her large brown eyes and curly hair, and wearing a close-fitting velvet jacket and small flowered hat, Bella Soyer resembled a Renoir model.

Abraham Soyer encouraged his children to draw—with pencil or pen, since there were no crayons available—and to make paper cutouts of soldiers and horses. One day the twins copied

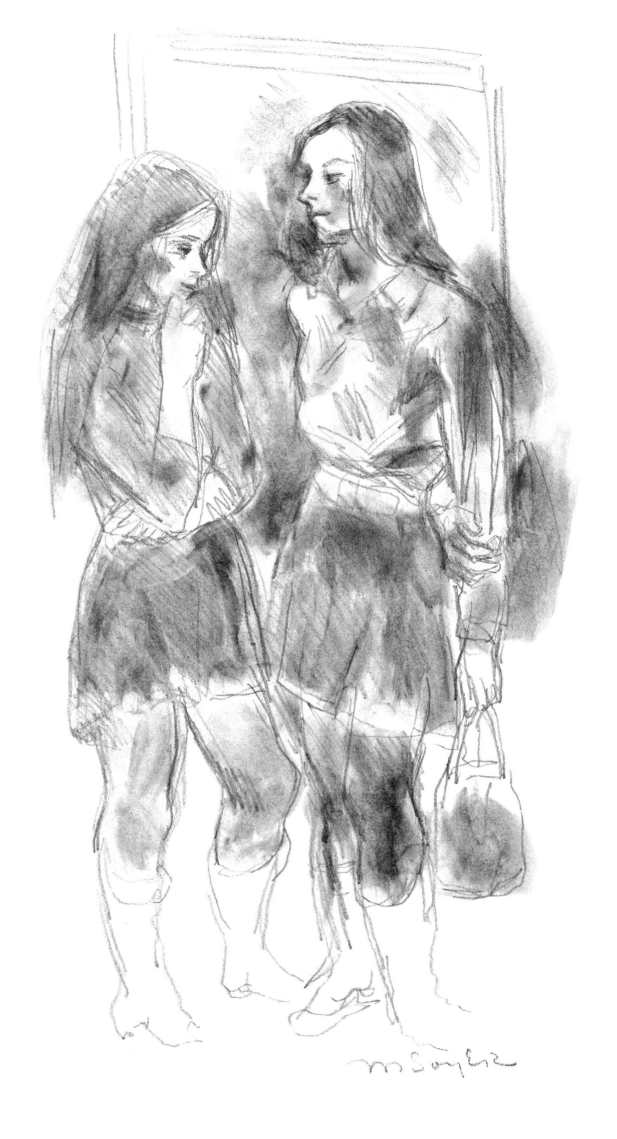

a photograph of little Alexei, the Crown Prince of Russia. They brought their drawings to school for their classmates to see. A boy snatched them to show to the drawing-master, who angrily called the two culprits to his desk. "Remember," he warned sternly, "that while you may draw the likeness of anyone, even of God Almighty Himself, you must never, never portray a member of the Imperial family."

This teacher was a kindly man and a friend of the father. He often gave the boys small gifts. They were thrilled to receive a drawing he had made of trees swaying in the wind along the edge of a river with a rowboat rocking on the water. At first Moses copied this drawing with painstaking care; but soon he grew bold enough to alter the design, adding a tree, changing the position of the boat, introducing a human figure or an animal. He was on the path to freedom.

The twins knew another "artist," Ivan Ivanovitch, their landlord's son. He was a serious,

dreamy adolescent who took the youngsters fishing, mended their kites, and let them fly his pigeons. One day he sketched their father. The boys watched as he worked. The finished study somewhat resembled the severe, somber icons of saints that were in Ivan Ivanovitch's home. Mr. Soyer was given enormous eyes gazing sternly out at the spectator, and an ascetic head larger than life, framed by a heavy black beard. The finished drawing was not a masterpiece, but it served to make the boys aware that one could draw from a model instead of merely copying or relying on memory.

Children born and raised in Vienna or Berlin, Paris or London, New York or Washington, are often taken to magnificent museums by their parents. Moses and Raphael might never have glimpsed any of their country's museums had it not been for a curious accident. One summer the family's pet cat went mad, scratching and biting the twins. Father took them to Moscow for treatment against rabies. It was a long journey, but it had its bright spot—a visit to the

Tretyakoff Gallery. There they saw works by celebrated national artists such as Repin, Serov, and Vereshchiagin which impressed them with their patriotic, anecdotal themes. The boys were convinced they were seeing the greatest works of art ever produced; nothing could be finer or grander.

Had Moses and Raphael become artists on Russian soil, it is likely that their art would have developed in a totally different direction. Conceivably, the Soyers might never have left Russia but for an unexpected occurrence. They were poor and there was not always enough money in the house for food or rent; still, Mr. Soyer liked his work and, fortunately, did not suffer individual discrimination as a Jew. In little Borisoglebsk, which was outside the Pale of Settlement (the provinces where the bulk of Russian Jewry were confined) none of the ugly pogroms occurred that cost the lives of so many Jews in Odessa, Kishinev and other large cities. The Soyers, in fact, were loved by their neighbors who included many non-Jews.

This affection almost proved to be the family's undoing. Young revolutionaries liked to gather in the Soyer home. Occasionally they produced anti-government leaflets on the premises. One day, the Soyers were warned about a projected police search. Just in time, the father discovered revolutionary literature left behind by his young guests. It was quickly burned in the big stove and the police found nothing.

Nonetheless suspicion remained. One day Abraham Soyer was summoned to police headquarters. Bluntly he was told that the governor of the province would not renew his residence permit; the family would have to leave the country in twenty-four hours. Friends intervened, and he obtained a few weeks' grace. During this time, he communicated with relatives in America, obtained steamship tickets and sold household goods. After many touching farewells, the Soyers set forth for the Promised Land.

II

Moses Soyer recalls the fearful experience of crossing a rough, stormy Atlantic from Liverpool on what was to be the last voyage of a creaky, old steamer. Huddled on deck, the children watched as the adults sought to enliven the painfully slow passage by dancing and by singing their folksongs to the accompaniment of balalaikas. When, on a gray autumn morning, the two weeks' ordeal was over and the ship docked in Philadelphia, the children were astonished. Their mother's relatives, who had come to greet the newcomers, looked utterly strange to them. The men wore carefully pressed suits, and their faces were clean shaven!

The enormous effort required of a Jewish immigrant boy who yearned to become an artist in the early 1900's has been described touchingly in autobiographies written by the sculptors Jo Davidson and William Zorach, and by the painter Maurice Sterne. Moses and his brothers came to America years after these three artists had arrived, but conditions had nevertheless changed very little. The children faced the same problems of adjusting to a new and different society, and of learning a language that had nothing in common with their native Russian.

Father Soyer went on to New York in search of a teaching job, while mother and children were sheltered with relatives in Philadelphia. The twins, despite their *gymnasia* education and their knowledge of German and French, were put in the first grade with six-year-olds. They

Titian
Presentation
in the Temple

Cima da
Coregliano

M Soyer

Michael angelo's Pieta Florence

avenged themselves on this absurd system, playing hooky as often as they could. They learned very little those eight months in Philadelphia, but the time was not entirely wasted. When the teachers found out that the two could draw, they kept the boys busy decorating the classrooms with pictures of the Liberty Bell, Betsy Ross designing the flag, Abraham Lincoln's log cabin, and—in anticipation of the Christmas holidays—good old Santa Claus. Teachers from other classes would knock on the door and ask, "May we borrow the Soyer boys for the holidays?" Moses estimates they must have covered miles and miles of blackboard with colored chalks.

In Philadelphia the twins also got their first impression of an American museum. They did not see the huge Greek temple in Fairmount Park now housing the splendid Philadelphia Museum of Art, for that was not yet built. The Pennsylvania Academy of Fine Arts, which they accidentally discovered by venturing out of the drab and dreary Jewish section, was limited in scope.

But to the boys it was a real treasure house. Accustomed to the academic art of their homeland, they found in this museum the same style of painting and thus saw much that they could admire. One day, absorbed in the story-telling pictures, they forgot about the closing hour; wandering through long, dark rooms, they were spotted only when the guards made their final rounds with lanterns and flashlights before closing up for the night.

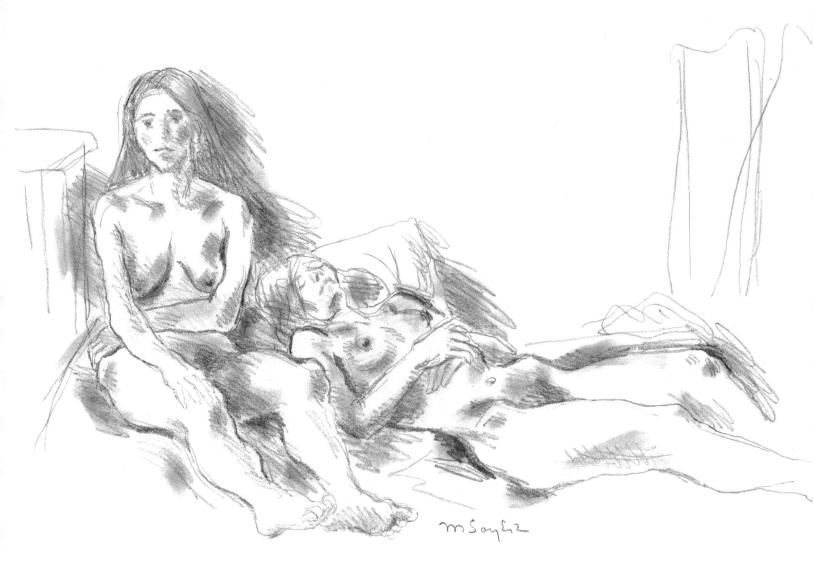

III

Mr. Soyer got a small job at a yeshiva on Henry Street in Manhattan and brought his family to New York, where they settled in a simple apartment on East 140th Street in the Bronx. The twins, and later Isaac (who was eight years younger), attended Public School 9, around the corner from their home. Despite their alert minds, they were not interested in book learning. They knew already that they wanted to be artists. Their father did not discourage them. Unlike Chagall or Soutine, Moses and Raphael did not have to run away from home to pursue their dreams. Abraham Soyer only warned, "Go to college first and get a degree." Like many self-educated men, he had profound respect for academic learning and college degrees. But despite his pleas, the boys dropped out of high school two weeks before graduation.

The family was still poor, and the brothers realized they had to help out. Moses remembers selling newspapers, tending soda fountains, and working at night in the Columbia University library where his job was to deliver books to designated tables. Despite all hardships, however, Moses and Raphael were stubbornly determined to pursue an art education. They got into free evening classes at Cooper Union. Moses still recalls the school's stifling routine of drawing from plaster casts. Then, in the fall of 1918, at the age of eighteen, the twins entered another free school, the venerable National Academy of Design.

30

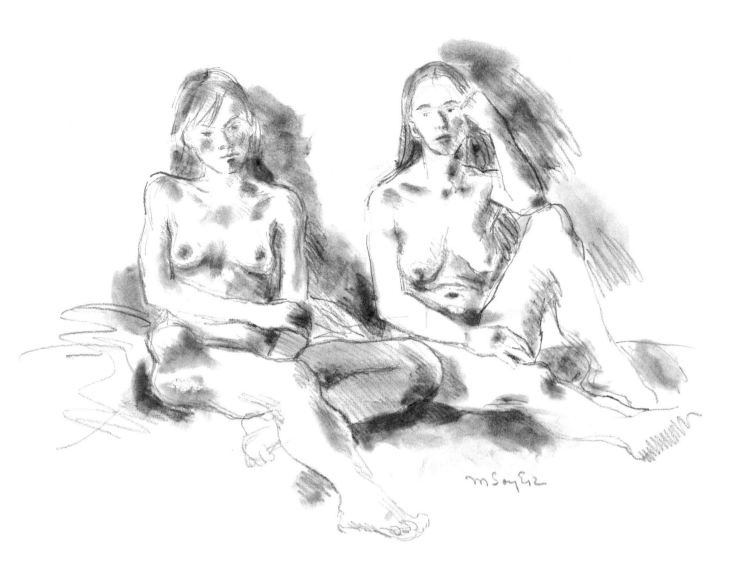

Moses Soyer's experiences there were not to his liking. The crowded classes were held in a dreary, badly ventilated room. Worse still, the instructors were insensitive and hostile to the new art currents, both European and American. The standard they held up to students was the work of John Singer Sargent, then at the peak of his fame as the world's greatest painter of society portraits. Moses never thought much of these paintings, though he did like Sargent's intimate, less pretentious genre pictures. At the Academy, the goal was clever painting enhanced by tricky lighting effects. Nothing was said about Thomas Eakins, Winslow Homer, and Albert P. Ryder, who had died a few years before; not a word, certainly, about the rebels Robert Henri, George Bellows, and John Sloan, representatives of the Ashcan School, so named because of their concern with slums and poverty. These men were repudiated as apostles of ugliness. The teachers at the Academy were only reluctantly aware of the Impressionists and Post-Impressionists. One instructor talked so angrily about "that wild man, Cézanne," whose nudes he considered obscene, that Soyer became interested in the work of this Frenchman. He did not have to go far in his search: the Metropolitan Museum had already acquired its first Cézanne.

While working at the Columbia University library, Soyer met another young art student, Leo Jackinson, who tragically drowned at the age of twenty-two. Cultured and gifted, Jackinson spoke disparagingly of the Academy as a bastion of conservatism. He took Moses to an unusual place, the Ferrer Art School, located in an old building in the Spanish section of Harlem.

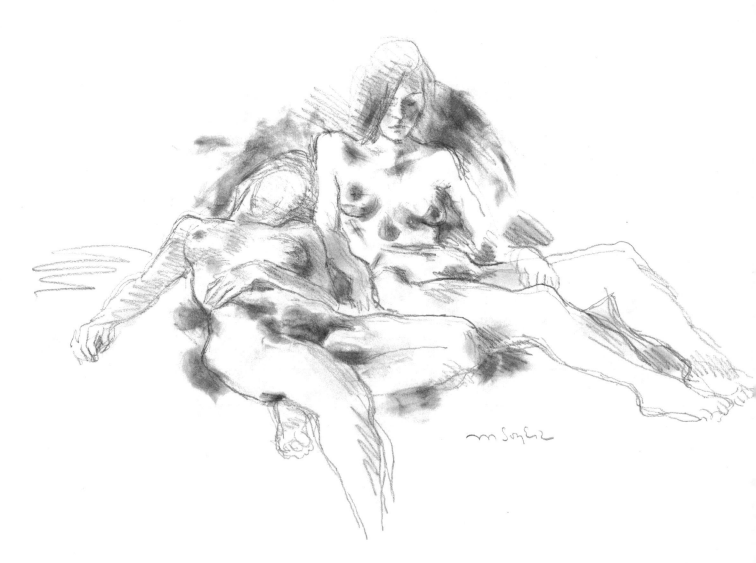

It was named after a martyred Spanish labor leader whose portrait occupied the wall facing the entrance door. Not a real school, it was rather like the famous Académie Suisse in Paris, or the Académie de la Grande Chaumière where, for a small fee, artists could draw from the living model in a laissez-faire atmosphere. A gypsy-like woman, Romany Marie (who later became a legendary figure as the owner of a bohemian cafe in Greenwich Village) presided over the Harlem establishment, sitting at the desk and collecting half a dollar from each pupil for each session.

For Moses Soyer, the important experience at the school was his encounter with Robert Henri, who alternated on Sundays with George Bellows to offer criticism to the students. Soyer remembers Henri as a warm, generous, magnetic man whose gaunt, mournful face reminded him of Abraham Lincoln. Henri, a fine portraitist in the manner of Manet, had fought every battle for freedom in art and for juryless exhibitions. He was an excellent pedagogue, who interspersed his criticism with lively anecdotes about his student days in Paris at the Ecole des Beaux-Arts and the Académie Julian. Seeing one of Moses' drawings, he mercilessly dissected it, pointing out its superficiality, its lack of character, its empty cleverness. But there was no malice in his criticism; he wished sincerely to help these wide-eyed young men. To reinforce a point, he would pull from his pocket the current issue of *The Liberator*, a progressive periodical and successor to *The Masses*. Opening it at random, he would show drawings by Honoré

32

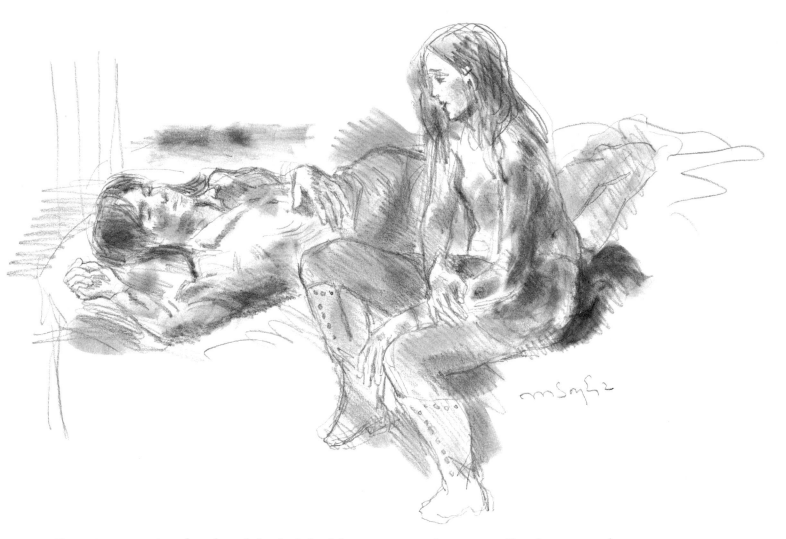

Daumier, an artist who, though he had died forty years earlier, was still unknown to these students.

Soyer was struck by the love and sympathy with which the French master had drawn proletarian men, women, and their undernourished children, as well as by Daumier's feeling of movement and simplicity. Discussing these drawings, Henri used terms such as "significant form," "volumes," and "space relationship" that Soyer surely could not have heard mentioned at the Academy. Thereafter, Moses Soyer bought every issue of *The Liberator*. He was captivated with its illustrations by members of the Ashcan School, who dealt with the hard life of simple people. He was also deeply moved by the powerful political cartoons of Boardman Robinson, Art Young, and William Gropper, which assailed injustice and inequality, particularly child labor and police brutality.

His brother Raphael was also impressed by what he saw in *The Liberator*. Indeed, the magazine seemed to liberate both young men, for under its influence they decided that it would make no sense to return to the stodgy Academy. Aware, too, that people were commenting on the similarity of their work, they felt it would be wise to go separate ways and to study in different art schools. Raphael enrolled in the Art Students League uptown, while Moses turned to one of the most remarkable pedagogical establishments in the United States, the art school of the Educational Alliance on Manhattan's lower East Side.

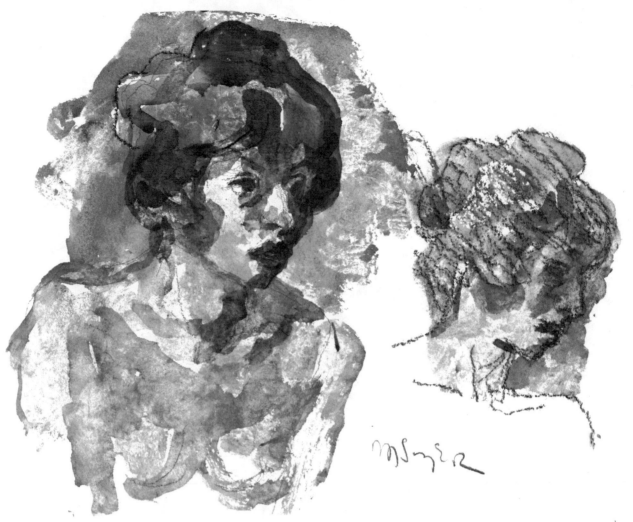

The Alliance was founded by well-to-do American Jews in 1889 as a community center for newcomers to the ghetto of New York. At the start, only casual art instruction was provided. Jacob Epstein and Jo Davidson availed themselves of the early drawing classes. Henry Mc-Bride, who became a leading art critic, was one of the teachers. By 1914 a fullfledged art school was in existence.

Ultimately, the alumni, in addition to Moses Soyer, were to include the now celebrated Peter Blume, Philip Evergood, Adolph Gottlieb and Chaim Gross. Whatever defects the school may have had, its standards were high. It was innocent of the restrictions that shackled other art schools; and its students were allowed absolute freedom of expression. One of the school's more notable features was the kind of models employed—not impeccable nudes, but people recruited from the streets: a jovial Italian woman, a pregnant gypsy, a wistful Negro child, a bearded Hebrew scholar. Due to the special ethnic composition of the neighborhood, most of the sitters were Jewish. Abbo Ostrowsky, director of the art school, would walk to nearby Seward Park and approach the elderly people relaxing on benches, reading their newspapers, or chatting. Addressing them in Yiddish, he explained why he needed models.

Like most of the students, Moses could spend only a small part of his time on art. To eke out a living, he worked as a proofreader in the classified advertising department of the *Morgen Journal*. When one of the editors found out that he was an artist, he urged Soyer to write an art column, "In der Velt fun Kunst," for the weekly supplement, *Der Amerikaner*. Soyer received only eight dollars per column, but he now had an excuse for traveling uptown to the art gal-

leries on 57th Street. Once, he even went as far as Boston to view the murals executed by Sargent for the Public Library there. On another occasion, he reviewed an exhibition of Russian artists who had come recently to the United States; among them was David Burliuk, in later years to become an intimate friend.

Every spare minute, though, was spent at the Alliance. Soyer still recalls the interminable discussions on all kinds of topics, for instance the relative importance of Piero della Francesca and Paul Cézanne. While the students differed in many ways, they were united in their consuming desire to become artists.

Idolizing Rembrandt, Moses studied the works of the great Dutch master in the priceless collection bequeathed to the Metropolitan Museum by the wealthy merchant, Benjamin Altman. To achieve Rembrandtesque effects, he would so pose the model that part of the face was bathed in light, leaving the rest in transparent shadow.

Soyer's few surviving pictures from this period—among them one owned by Ostrowsky, and another by the heirs of the late Dr. Samuel Margoshes, editor of *Der Tog*—are as yet strongly derivative. But they show merit. Ostrowsky was among the first to recognize the young man's talent. In 1923 he asked Soyer to join the staff of instructors at the Educational Alliance. Only twenty-three years old, Moses gratefully accepted, for in those days few galleries were open to newcomers, however gifted. Art patrons were scarce, and those who were on the scene bought works by celebrated academicians or, if they could afford it, by old masters.

IV

After three years of intermittent teaching and painting in the tiny combination studio and living quarters which he occupied across the street from the Educational Alliance, Soyer got several breaks. In 1926 he met the dealer J. B. Neumann, who had come to the United States from Berlin where he had had a gallery. The two met when Neumann was showing works by Max Weber, then rather unknown but already at the height of his powers. Soyer was now writing on art for a Philadelphia magazine, *The Guardian,* edited by Harry Alan Potamkin, and also for *Der Amerikaner.* Introducing himself as a reviewer, Moses told Neumann how much he liked the exhibition; the dealer asked, "What do you do besides write?" When Soyer answered timidly that he was an artist, Neumann volunteered to come to his studio. Young Soyer was thrilled. He had dreamed of showing his pictures to the public, but he had done nothing to make the dream come true. After Neumann made his visit and saw the oils, he said encouragingly, "Bring your pictures to my gallery. I will keep them there, and one day I will give you an exhibition."

The second piece of good fortune was a traveling art scholarship awarded by the Arbeiter-Ring, a Jewish labor organization. Given through the Alliance, it enabled Soyer to go to Europe. He did not sail alone. He had fallen in love with Ida Chassner, a student who posed for him. She studied dancing and acting at the Neighborhood Playhouse. Ida agreed to share her life with the still impecunious artist. They were married on June 29, 1926. A few weeks later they were off to Paris.

Arriving on a hot August day, they were met at the Gare St. Lazare by Abraham Goldberg,

notre Dame ~ Paris

an American painter who had settled in Paris. To his surprise, they did not ask to be taken to a hotel. Checking their luggage at the railroad station, they said they wanted to go at once to the Musée de Louvre.

Today, more than forty years after this first encounter with some of the world's most outstanding paintings, among them Titian's *Portrait of a Man with Gloves,* Rembrandt's *Bathsheba,* and Delacroix' *Liberty Leading the People,* Soyer still clearly recalls the feelings that overwhelmed him at this confrontation. He was too modest a youth to harbor grandiose dreams that he might one day rival even the least of the masters presented here. His self-effacing hope was simply "to paint a little better than I do now."

He did not paint much during his two years in Europe. Instead, he studied drawing. He went to the Académie de la Grande Chaumière; it provided models but, like the Ferrer School, it offered no instruction. Older artists, too, came for hours of sketching. Some, among them the sculptor Ossip Zadkine, were becoming well known. Sketching was intended as an exercise. Soyer felt, and still feels, that the practice of drawing is as essential for an artist as daily practicing of scales is for a pianist.

Above all, he learned much from his frequent visits to the Louvre, where he came to know intimately every painting, and even its location. When asked who his instructors were, Soyer

likes to quote Cézanne's reply: "The Louvre." He would go also to the Palais du Luxembourg where he saw works by yesterday's outsiders, particularly the Impressionists. (The Musée de Jeu de Paume had not yet been established.) The nineteenth-century giants Daumier, Courbet, and Degas exerted a much greater influence on him than did the Fauves, the Cubists, or the Surrealists.

During side trips to Amsterdam and London, the newlyweds saw pictures and more pictures. In Paris they lived frugally in a combination home and studio near the Café du Dôme. It was there that their son David was born on July 9, 1928.

Soyer does not regret having indulged in no activities à la bohème, but he is sorry now that shyness prevented him from making the personal acquaintance of some of the artists he admired, such as Pascin and Soutine. In a cafe, he once saw a man with a flowing red beard sipping wine. "There's Matisse," someone whispered, and everybody craned his neck to stare. Soyer dared not approach Matisse, thirty years his senior and a world-famous personality.

V

Back in New York, Moses painted furiously, and with great determination. He now saw clearly what he wanted, and what he did not want. As an American artist, he felt it inappropriate for him to imitate contemporary Europeans—to paint languid odalisques as did Matisse, swan-necked girls like Modigliani's, or carcasses of beef à la Soutine. On the other hand, Soyer was adverse to parochialism, and could not understand why Bellows boasted of never having visited Europe. He considered America's Regionalists more isolationists than universal men. And while he appreciated the way Winslow Homer expressed the character of the Maine coast, he esteemed Courbet's seascapes as grander and more poetic. One of his great favorites has always been Degas with whom he shares an interest in the theme of dancers. So far as we know, this aloof bachelor and upper-class snob formed no personal attachment to any of the ballerinas of his day; in fact, he seems to have been indifferent to the private tragedies of the teen-age élèves of the ballet whom he observed as they were practising or resting, fatigued and already blasé. Unlike the detached Degas, Soyer saw dancers not just as objects to be painted, but as individuals. Through his dancer wife and her teacher and friend, Helen Tamiris, Soyer became intimately acquainted with, and personally involved in, the world of dance. The girls whom he paid to pose were not the primitive creatures who came to Degas' studio. They were usually college girls, serious and intellectual, earning money for tuition by posing. Soyer looked on them with sympathy and affection. It was this human approach, along with his ever increasing virtuosity as a painter, that induced the discriminating J. B. Neumann to become his dealer.

In December, 1928, a few weeks after his return from Europe, Moses had a successful one-man show at Neumann's Art Circle gallery. Hoover's America was still flamboyant, still optimistic. Less than a year later the stock market crash of October 19, 1929, was to mark the end of prosperity. The decade that followed was a difficult time for artists to earn a living from art alone. The few patrons rich enough not to be much affected by the national tragedy now had other things to do than purchase art. Without the WPA Art Project initiated by the Roosevelt administration, thousands of American artists would have starved or given up all creative efforts.

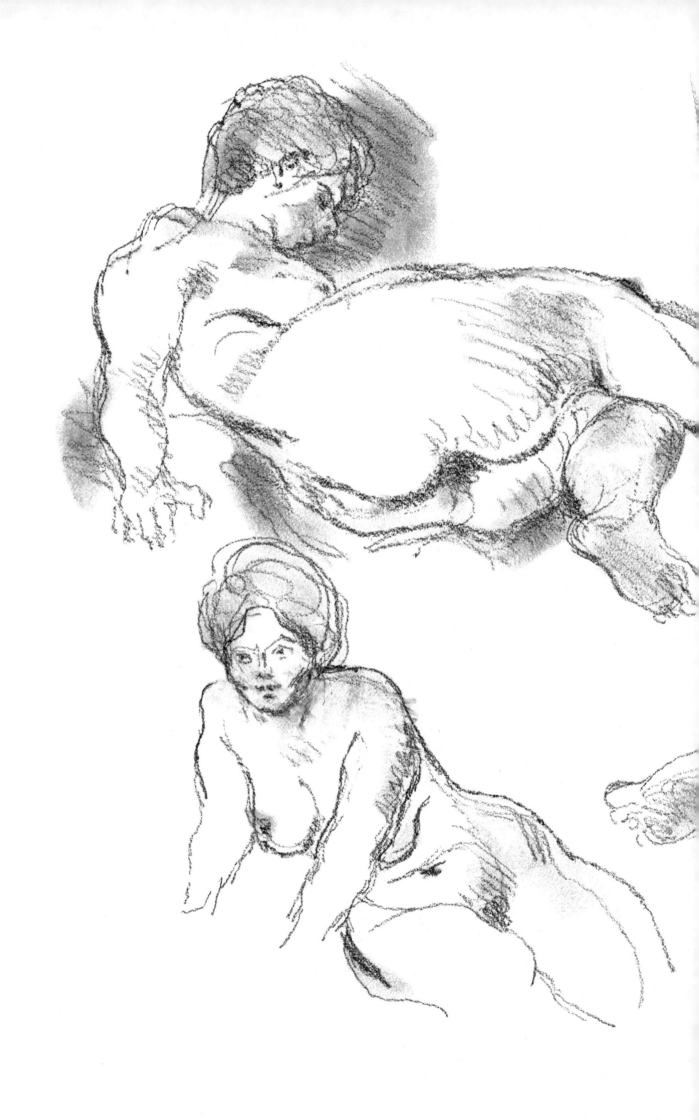

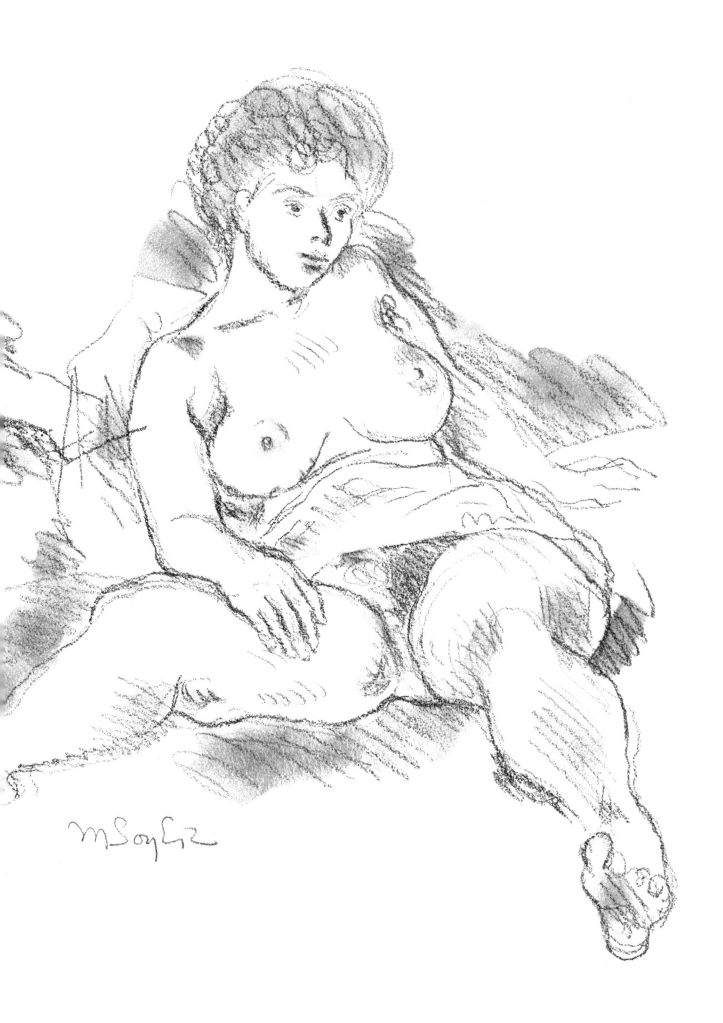

Soyer owes his survival as an artist both to his wife's help, for she was employed as a dancer at Jacob's Pillow, and at the Rainbow Room where the wages were better; and particularly to the Art Project. WPA lent dignity to its recipients, giving them a feeling of being useful members of society. It provided Moses Soyer with a check each month in return for the one or two pictures he completed during that period. The amount was small, but since the couple had only one child, they were able to manage. Moses was put in charge of a group of artists who had been assigned to paint ten large portable murals around the theme *Children at Work and at Play*.

Under WPA auspices, Soyer was free to paint any subject he chose. When the Treasury Department wisely decided to make use of America's reservoir of talent by giving out commissions to decorate public buildings, Soyer was one of the artists called on. In 1939, for $2,000, a big sum in those days, he painted a large oil on canvas for the post office at Kingsessing (now part of Philadelphia). He chose to paint the superb view from the top of the steps of the Philadelphia Museum. His brother Raphael contributed the other mural for the building, a vista of the bridge that connects Camden with Philadelphia.

American artists in those depression days were also fighters. Moses, along with Ben Shahn and others, helped organize the Artists' Union. Its aim was basically that of all unions—to improve working conditions for its two thousand members. The Artists' Union carried its demands to the government which, after Franklin D. Roosevelt's election, sympathized with the plight of creative people.

Soyer remembers marching in parades with members of his union on May Day. For these parades, the artists produced superb banners bearing such slogans as "Better Conditions," "Unionize," "Down with Fascism," and "Down with Father Coughlin" (a reference to the Catholic priest who had become a reactionary rabblerouser). Left of center, the union was too radical for some artists, especially the Regionalists. Ben Shahn was one of the editors of its magazine, *Art Front,* and Moses served as chairman of the cultural committee, whose main task was to find speakers for meetings. Soyer was also one of the founders of the American Artists' Congress, an organization of well-known painters and sculptors devoted to the struggle against war and fascism.

Curiously, this same man Soyer, who could not keep aloof in the trying years between the stock-market crash and America's entry into World War II twelve years later, painted no marching and shouting workers, and produced no propaganda pictures. One finds no dying strikers, no starving children or brutal mounted police in his work. Indeed, Soyer was sometimes attacked by more radical colleagues as insufficiently social-minded. Such critics overlooked several of his paintings that did, clearly, mirror some of the tragic manifestations of an era in which millions went hungry. *Hooverville* (1934) is such a painting. Along the Manhattan waterfront, mainly on the Hudson River side, the unemployed built shanties out of scraps of wood, cardboard, tin, and whatever other discarded materials they could find. In Soyer's picture, these displaced persons of the big city are seen sitting or resting around a fire. Though there are no arms raised to the sky or fists shaken in revolutionary fervor, this brooding picture is a silent attack on an unjust society.

Low-keyed, too, is *Employment Agency* (1935). In this picture, painted at a time when twenty million Americans were without jobs, the resigned countenances of the woman and

42

two men waiting in a bare room indicate their recognition of desperately slim chances for work.

Another memorable picture, *Men of the Waterfront III* (1938), portrays unemployed dock-workers. Soyer also painted two pictures for a Spanish radical magazine which, during the Spanish Civil War, published an issue with illustrations by anti-war artists from all nations. Again, Soyer's pictures are not activist; they depict women with wounded soldiers, rather than men with cannons and rifles.

As the depression waned and America entered the war, the Artists' Union disintegrated, as did the Artists' Congress. WPA ceased to function; many younger artists were called to arms. Soyer, forty-two when the Japanese attacked Pearl Harbor, was required to register for the military, but was not drafted.

Despite his involvement in public affairs, Soyer had been immensely busy painting during the thirties; he had also been teaching at the American Artists School. His work now began to sell, due to efforts of his new dealer, William Macbeth, who had sponsored the revolutionary Ashcan School back in 1908, and thanks especially to the enterprising spirit of Herman Baron, founder of the ACA Gallery, whose "stable" Soyer joined in 1944.

VI

Around 1945, a revolution of sorts occurred in the U.S.A. The styles of painting that had been practiced by Soyer and others were passed over in the museums and galleries in favor of what was called Action Painting and Abstract Expressionism. Some of Soyer's contemporaries who had been active with him in the WPA, the Artists' Union, and the Artists' Congress, became jittery. Many decided to jump on the new bandwagon, to give up figurative art and traditional painting styles. Frequently the results they obtained were mediocre.

Soyer did not allow himself to become sidetracked. He remained with a minority who did what they had to do, feeling that art—at least their art—was not like a car that must be replaced by a new model every two or three years. Fortunately for Soyer, there was no dearth of true

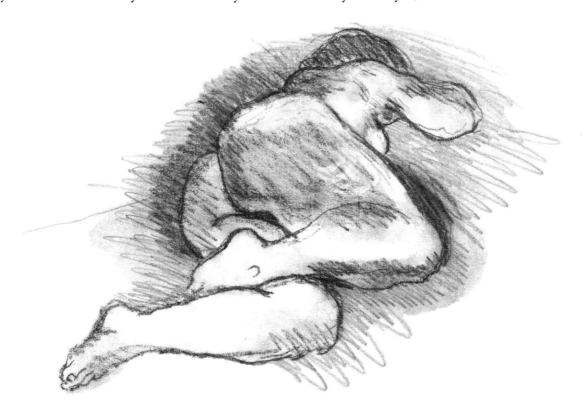

connoisseurs who, while welcoming some of the innovations that exploded in the years following the end of World War II, remained appreciative of what a figure artist like Soyer produced.

Moses does not object to being called a traditionalist—that is to say, the heir of a great and noble culture. Tradition slavishly imitated can be an obstacle to development, a hindrance to the growth of fresh expression. But its arbitrary abandonment can also be a curse. Jewish writings are full of stern warnings: "Remove not the ancient landmarks which the fathers have set." The French Socialist leader Léon Blum, who can hardly be called a conservative, wrote: "Tradition does not imply standing still; it expresses the continuity of nature and history."

Soyer did not stand still. While he continued to use the brush dipped in oil pigments, applying it to time-tested canvas in the Renaissance and Baroque tradition, his brushwork has, in the course of decades, grown freer, more subtle. His palette has brightened, his treatment has broadened, his forms have loosened. Yet he has never allowed the self-propelling action of accident to take over and dominate, subjecting him to the blind tyranny of the haphazard. Nor has he ever doubted the validity and rightness of what he was always determined to be: a humanist Realist.

There are some who confuse Realism, a penetrating manner of looking at man and his world that will never die, with Naturalism, the shallow glance at surface appearance. Realism is concerned with interpreting the essence of the subject in order to reveal truths hidden by the accidentals of ordinary visual appearance. Naturalism only aims at achieving a semblance of the object or scene depicted; the naturalistic artist is interested mainly in mechanical or photographic accuracy.

A Realist, Soyer is occupied with uncovering underlying structure; verisimilitude, therefore, is unimportant to him. His chief concern is to convey his feeling for a subject. He knows how crucial it is not to go beyond this point, fully understanding what Renoir meant when he admitted how difficult it was "to decide the exact moment when one should stop imitating nature." He agrees with this Impressionist master whose lyricism transformed nature, and who warned: "The painting should never reek of the model . . . a painting is not a legal statement."

Robert Henri and his associates, who were among young Soyer's idols, were not Naturalists either; each of them saw nature through the filter of his own personality rather than through a photographer's lens. Their art was a revolt against the sugary, anecdotal, or historical trivia that filled nineteenth-century Paris salons, as well as their equivalents in other large cities of Europe and also America.

From the American Realist school, and from the masterpieces he encountered in the Palais du Luxembourg, Soyer learned how to compose a picture in his mind before putting down his first brushstrokes; how to change an angle even in the course of painting. And he found out how to use colors the way a composer uses musical tones—the hues of the model's dress, of the wall, of the tablecloth. Thus he achieved a fugue-like composition and what Clive Bell has called significant form—that is, the fundamental quality shared by all objects which evoke esthetic emotion. In the orchestration of subdued color, and the serene calmness, Soyer is the counterpart of Giorgio Morandi. The Italian's universe is the static world of still life—cups, bowls, and bottles; Soyer's art, however, requires the human presence. While Soyer has painted a few landscapes and cityscapes, as well as a number of pure still lifes, ninety per cent of his work is concerned exclusively with the human figure. A rare exception is the painting of an interior,

44

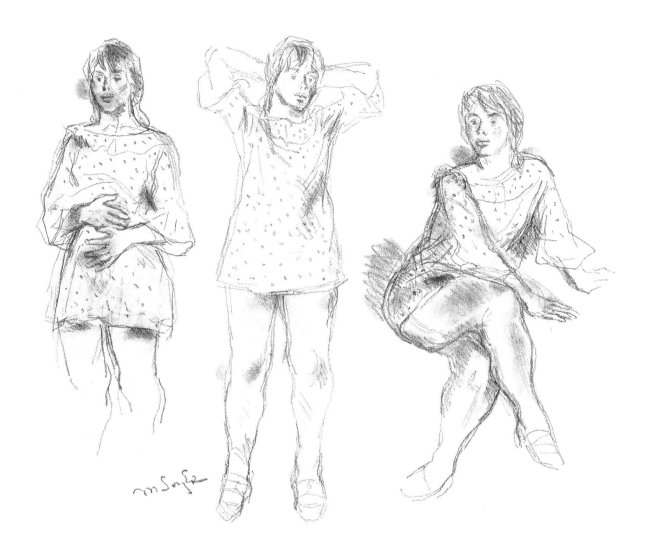

The Artist's Studio after Five O'Clock (1963). But is it really empty of the human presence? Not at all. There are two portraits (one on the mantlepiece, another on the easel) and the plaster cast of Michelangelo's head of a slave that frequently turns up in Soyer's work. Even in this painting, then, the human presence is keenly felt; the artist and his model have left, but their spirit still permeates the empty room.

Soyer's abiding interest in people explains why the artist has so often produced portraits of identifiable sitters, in addition to numerous pictures of dancers and seamstresses for which anonymous models posed. But he has done very few commissioned portraits because, as a rule, clients demand prettiness rather than the truthful statement of individual character. In addition to some self-portraits, and to portraits of members of his own family who appear again and again, Soyer has painted striking pictures of fellow artists: Joseph Stella, Abraham Walkowitz, David Burliuk, Milton Avery, and Marvin Cherney, to mention only some of those no longer among the living.

Through barely perceptible detail or subtle twist, the artist uncovers the secrets of his sitters. Even if a viewer does not know the person portrayed, a Soyer picture intrigues, beguiles, for its author never permits his portraitures to deteriorate to the level of mere craftsmanship. Moses does not have to please anyone—to make people look young, or alter unpleasing features.

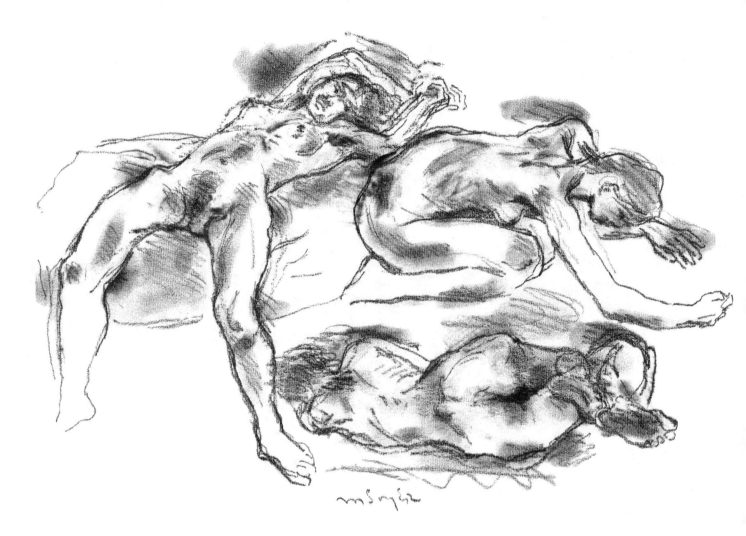

It is not his task to reproduce perfectly skin, hair, cloth, or fur at the expense of psychological insight. As a neophyte in Paris, Soyer had been deeply impressed by Ghirlandaio's double portrait, *Old Man and His Grandson,* in the Louvre. An elderly man is sitting by an open window, gazing on a child's upturned face. The grandfather's nose is deformed, and there is a large wart on his forehead. What Soyer remembers are not the blemishes that mar the aged man's face, but the tender joy and deep love in his eyes, and the affection with which the child rests his hand on the grandfather's chest.

Moses Soyer is a Realist who knows how to think and who allows himself to feel. His pictures would not have achieved their high standing had he not also subjected his material to rigorous formal analysis, based on his conception of design as being the proper integration of balance, proportion, rhythm, order, clarity. And this is not all. If we are moved by this artist's pictures, it is equally due to his ability to distill the inherent poetry from everyday substance, to observe and render the world with a simplicity and directness that pierces to the core of visual experience. Strong feeling is here—the most important ingredient of all art—and simple grandeur is achieved through concentration on the essential, and by powerful brushwork and melodic color.

Soyer knows that we cannot shed our ties to humanity without impoverishing ourselves.

46

In order to make his stirring statements, he depicts the human body and, in particular, the human face. He might agree with Sophocles, who held that while there are many wonderful things in nature, the most wonderful of all is man; and with Goethe, who maintained that it is art's aim to render the dignity of man within the compass of the human form. To the German poet, art was identical with the youthful athletes fashioned out of marble by Praxiteles and his followers. For Moses Soyer, however, who is a classicist in his solidity of form, yet anti-classicist in his choice of models, it is art's goal to go beyond physical beauty in order to reveal the nobility of the dreaming, reflecting, brooding, and often troubled contemporary face.

With all his poise as a person, with all his self-assurance as an artist based on a career of nearly fifty years, Soyer admits that he faces a new blank canvas with uneasiness, if not outright fear. Each of his pictures, seemingly so peaceful and as calm as the atmosphere in his quiet studio, is born out of the struggle to impose three-dimensional reality on a flat rectangular shape. The artist's personal criterion of success is to produce a picture that lives—not in competition with the physical world, but on an emotional plane, where it emerges from his deepest feelings and most profound thoughts.

The façade Moses Soyer offers to the world is somewhat deceptive. There is nothing obviously artistic about the appearance and manner of this short, inconspicuous man. Yet, he seldom enters a restaurant, a gallery, a museum, or walks the streets without being approached by admirers. He and his wife live in Greenwich Village, in a simply furnished apartment containing a superb collection of small pictures and sculptures by twentieth-century artists, among them the deceased Jules Pascin, Jacob Epstein, André Derain, Elie Nadelman, Egon Schiele, George Grosz, Joseph Stella, Max Weber; and among the living, Pablo Picasso, Oskar Kokoschka, Henry Moore, and of course many Americans, including Philip Evergood, Jack Levine, Ben Shahn, Leonard Baskin, and Chaim Gross. From his own pictures on the walls, one of the studies for *Apprehension* (1959) is perhaps the most memorable; unusually expressionistic in execution, it shows several people waiting in fear for some catastrophe to strike—perhaps an explosion that might mean the end of the world.

Every morning the artist walks a mile uptown to his studio at the Chelsea Hotel, that New York landmark on West 23rd Street whose residents at one time included the painters Arthur B. Davies and John Sloan, and the writers O. Henry, Thomas Wolfe, and Dylan Thomas. By the end of the day, when he has dismissed his model and is about to leave, much has been accomplished. Because he loves his work, the days are too short for him. And after every summer vacation, he is eager to rush back to the studio. Organized and indefatigable, Moses Stoyer has completed enough drawings and oil paintings over the years to fill a medium-sized museum.

Yet while he puts in regular hours, as does any worker, Soyer is a free spirit. Like the late Thomas Mann, he conceals his genius and temperament beneath the appearance of a solid citizen. The American painter shares the German novelist's assiduous and meticulous care for structure and nuance. Soyer paints firmly organized pictures which strike a sober balance between emotion and restraint, often achieving grandeur even in a small canvas. His very personal art, filled with feeling for humanity, derives its strength from a discipline that weds clean, well-orchestrated colors to flawless composition. The resulting picture is neither stilted nor cold. Rather, his methodical manner is combined with lyrical spontaneity and his starkly honest forms are bathed in colors which conquer gloom.

Indeed, one is deeply impressed by Soyer's unflagging efforts to fit each element into the appropriate relationship with adjoining elements, never forgetting the need for over-all design, for a *gestalt*. Limiting himself to a small cast of characters, he never ceases to explore new spatial arrangements, shifting the emphasis from one spot to another, looking at objects from a new angle. He shuns trick solutions. Painting plays too important a role in his life for him to resort to gimmickry. It transmutes the melancholy of his soul into socially acceptable forms, offering a creative and constructive outlet for the pent-up emotions within him.

In Moses Soyer we have an artist who avoids both the Scylla of sterile abstraction and the Charybdis of photographic naturalism. He blends the reporter's task of objectively recording appearances with the poet's need to imprint subjective reaction upon exterior reality. Responding to the visible world by distilling its essence, he brings forth images which blend the miracle of creation with the subtleties of his heart and mind.

The paintings, which follow, are oil on canvas unless otherwise noted.
Dimensions are given in inches, height first.
The present location of each painting is given, where it is known.
Collections are in New York unless another place is indicated.
Most of the photographs from which the paintings are reproduced were taken by Geoffrey Clements, Walter Rosenblum, and Oliver Baker.

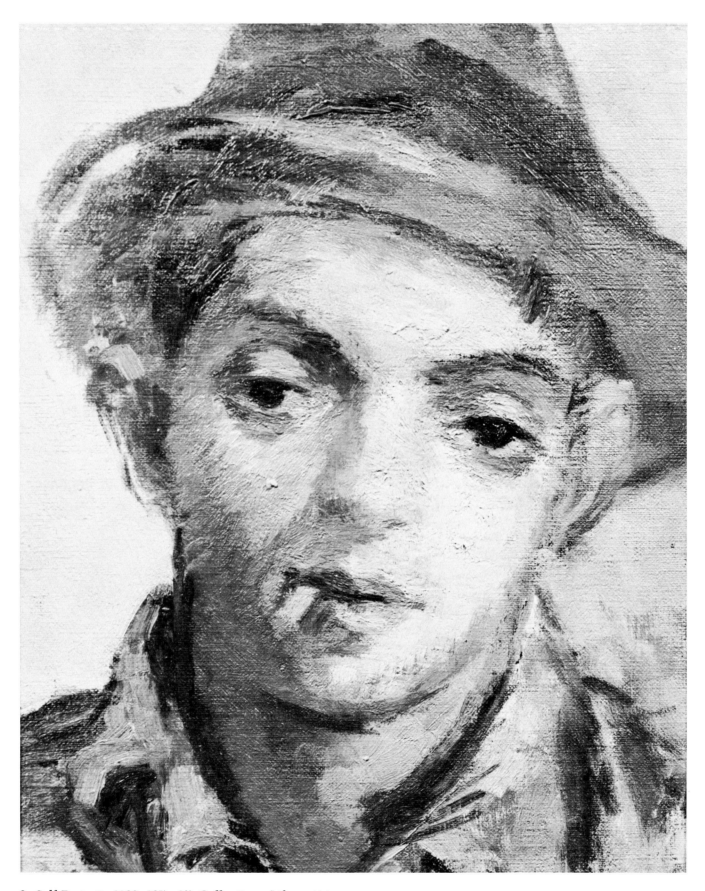

3. Self-Portrait. 1922. 12⅝ x 9¾. Collection of the artist

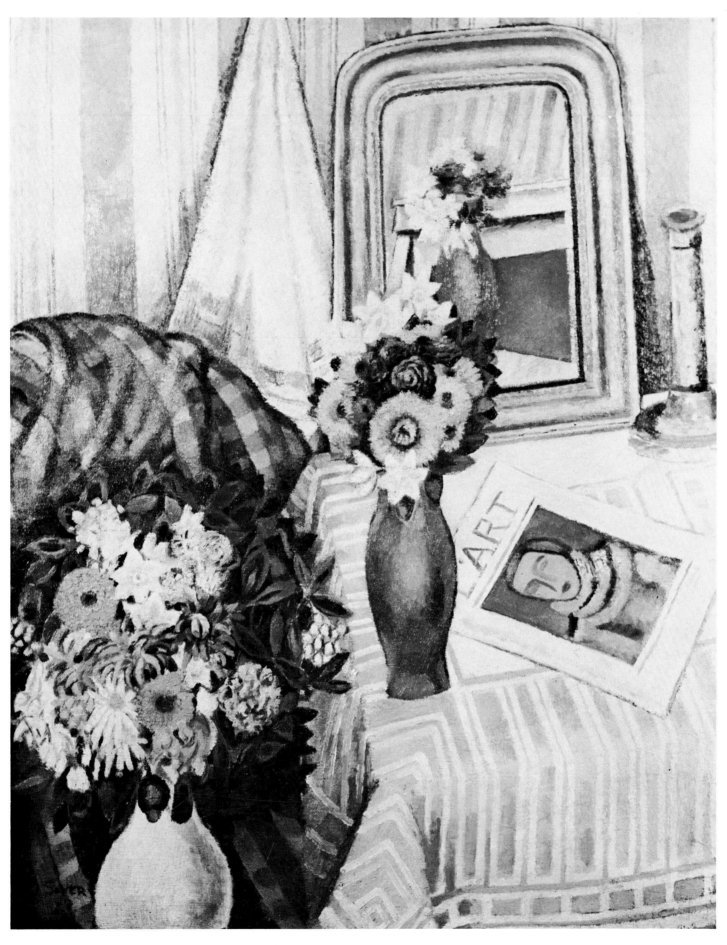

4. Still Life with Mirror. 1924. 24 x 20. Collection Emil A. Arnold

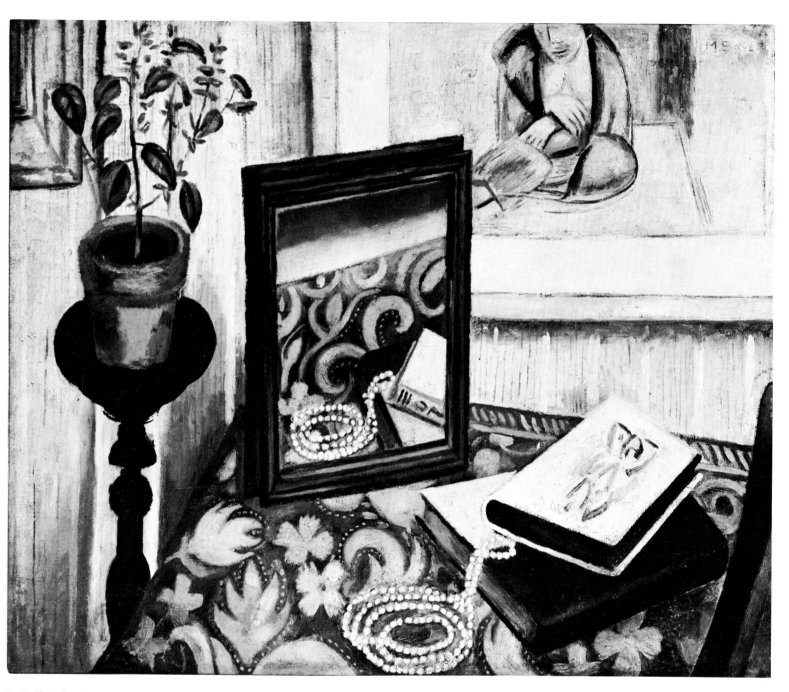

5. Still Life. Circa 1925. 26 x 31½. Collection Alexander Kahan

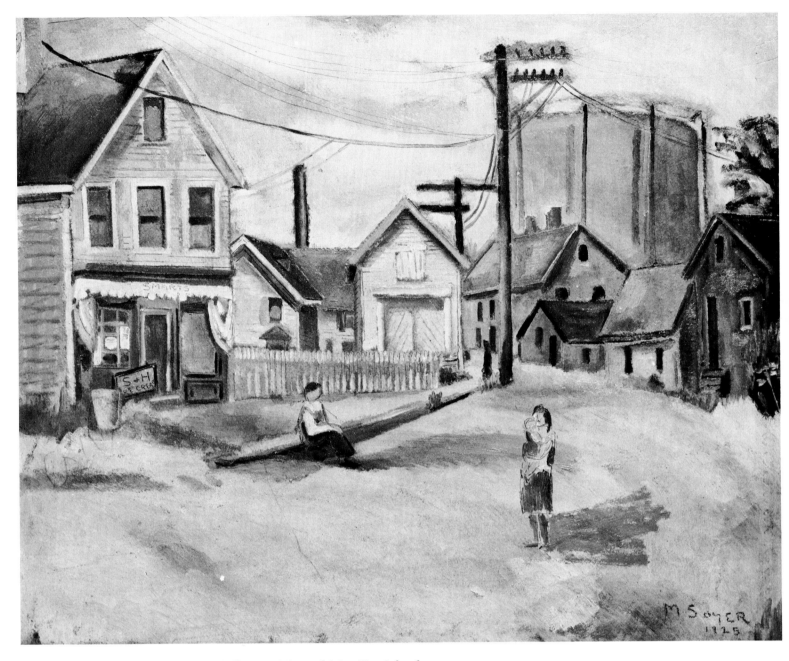

6. Edge of Town. 1925. 20¼ x 24⅞. Collection Mr. and Mrs. Nat Schonberg

7. Bronx Park. 1924. 20 x 24. Collection of the artist

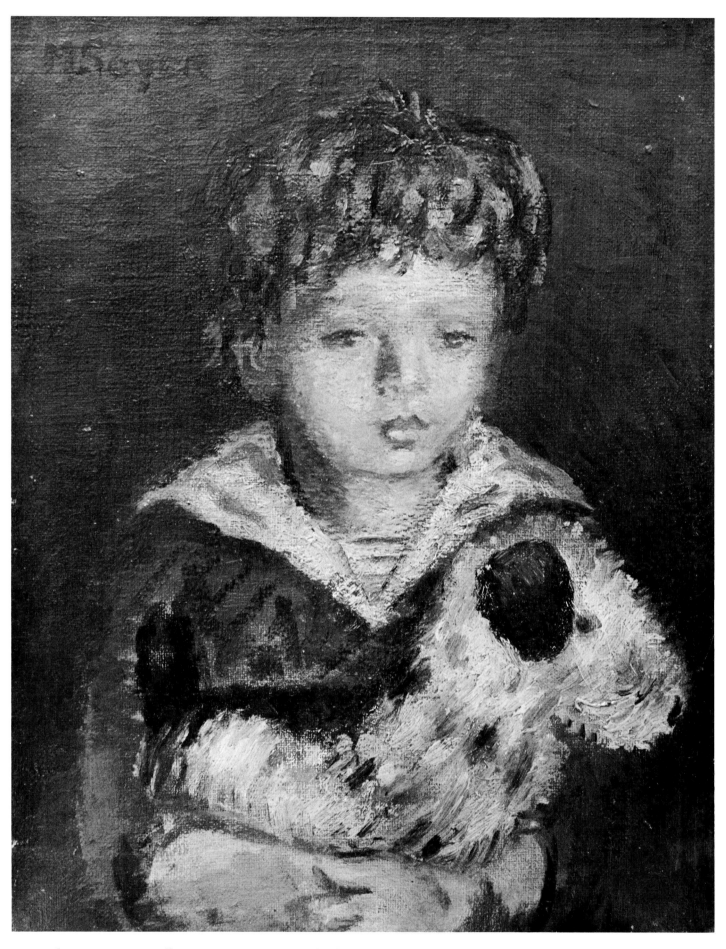

8. David. 1931. 18 x 14. Collection Mr. and Mrs. Raphael Soyer

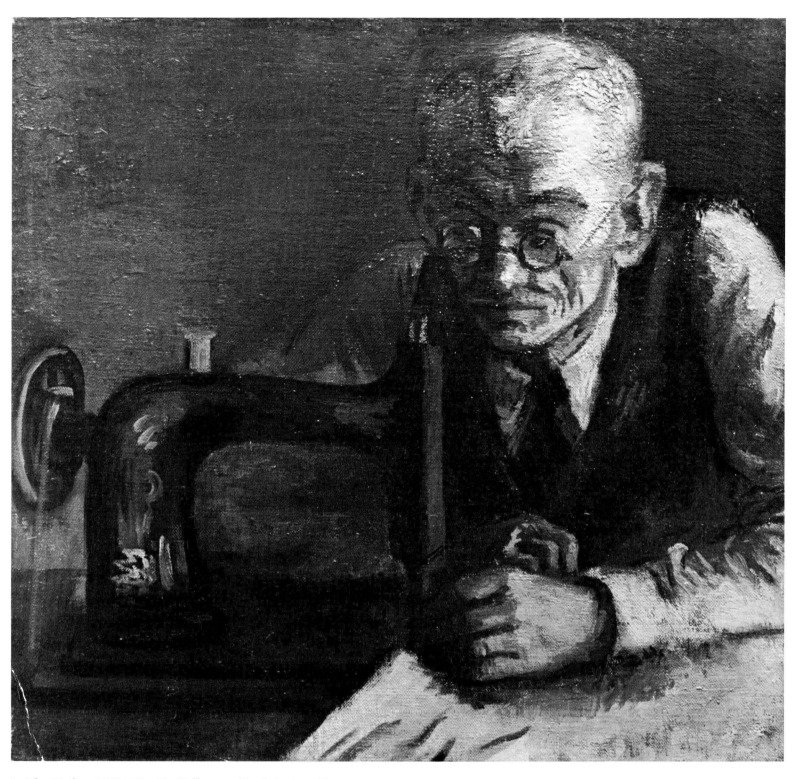

9. The Tailor. 1938. 16 x 20. Collection Emil A. Arnold

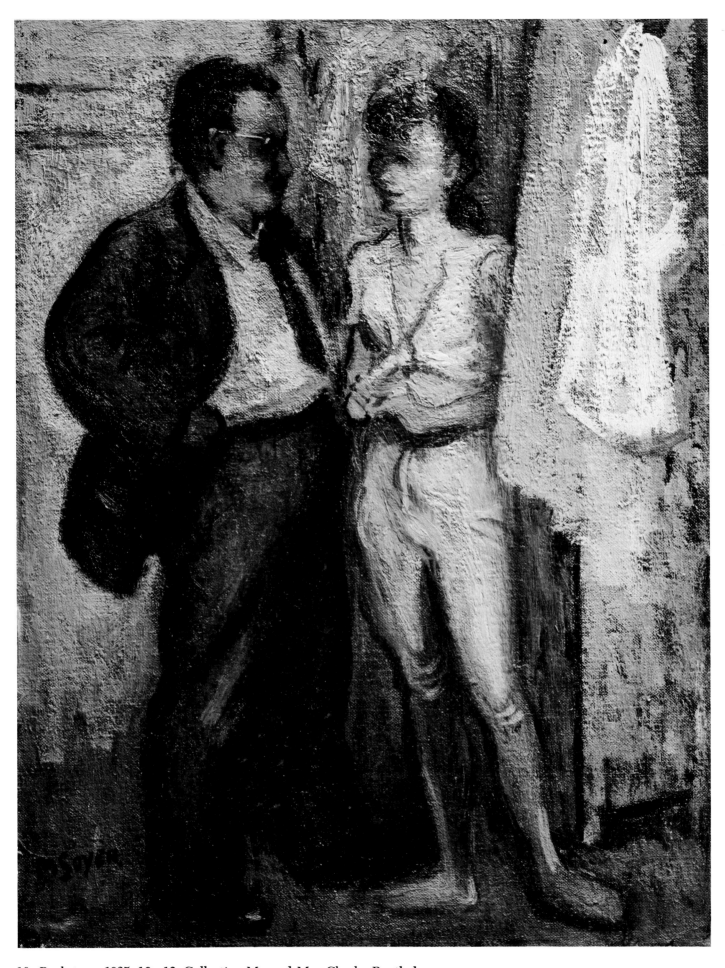

10. Backstage. 1935. 16 x 12. Collection Mr. and Mrs. Charles Renthal

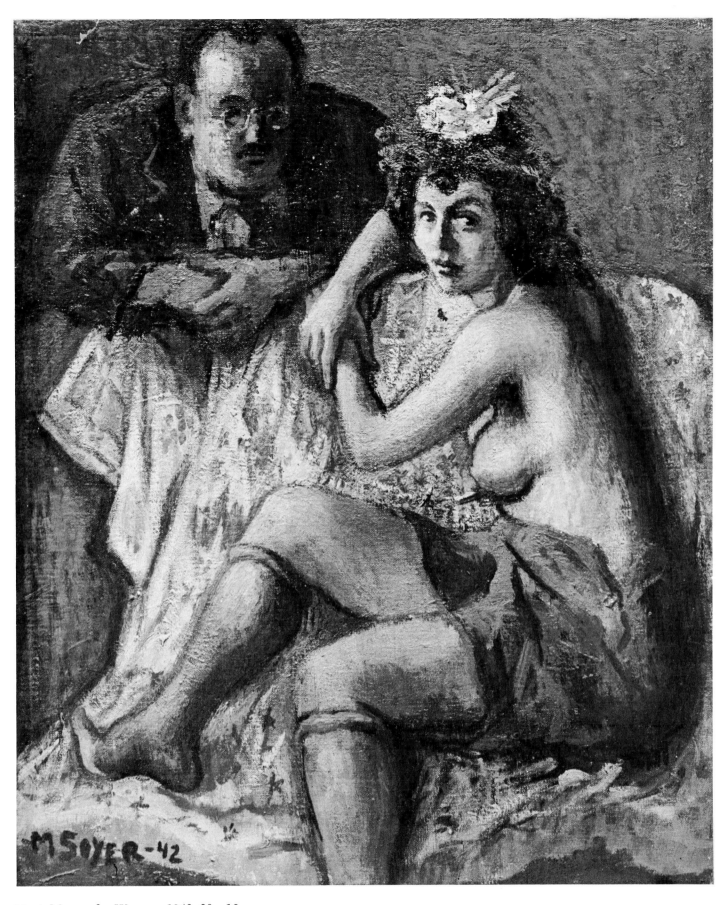

11. A Man and a Woman. 1942. 20 x 16

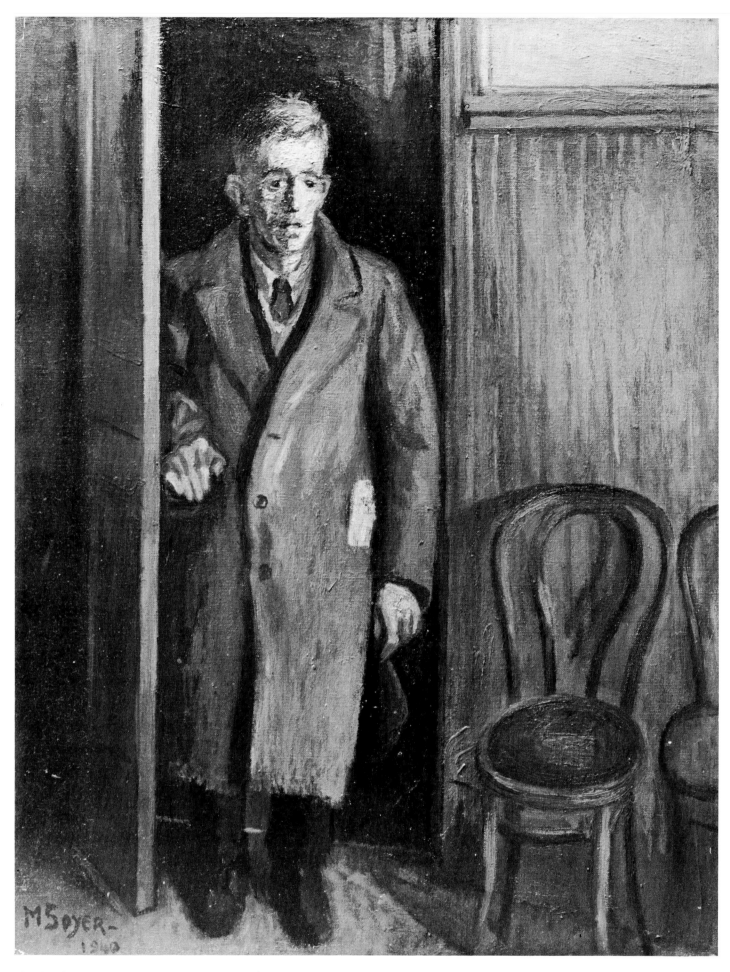

12. Employment Agency. 1940. 24 x 20. Collection of the artist

.3. Truro, Massachusetts. 1944. 20 x 24. ACA Gallery

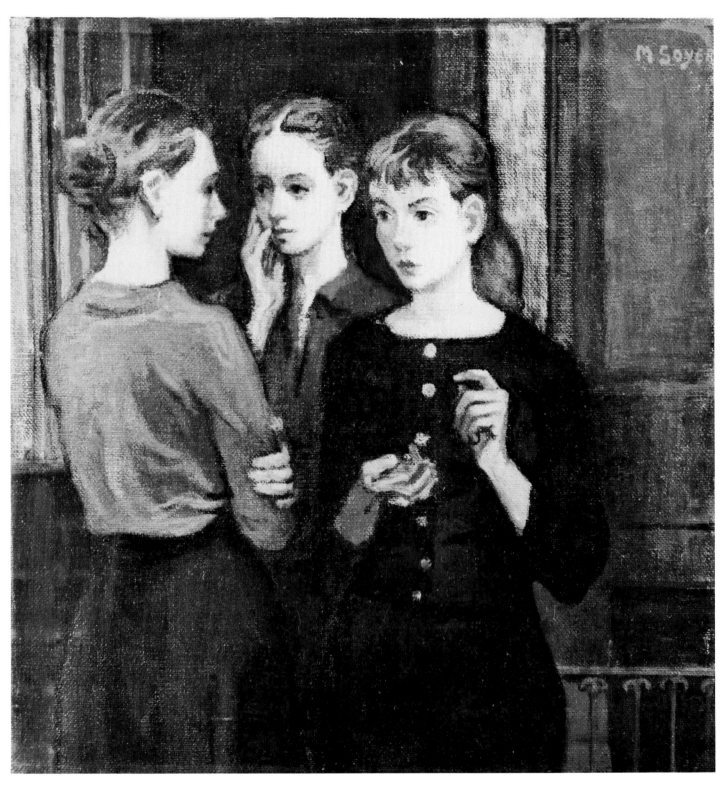

14. Conversation. 1945. 20 x 20

15. Ida. 1943. 12 x 8. Collection Ida Soyer

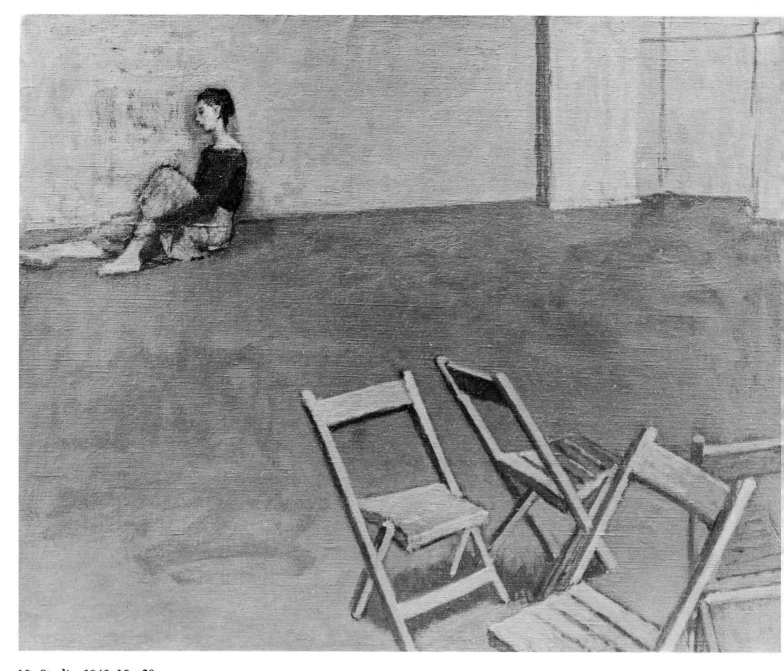

16. Studio. 1946. 16 x 20

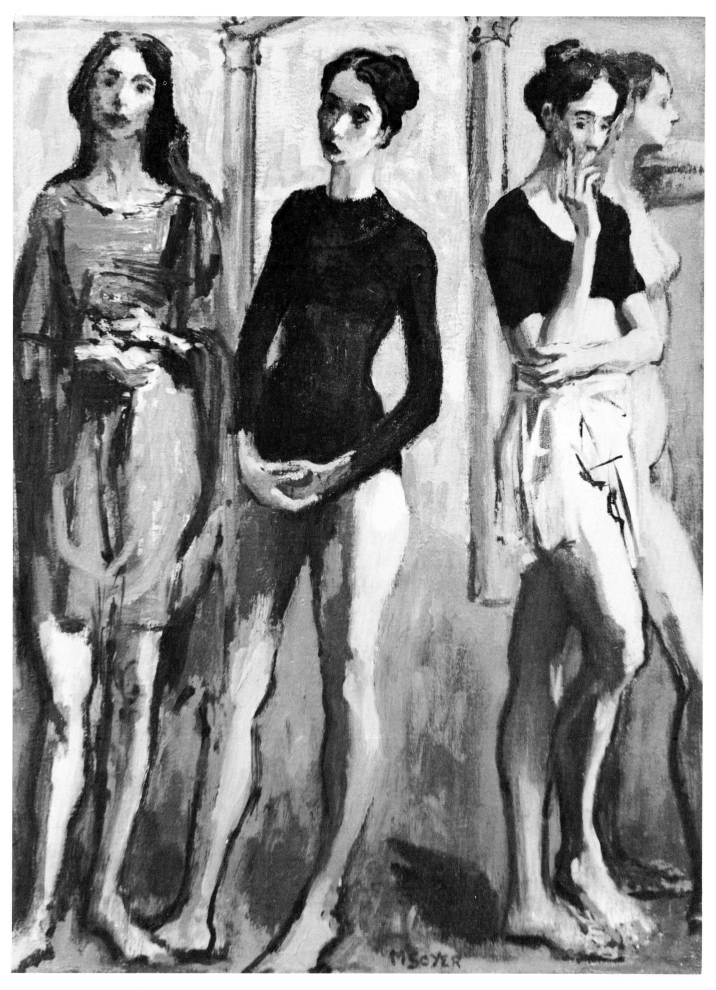

17. Four Dancers. 1950. 25 x 20

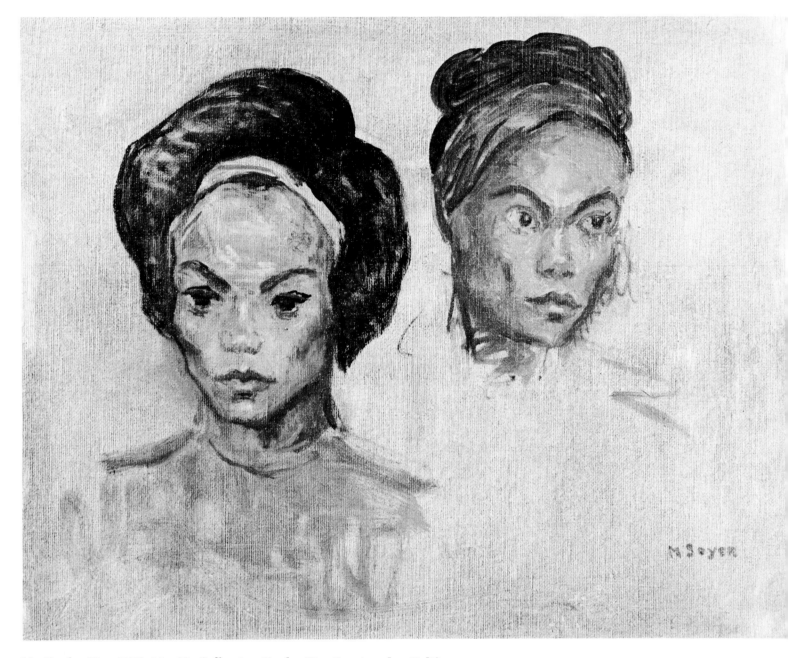

18. Eartha Kitt. 1964. 16 x 20. Collection Eartha Kitt, Los Angeles, Calif.

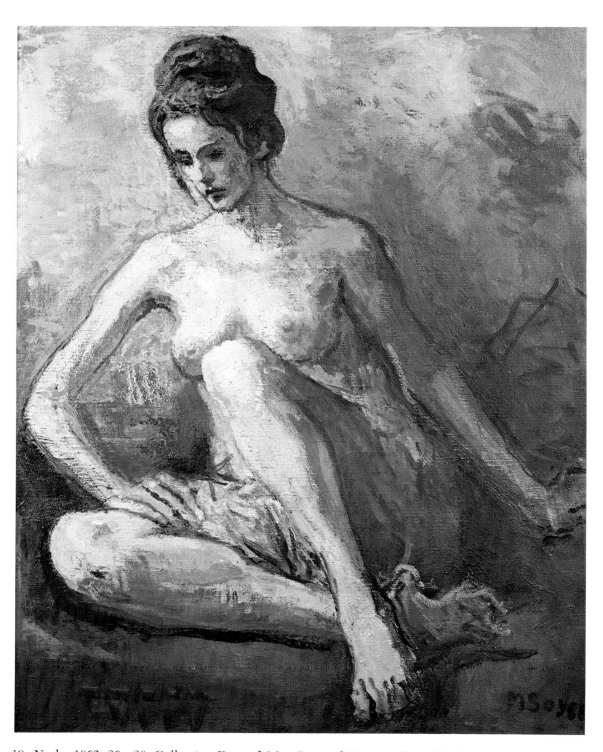

19. Nude. 1962. 36 x 30. Collection Dr. and Mrs. Bernard Epstein, Great Neck, N. Y.

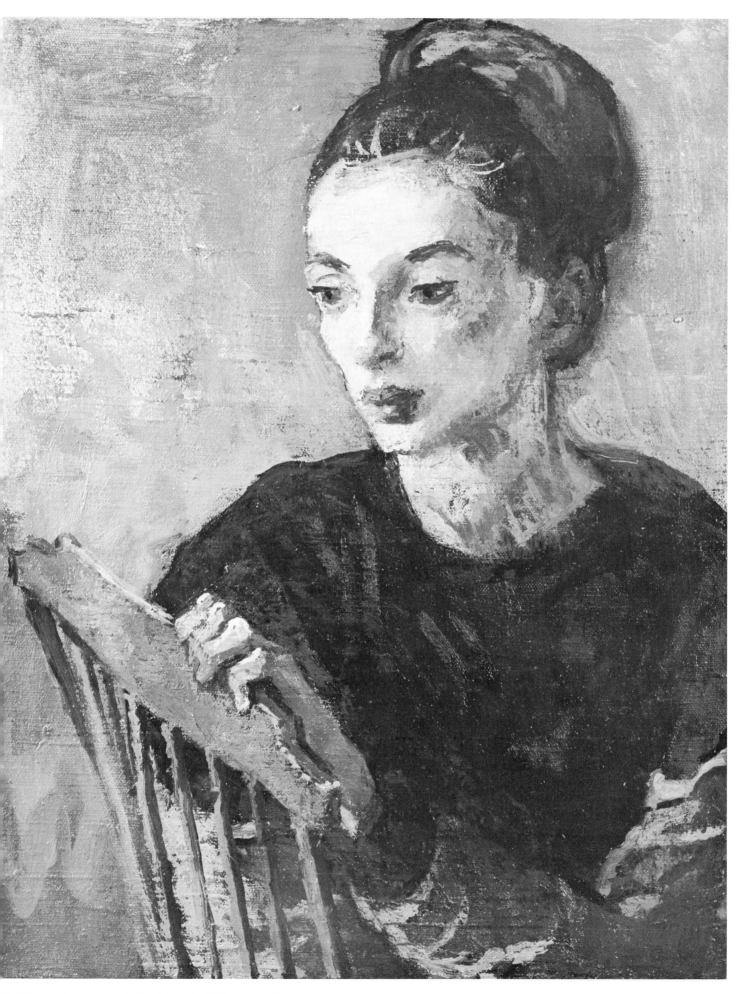

20. Noemi Lapzeson. 1954. 18 x 14. Collection Ida Soyer

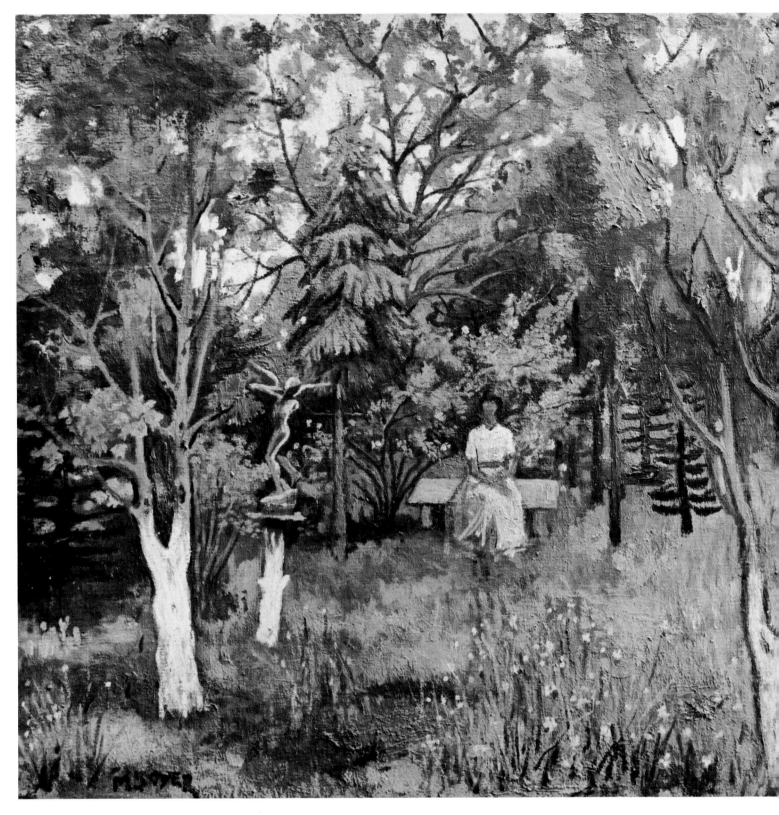

21. Late Afternoon. 1955. 30 x 30. Collection Ida Soyer

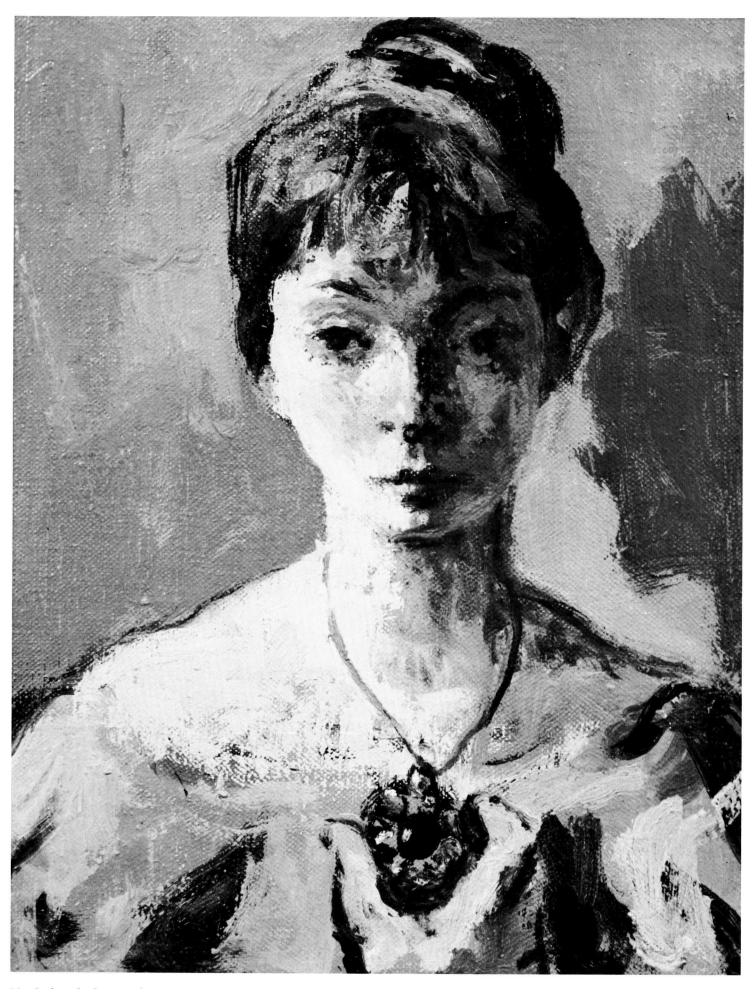

22. Girl with the Jewel. 1955. 10 x 8. Collection Ida Soyer

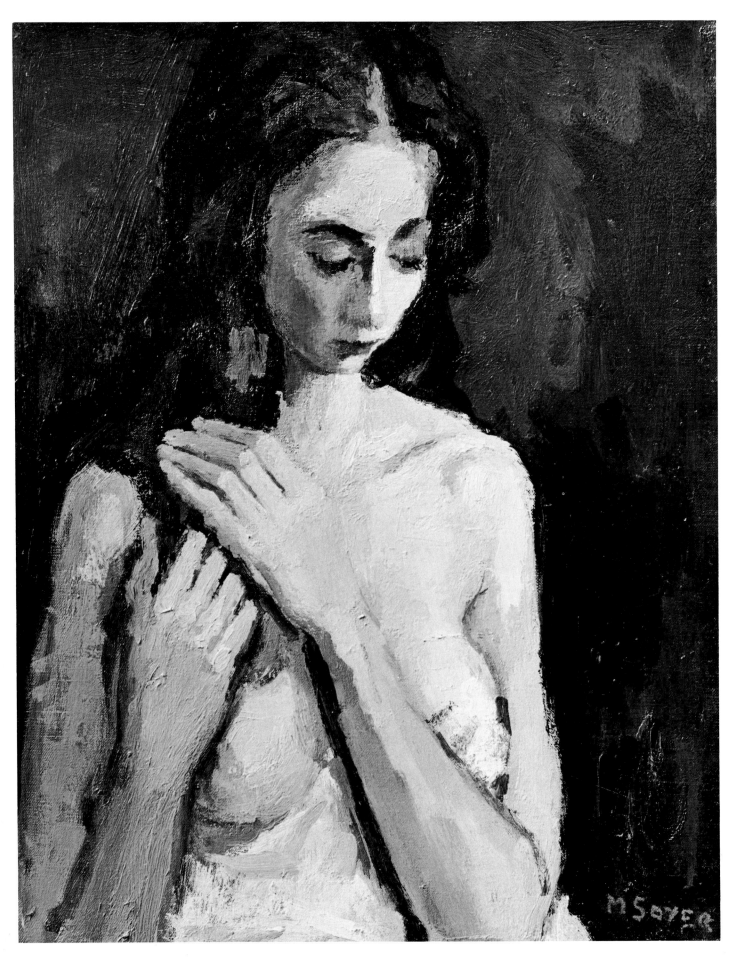

23. Judy. 1955. 20 x 16. Collection Ida Soyer

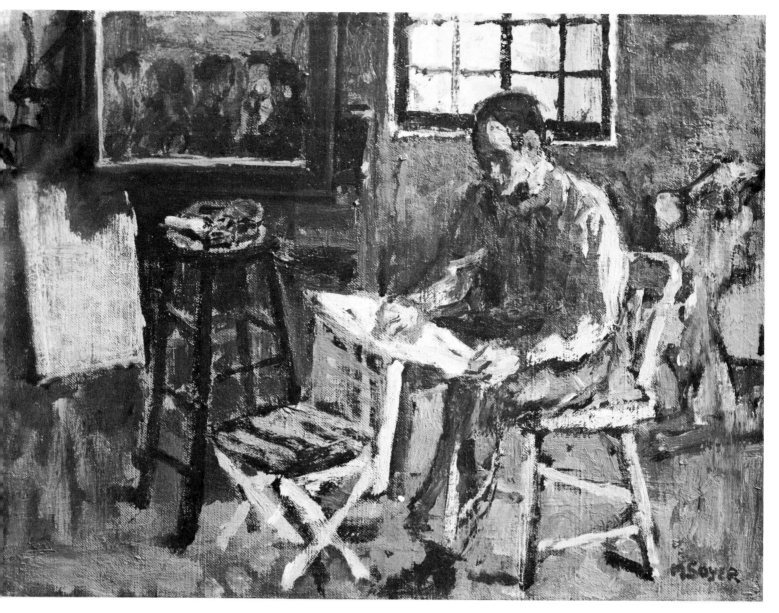

4. The Draftsman. 1962. 12 x 16. Collection of the artist

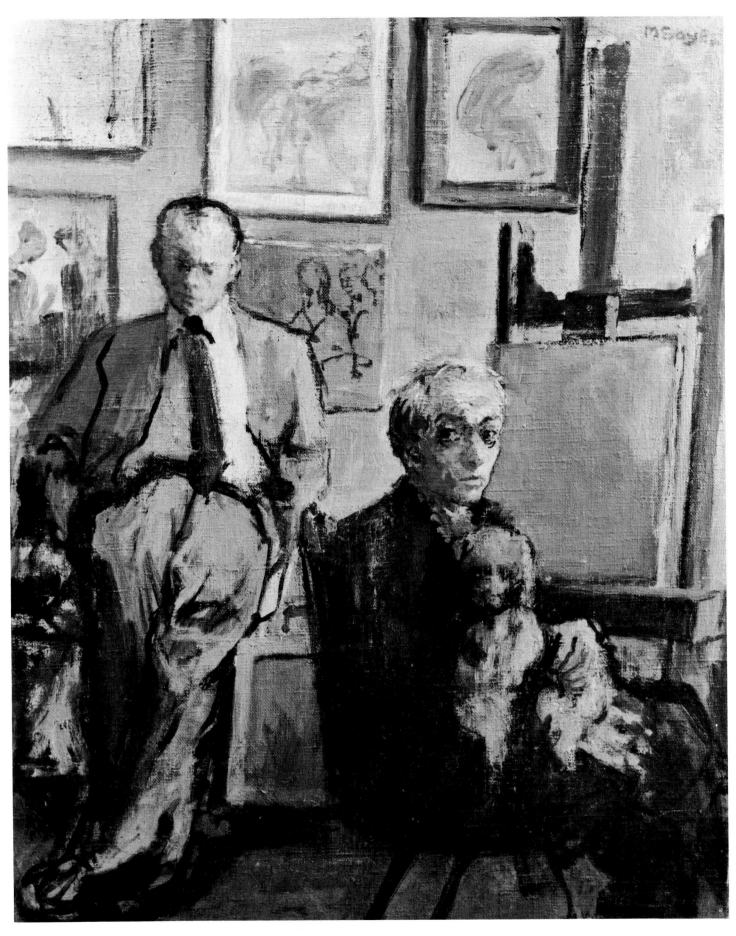

25. Artist and Friend. Circa 1958. 20 x 16. Collection of the artist

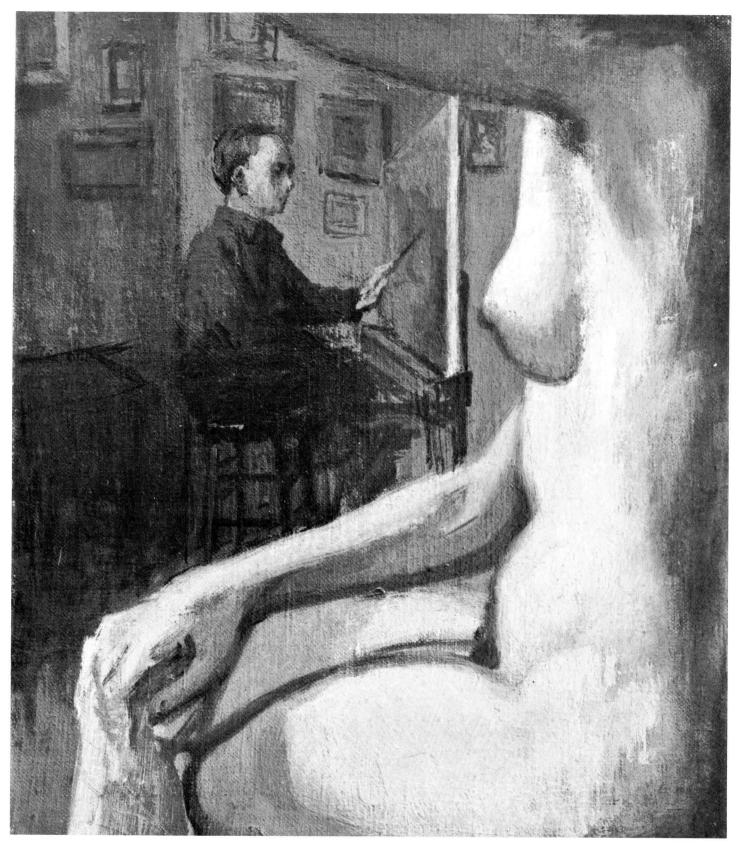

26. In the Studio. Circa 1958. 13 x 11. Collection of the artist

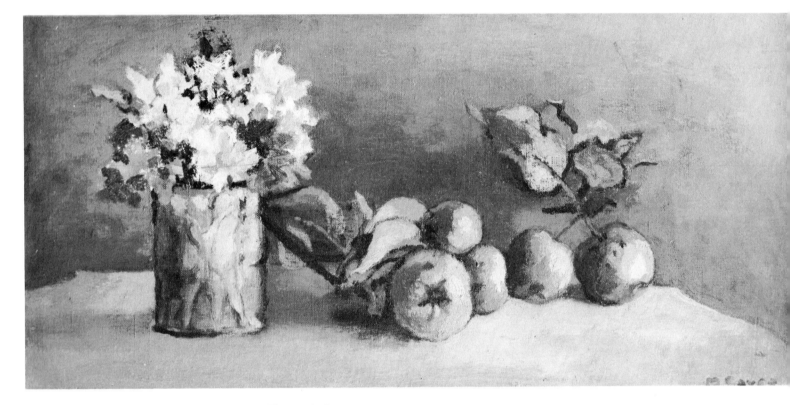

27. Flowers and Apples. 1959. 10 x 20. Collection Ida Soyer

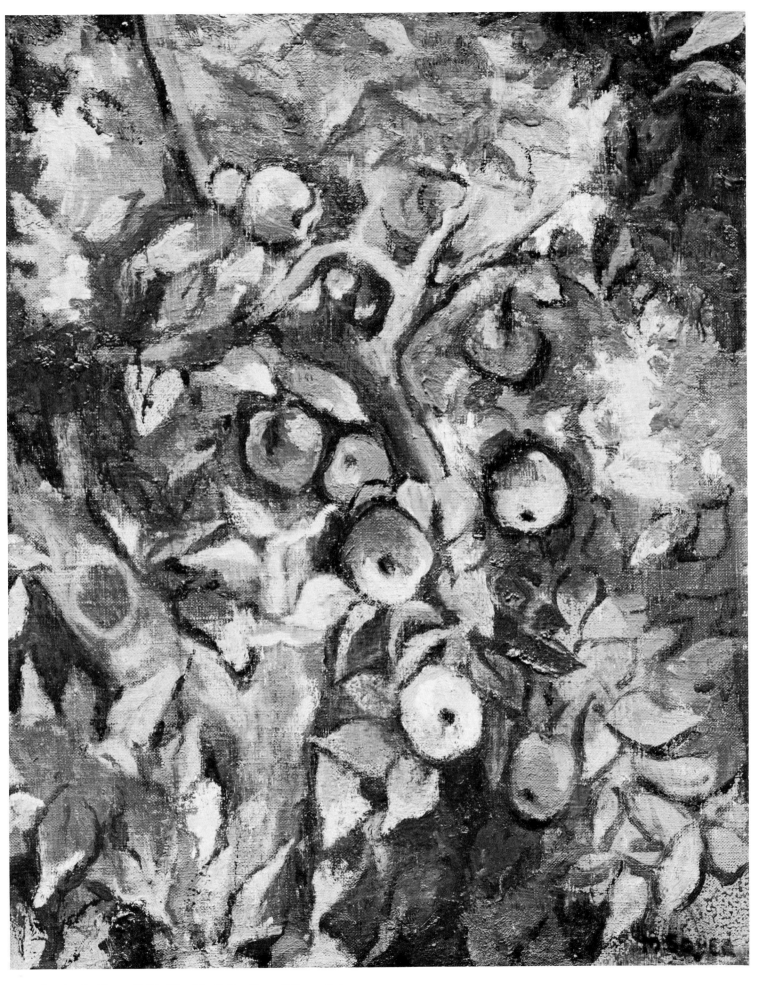

28. The Apple Tree. 1959. 20 x 16. Collection of the artist

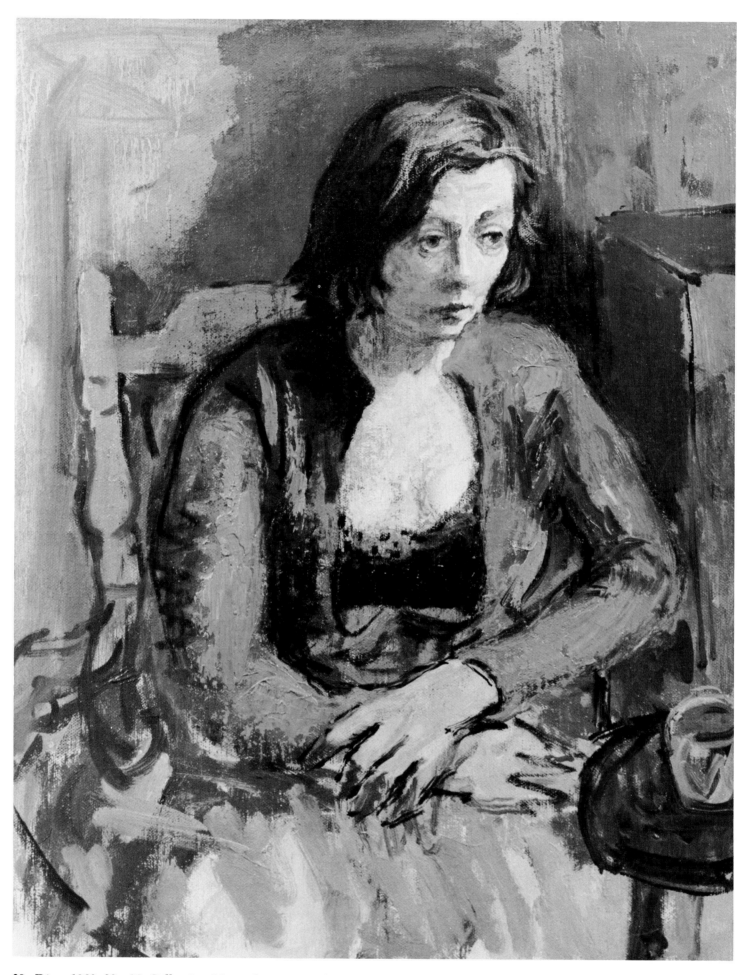

29. Dina. 1960. 20 x 16. Collection Mr. and Mrs. Douglas Newman

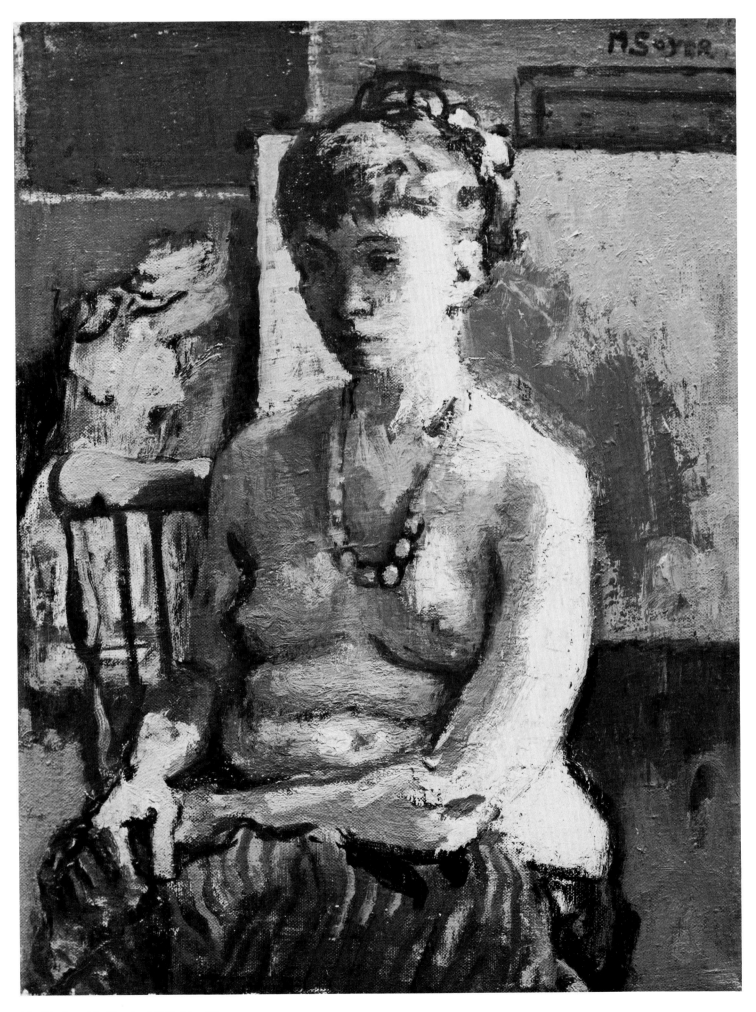

30. Nude with Beads. 1960. 16 x 12

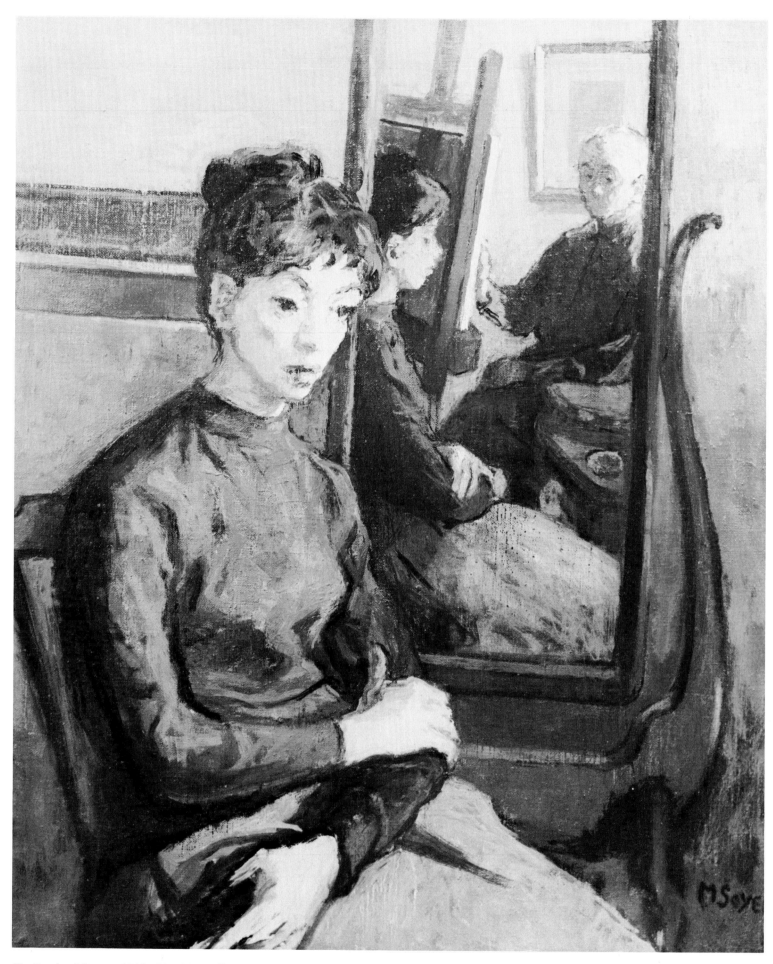

31. In the Mirror. 1962. 24 x 20. Collection Dr. and Mrs. Seymour Goodstein

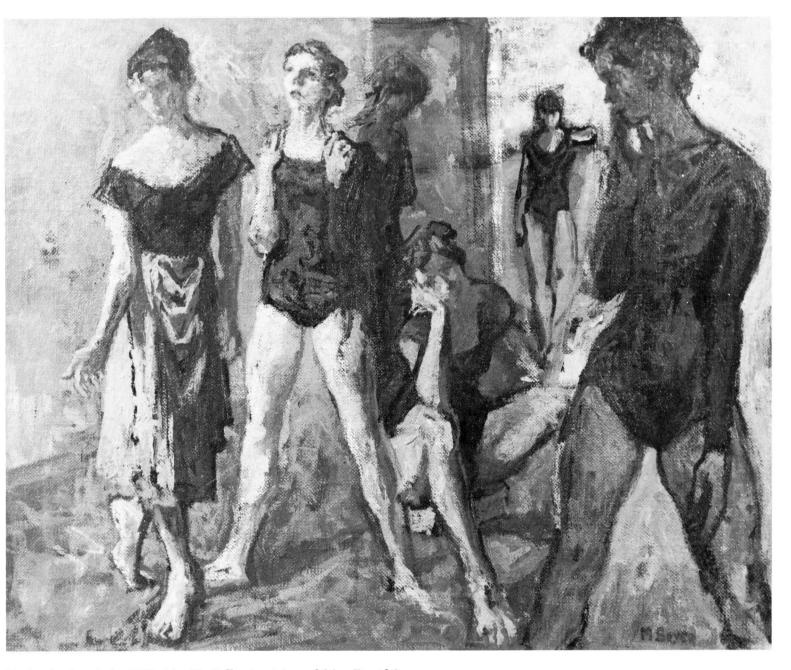

32. Studio Interlude. 1960. 24 x 30. Collection Mr. and Mrs. David Soyer

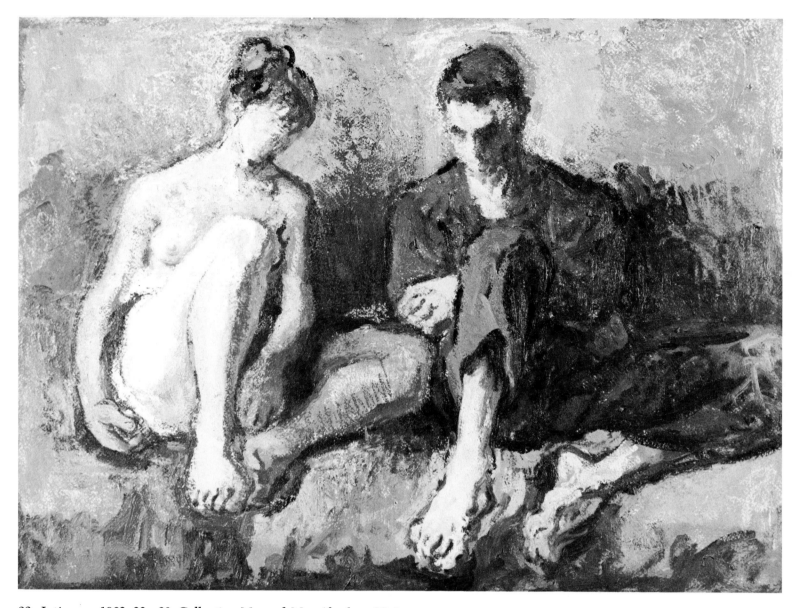

33. Intimacy. 1962. 22 x 30. Collection Mr. and Mrs. Abraham Nisin

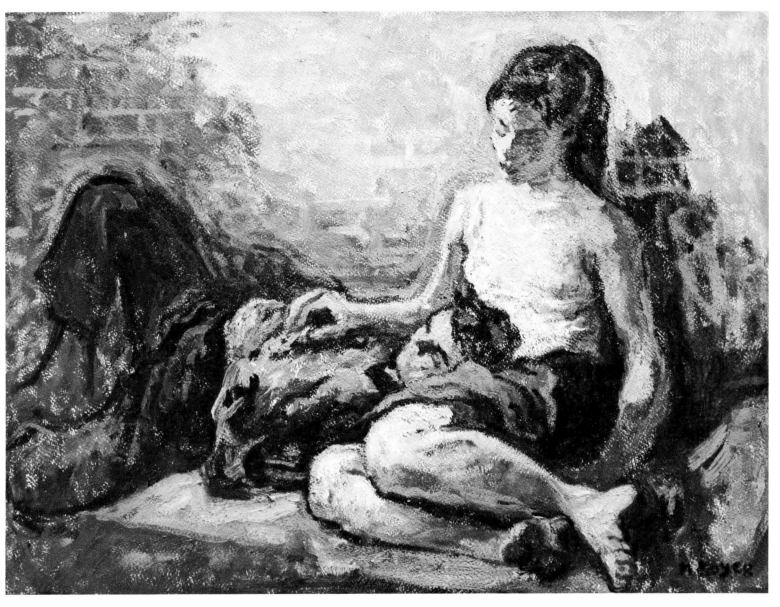

34. Lovers. 1962. 24 x 30. Collection Mr. and Mrs. George Orlan

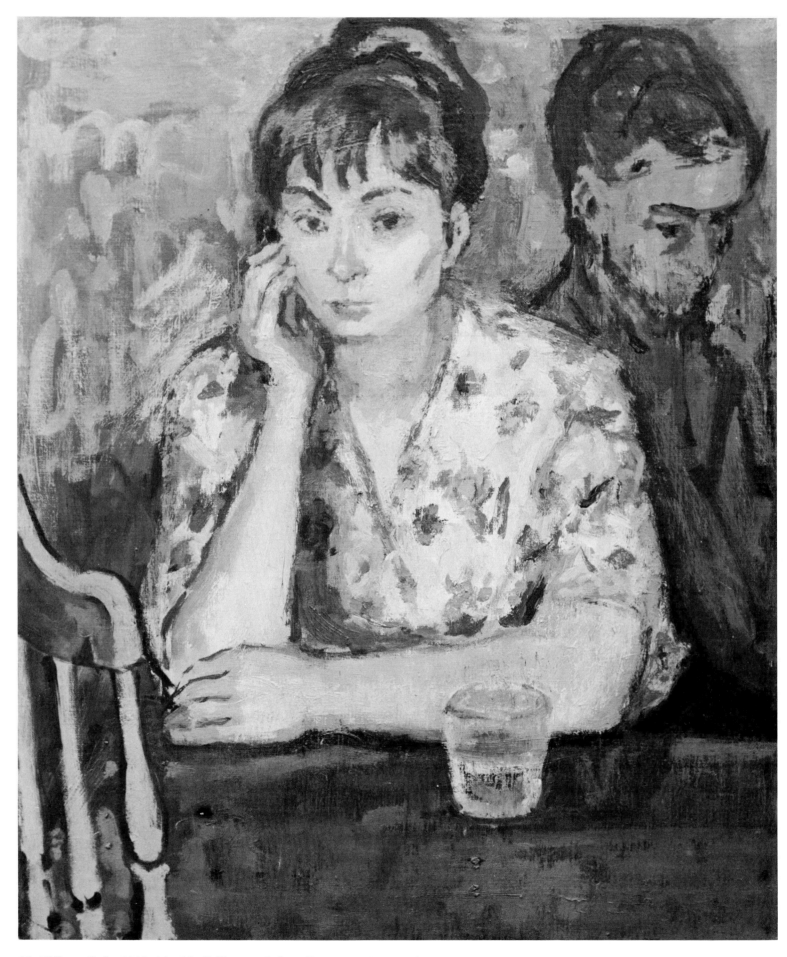

35. Village Cafe. 1960. 24 x 20. Collection Sidney Lawrence, Kansas City, Mo.

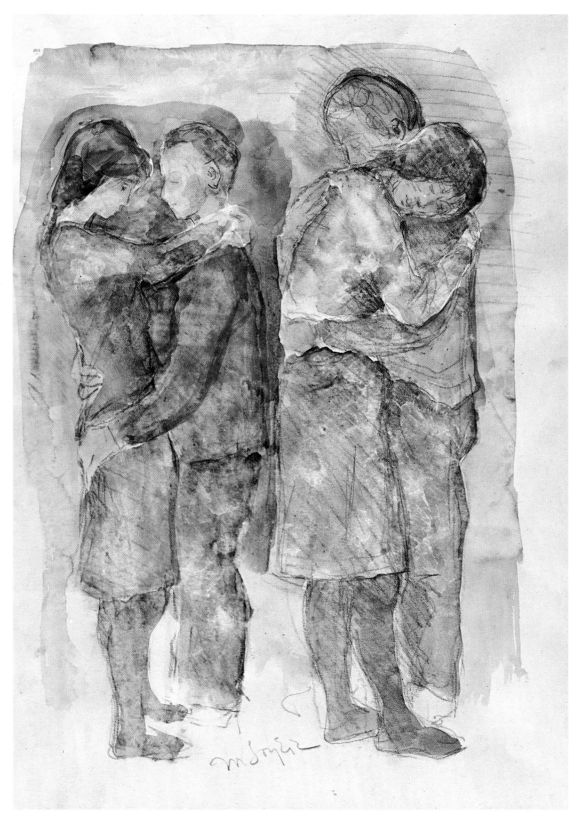

36. Lovers. 1965. Water color. 16 x 12. Collection Mr. and Mrs. Leon Siegal

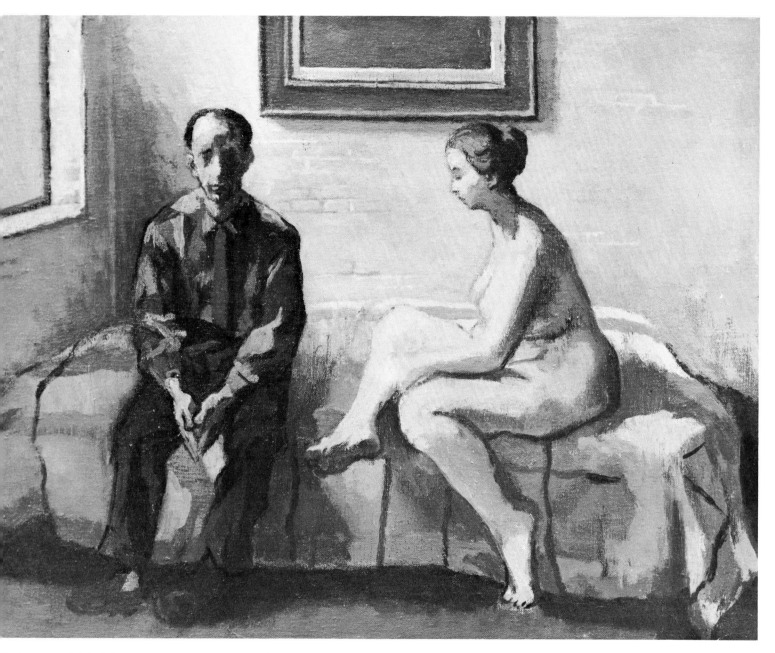

7. Artist and Model. 1961. 16 x 20. Museum of Modern Art

38. In the Morning. 1961. 28 x 20. ACA Gallery

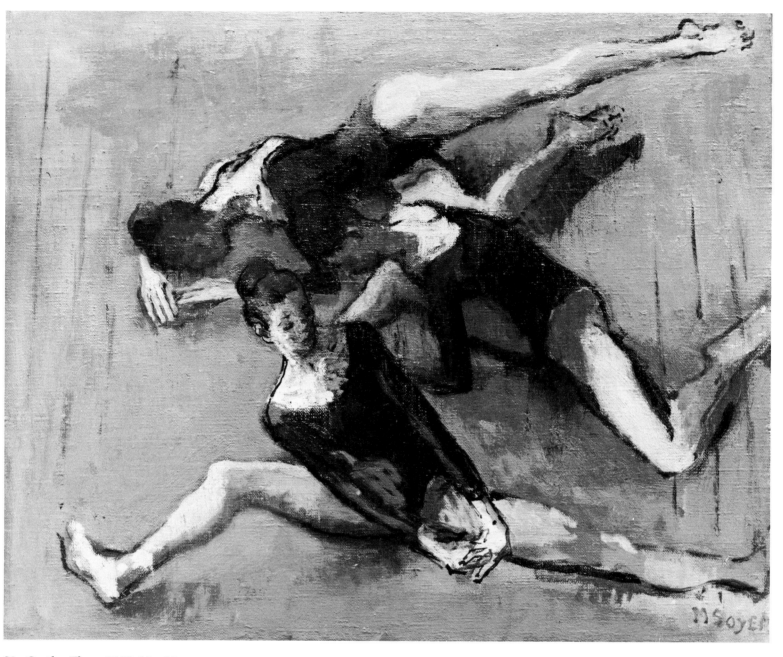

39. On the Floor. 1962. 16 x 20

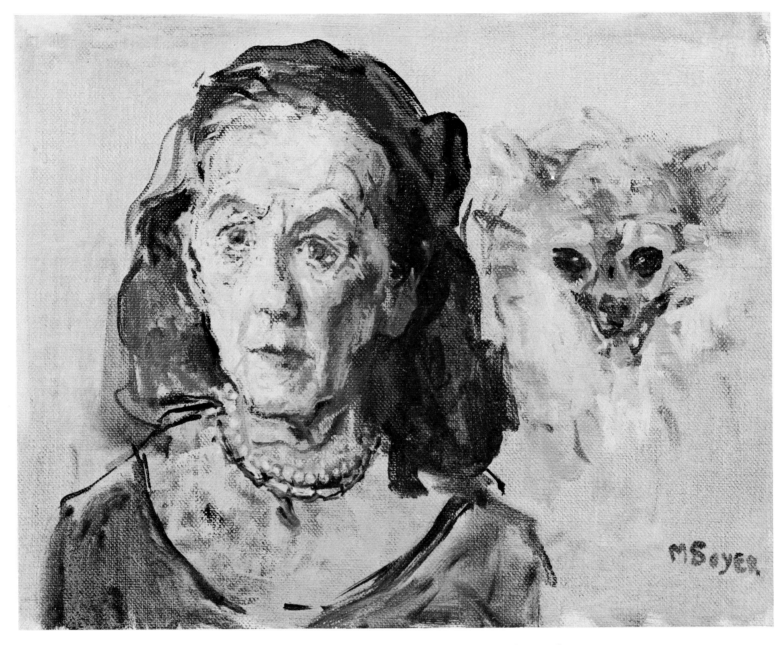

40. Study for Portrait of Julia Evergood. 1962. 16 x 20. Birmingham Museum, Birmingham, Ala.

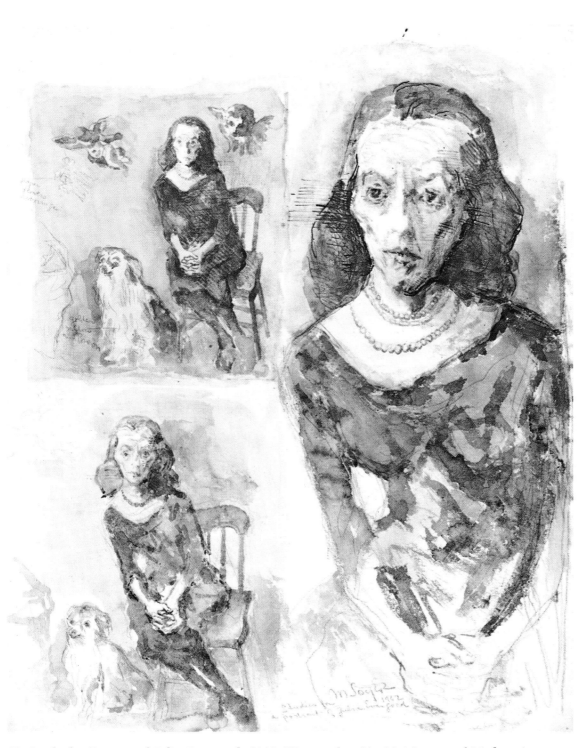

41. Study for Portrait of Julia Evergood. 1962. Water color. 24 x 20. Museum of Modern Art

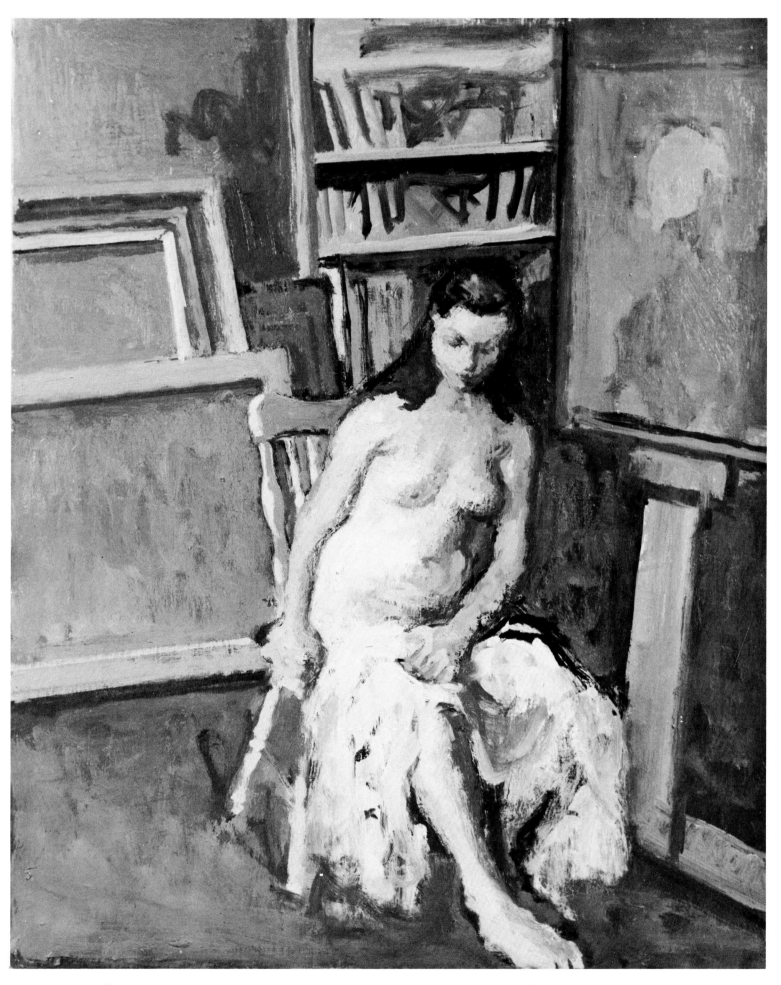

42. Girl with Yellow Drapery. 1963. 25 x 20. Collection Mr. and Mrs. Sam Berger, Scarsdale, N. Y.

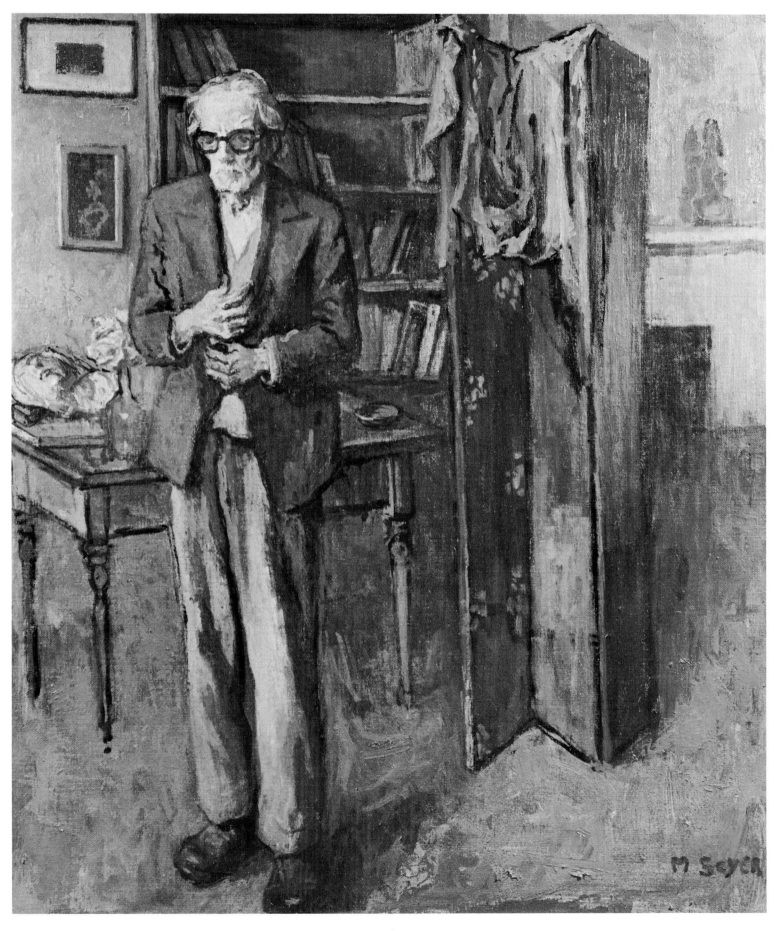

43. In the Studio. 1962. 42 x 36. Collection Mr. and Mrs. Harris Klein

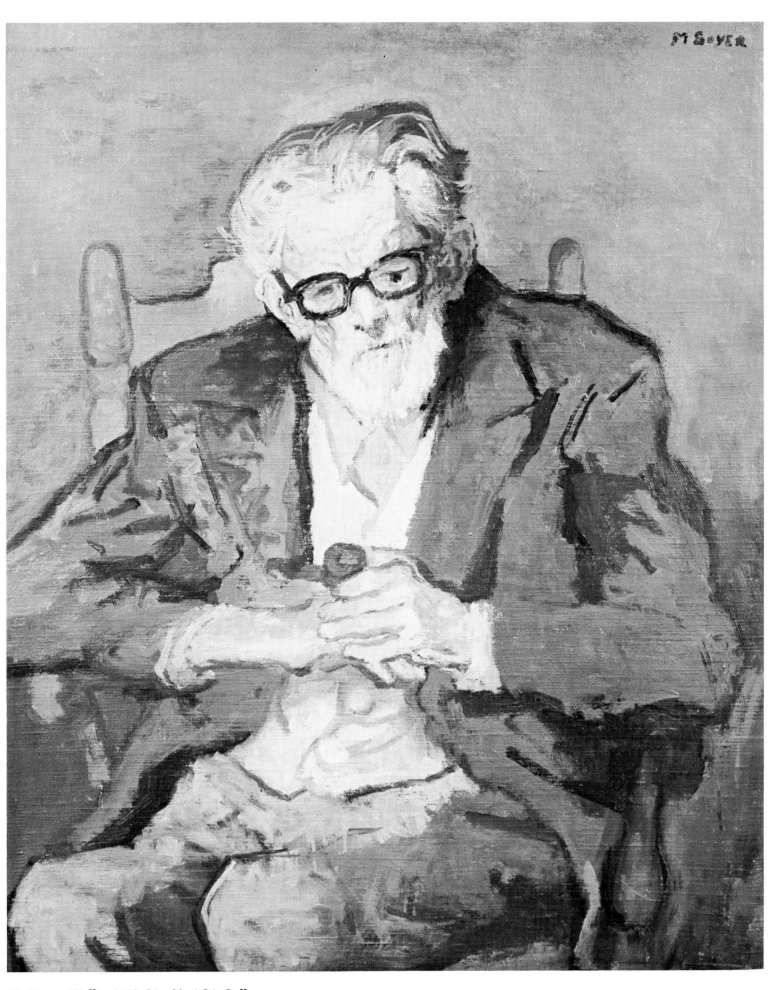

44. Keene Wallis. 1962. 36 x 30. ACA Gallery

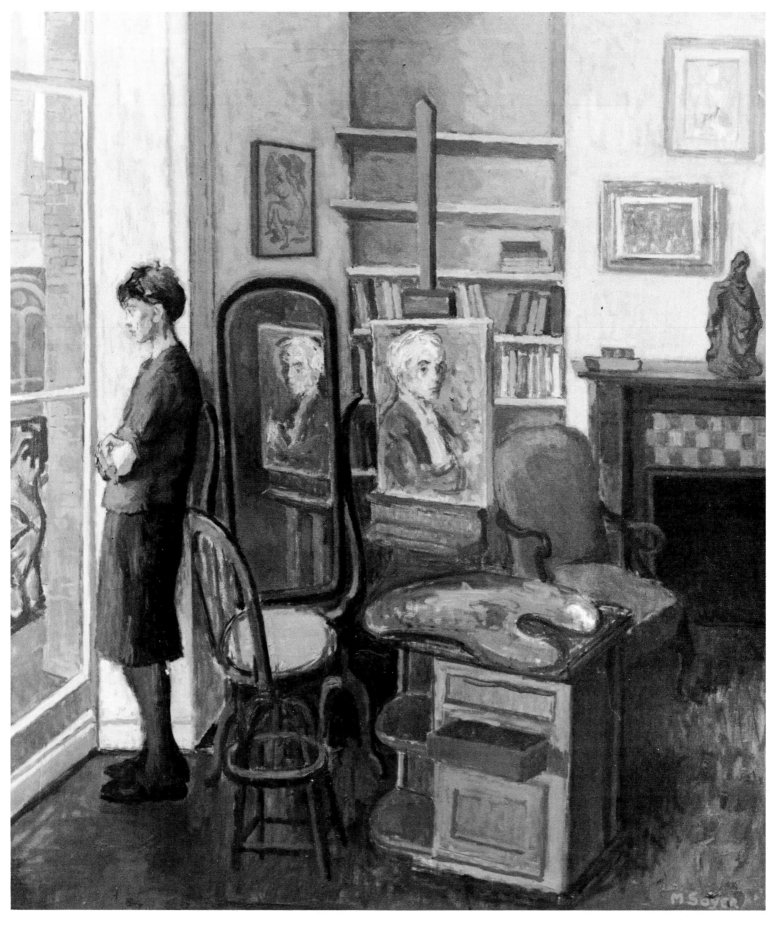

45. Studio Interior with Self-Portrait. 1968. 42 x 36. ACA Gallery

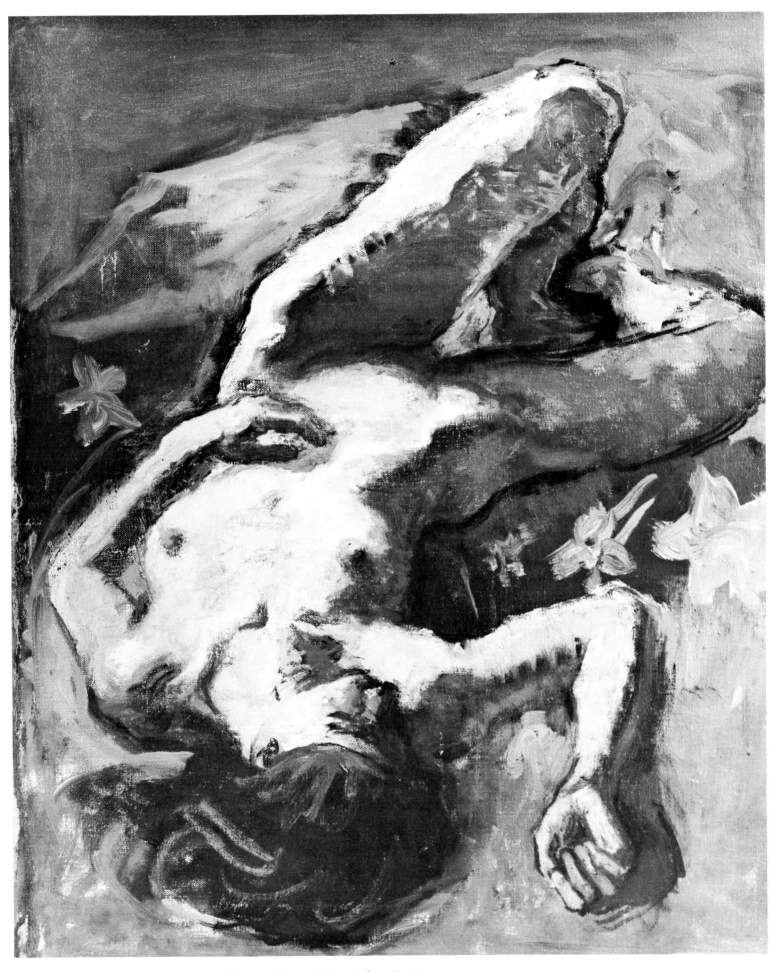

46. Reclining Nude. 1963. 20 x 16. Collection Mr. and Mrs. Sidney L. Bergen

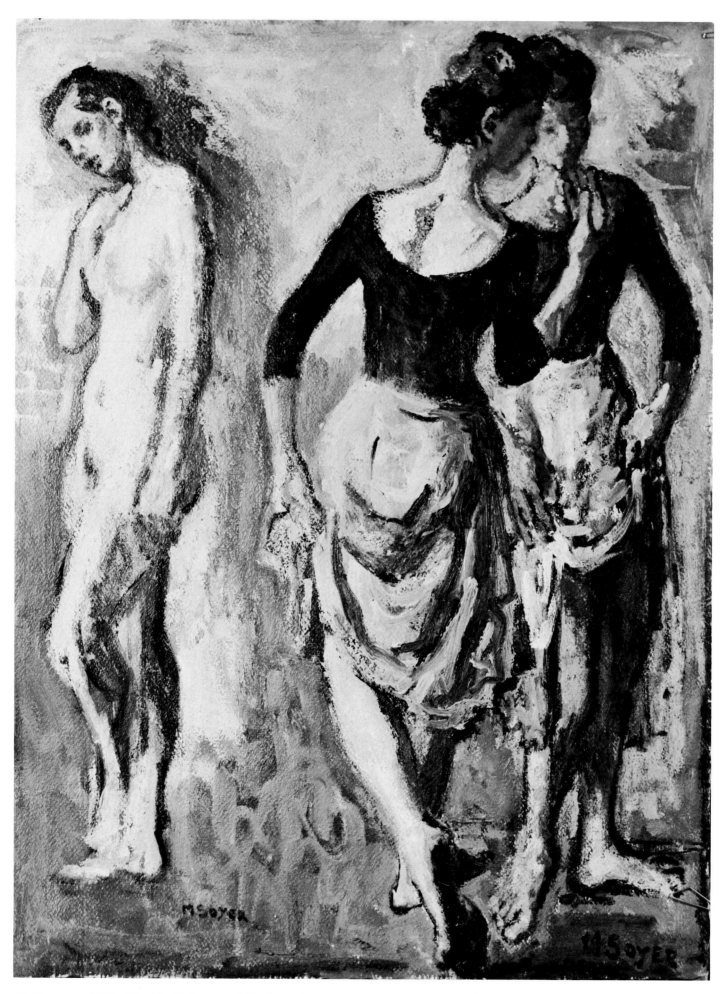

47. Dancers. 1963. 30 x 22. Collection Alfredo Valente

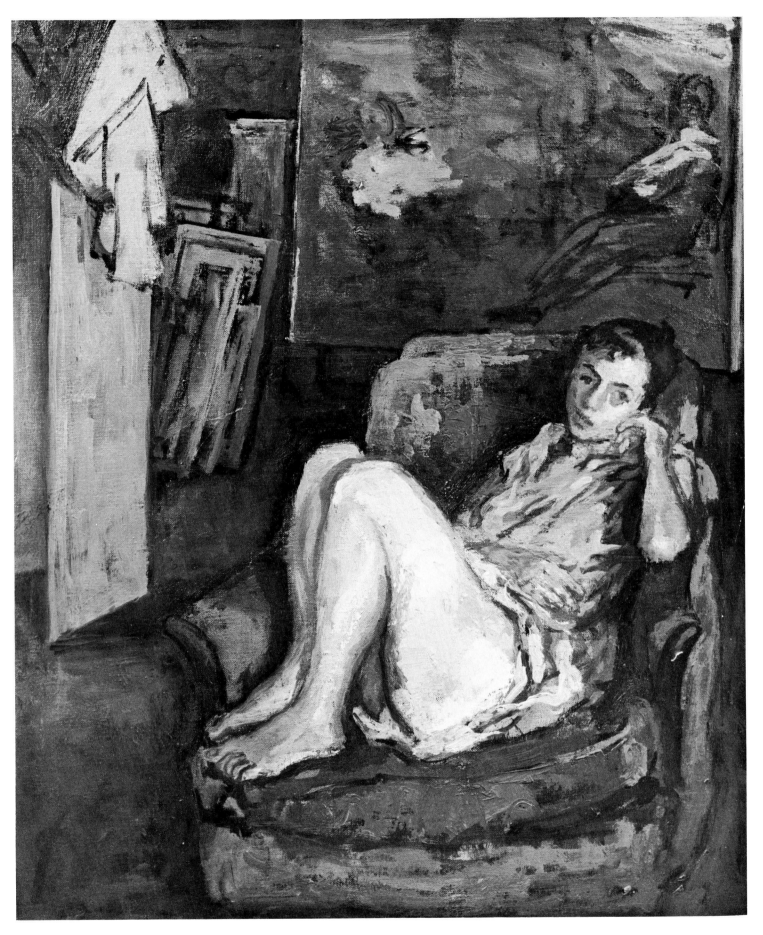

48. Rima. 1962. 20 x 16. Collection Sidney Lawrence, Kansas City, Mo.

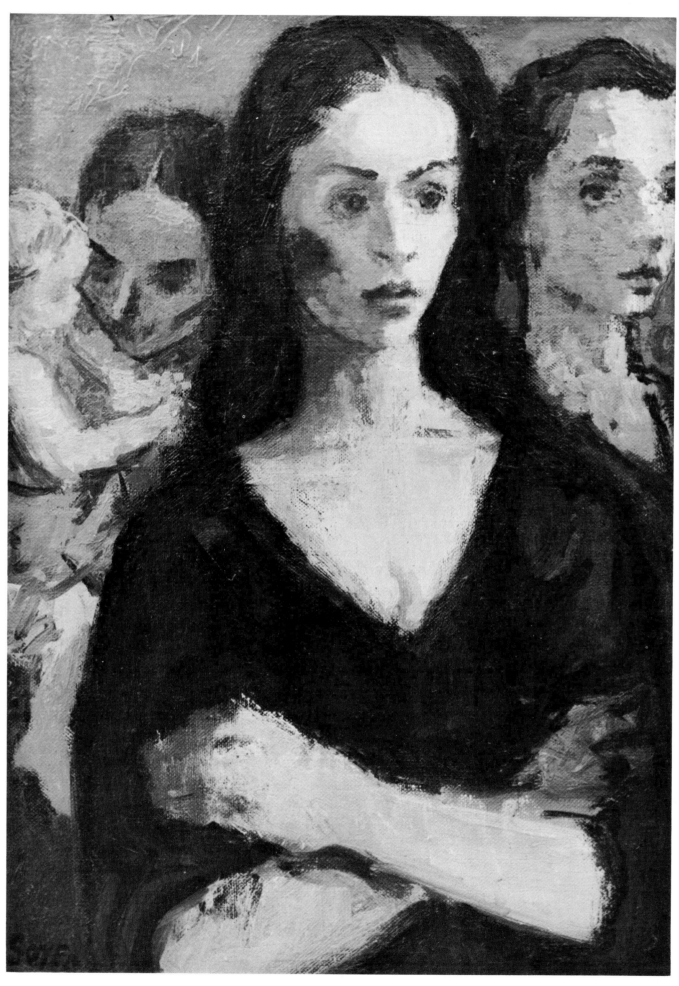

49. Women. 1963. 16 x 12

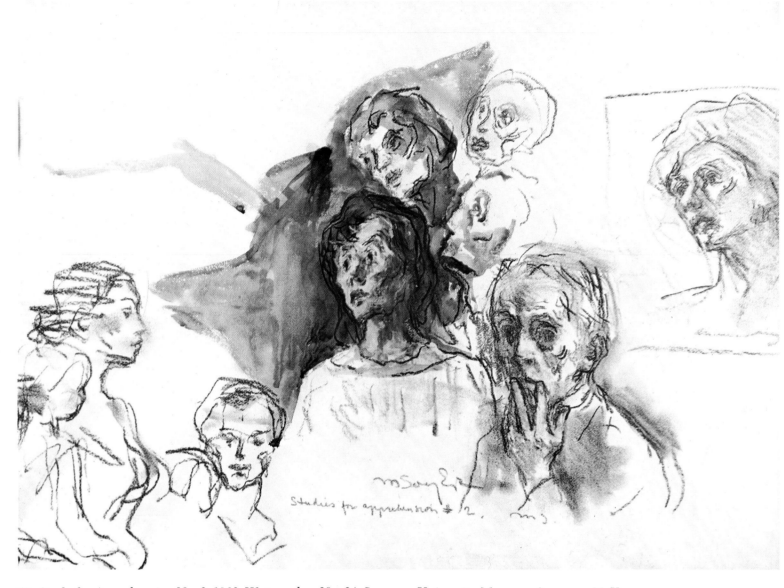

50. Study for Apprehension No. 2. 1962. Water color. 20 x 24. Syracuse University Museum, Syracuse, N. Y.

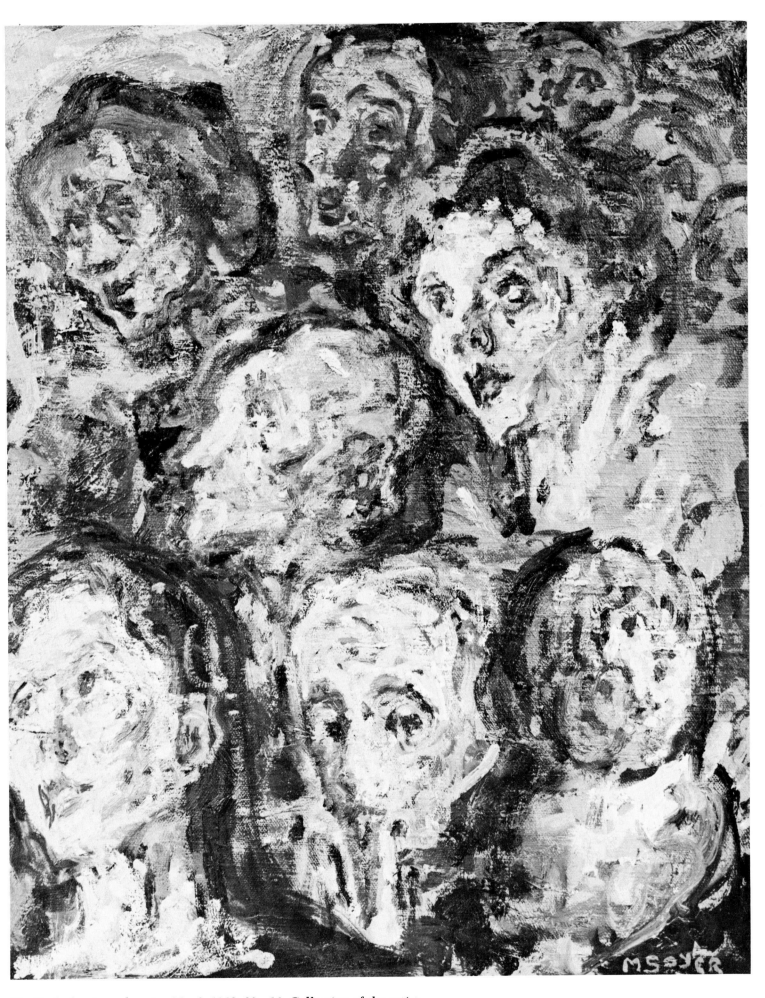

51. Study for Apprehension No. 2. 1962. 20 x 16. Collection of the artist

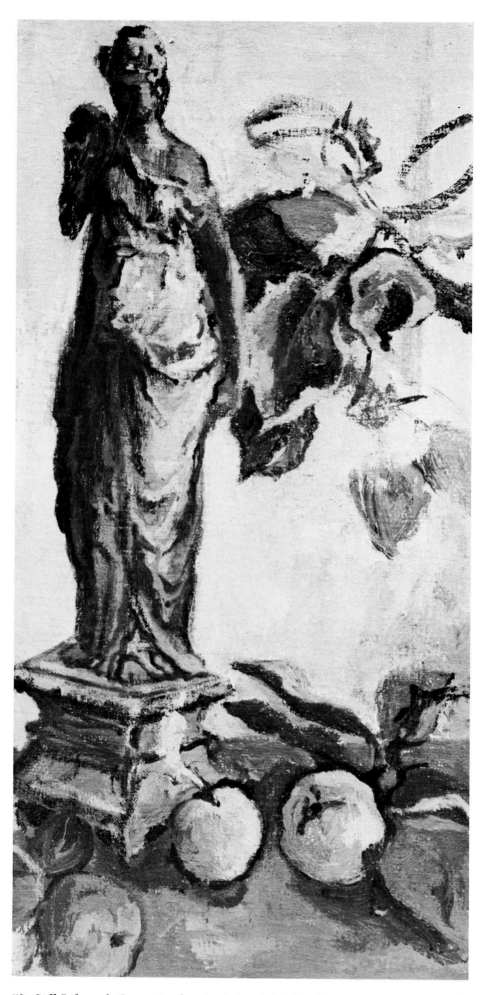

52. Still Life with Green Apples. 1963. 20 x 10. ACA Gallery

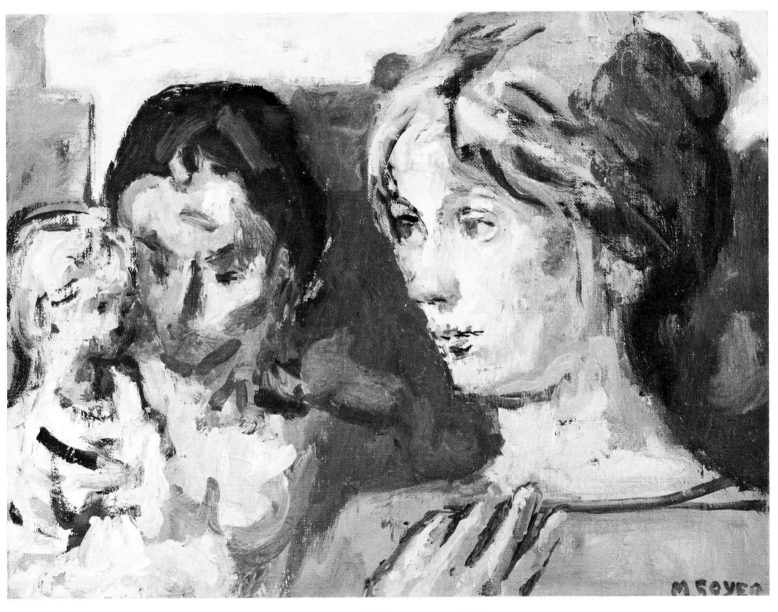

53. Street Scene. 1962. 12 x16. Collection Mr. and Mrs. A. Brodlieb, Lawrence, N. Y.

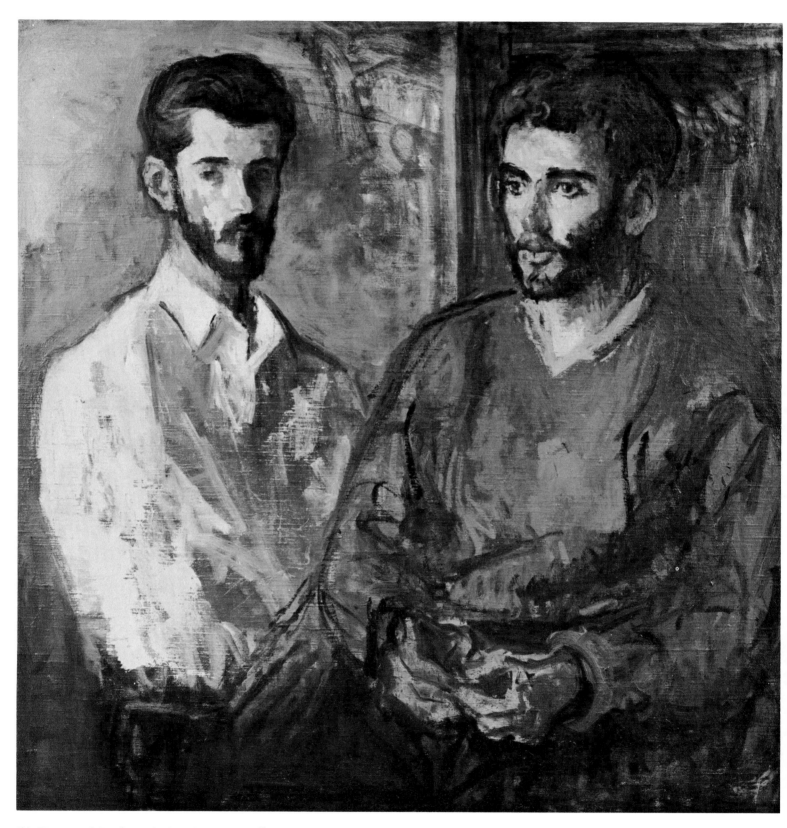

54. Peter and Paul. 1963. 40 x 40. ACA Gallery

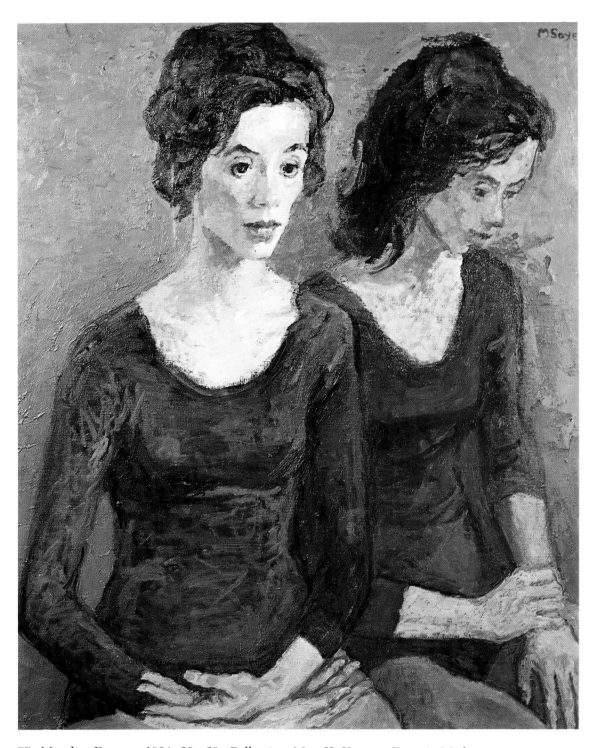

55. Maralia, Dancer. 1964. 36 x 30. Collection Mrs. H. Kramer, Detroit, Mich.

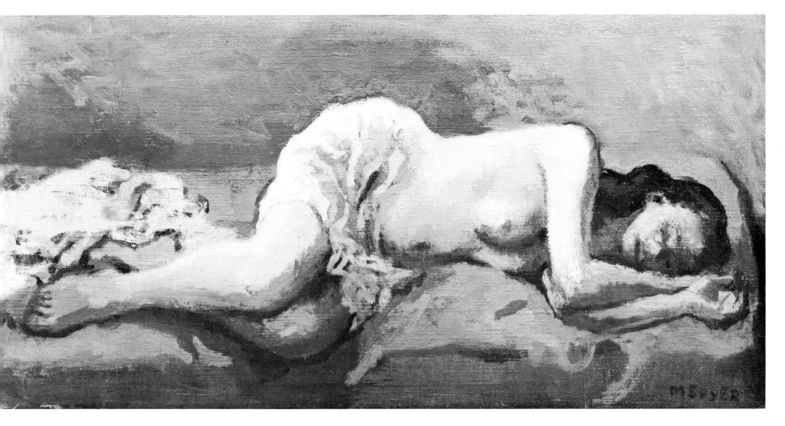

56. Nude with White Slip. 1965. 10 x 20

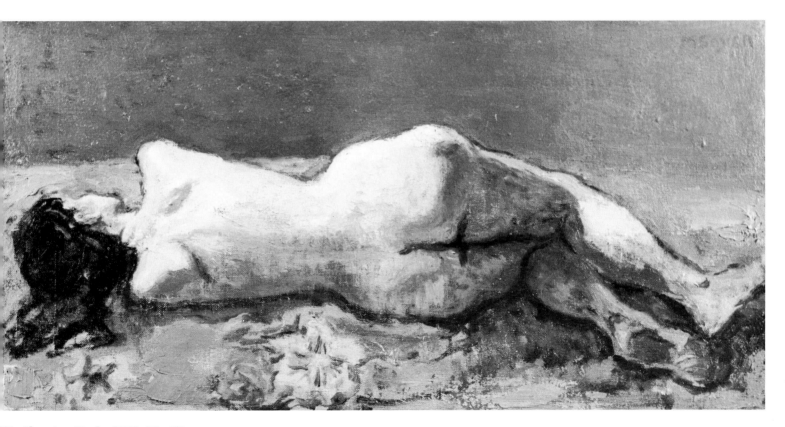

57. Sleeping Nude. 1966. 10 x 20

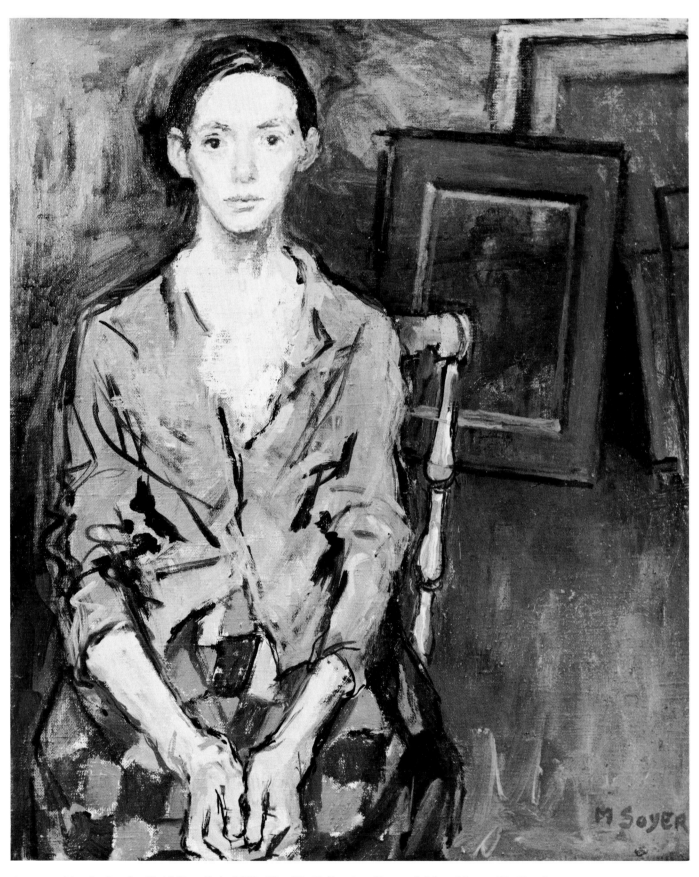

58. Jean (Study for the Reid Family). 1963. 20 x 16. Collection Dr. and Mrs. Meyer H. Friedman, Trenton, N. J.

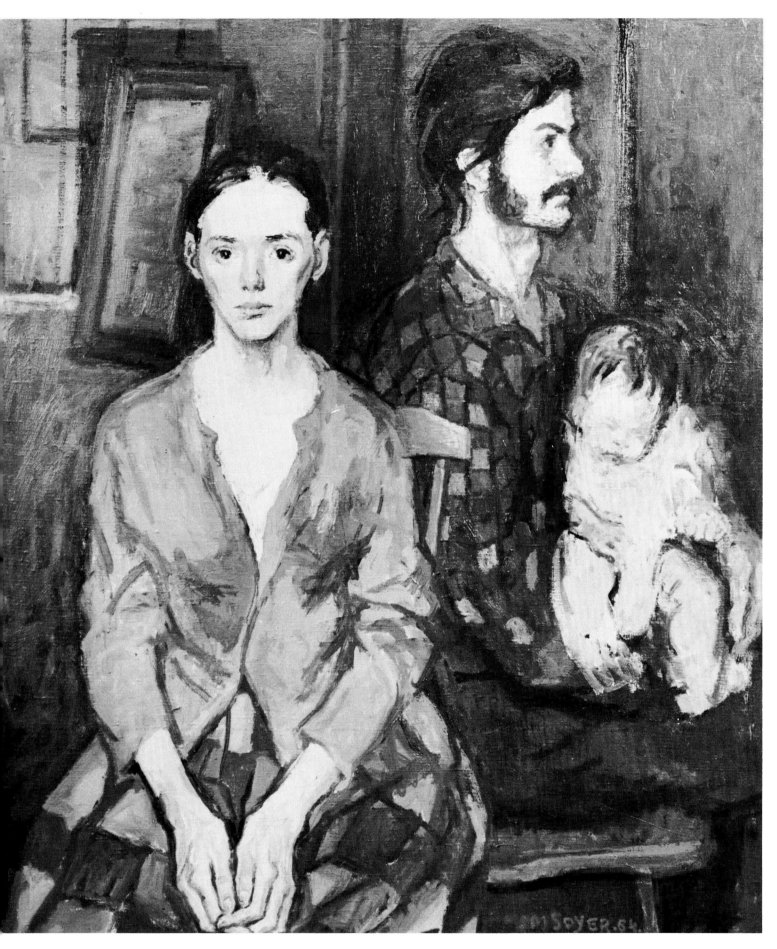

59. The Reid Family. 1963. 42 x 36. Collection Eartha Kitt, Los Angeles, Calif.

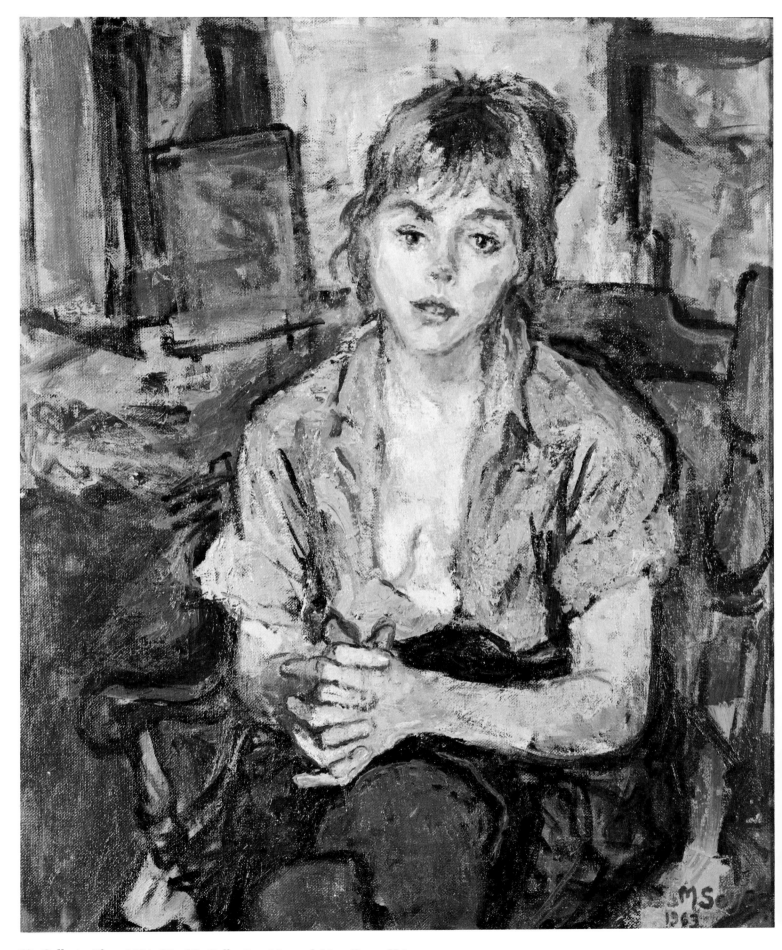

60. Cella in Blue. 1964. 36 x 30. Collection Mr. and Mrs. Percy Uris

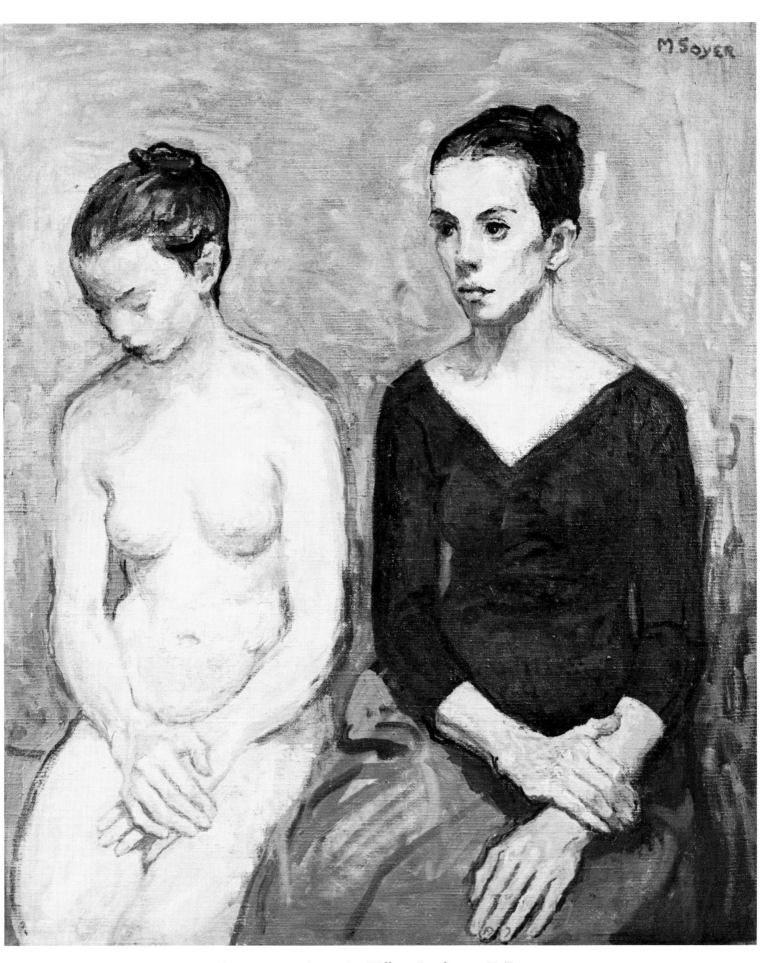

61. Phoebe Neville. 1964. 36 x 30. Collection Mr. and Mrs. Ira Willner, Larchmont, N. Y.

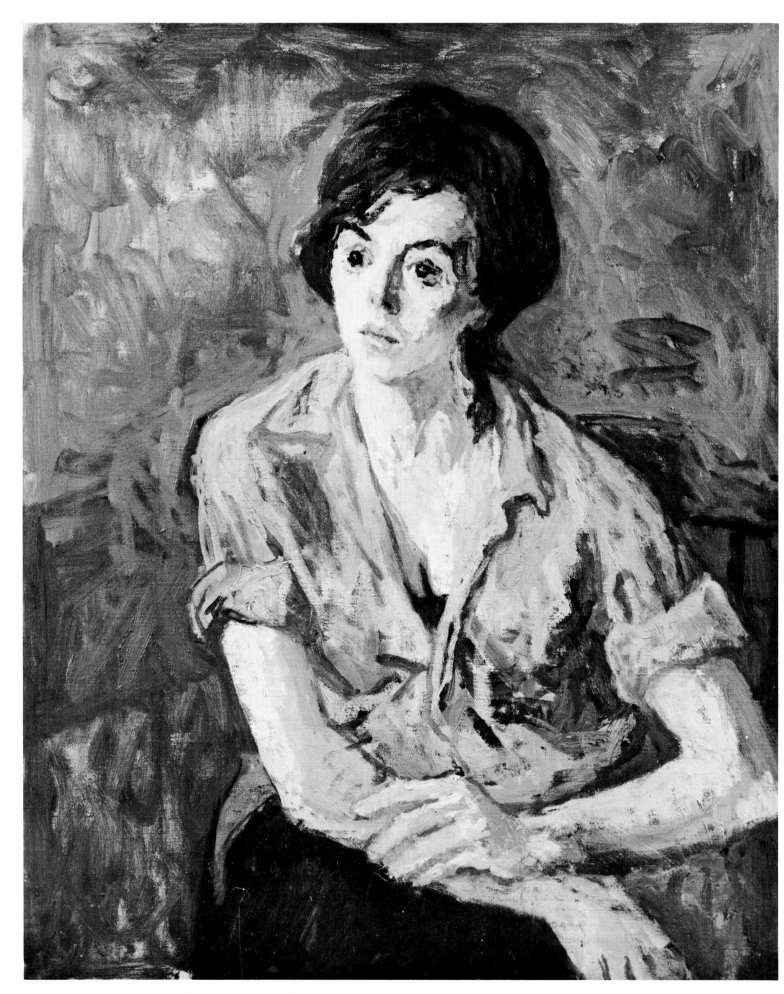

62. Maria. 1964. 30 x 25. Collection Herbert Adler

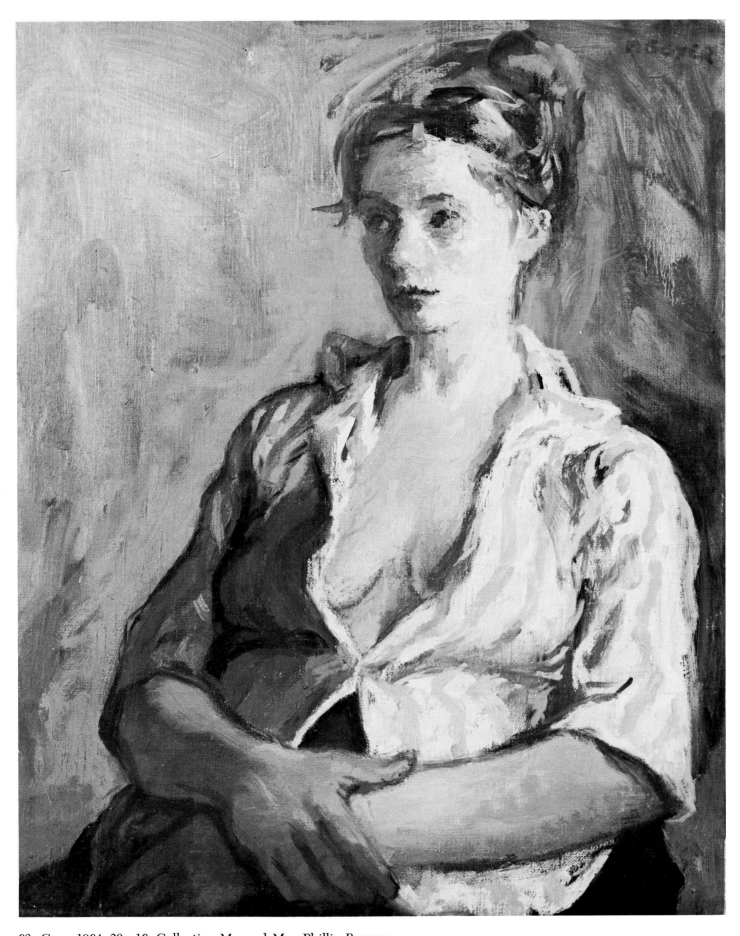

63. Cara. 1964. 20 x 16. Collection Mr. and Mrs. Phillip Berman

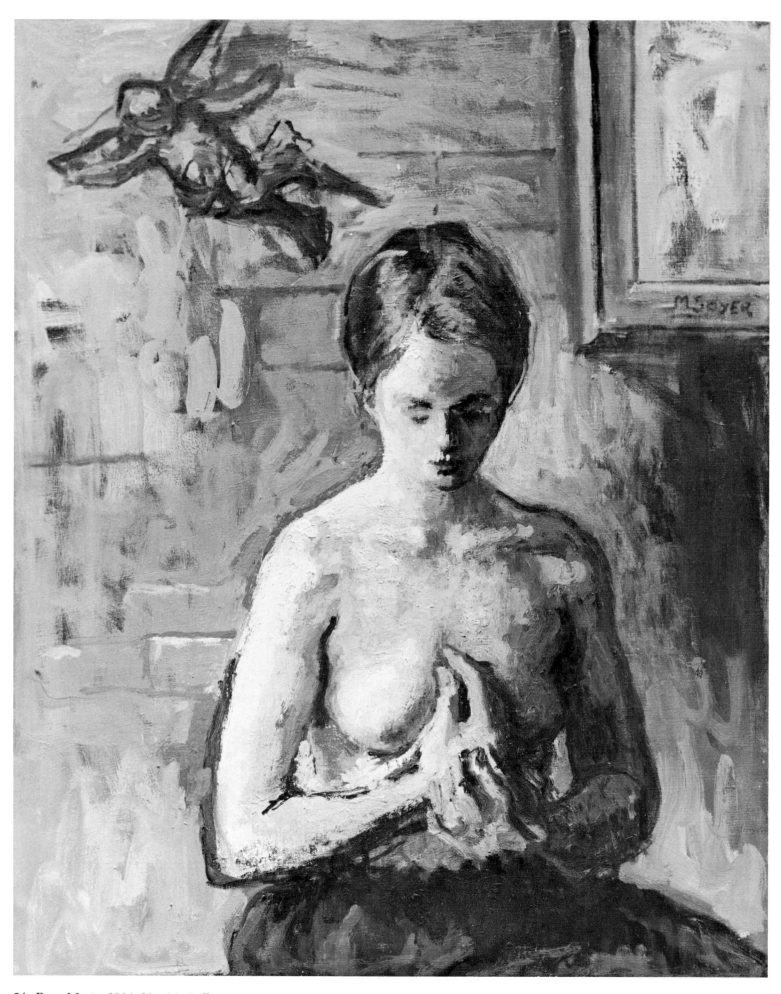

64. Rose Marie. 1964. 30 x 24. Collection Mr. and Mrs. Nathan Baker

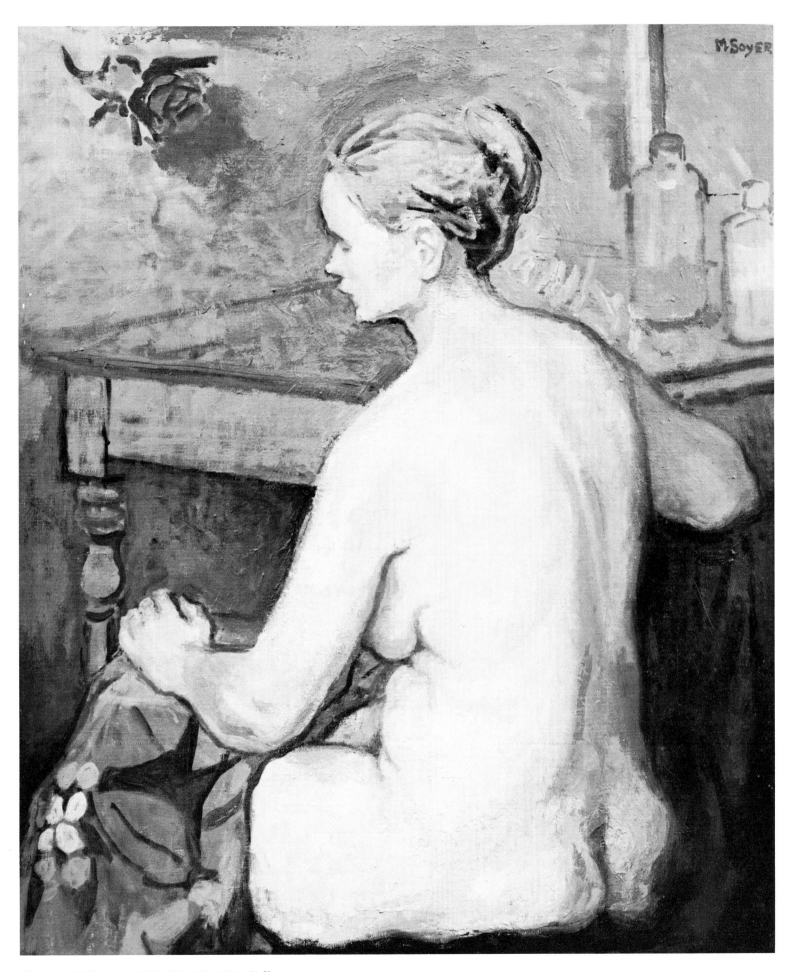

65. Seated Woman. 1964. 36 x 30. ACA Gallery

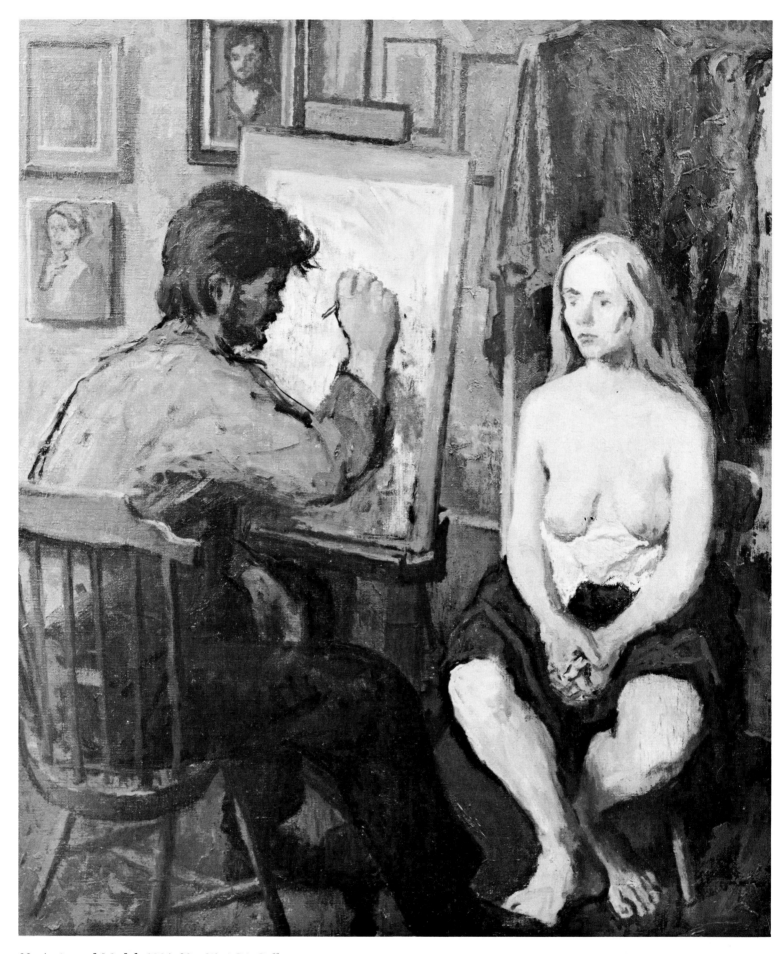

66. Artist and Model. 1964. 30 x 25. ACA Gallery

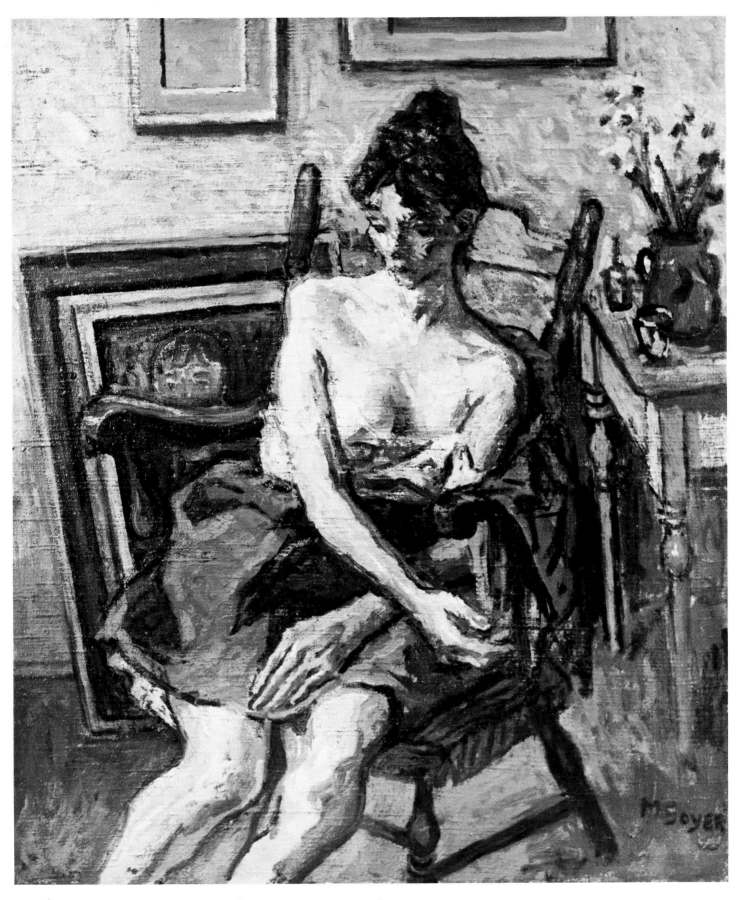

67. Marie Lise No. 2. 1964. 25 x 20. Collection Dr. and Mrs. Robert Aaron

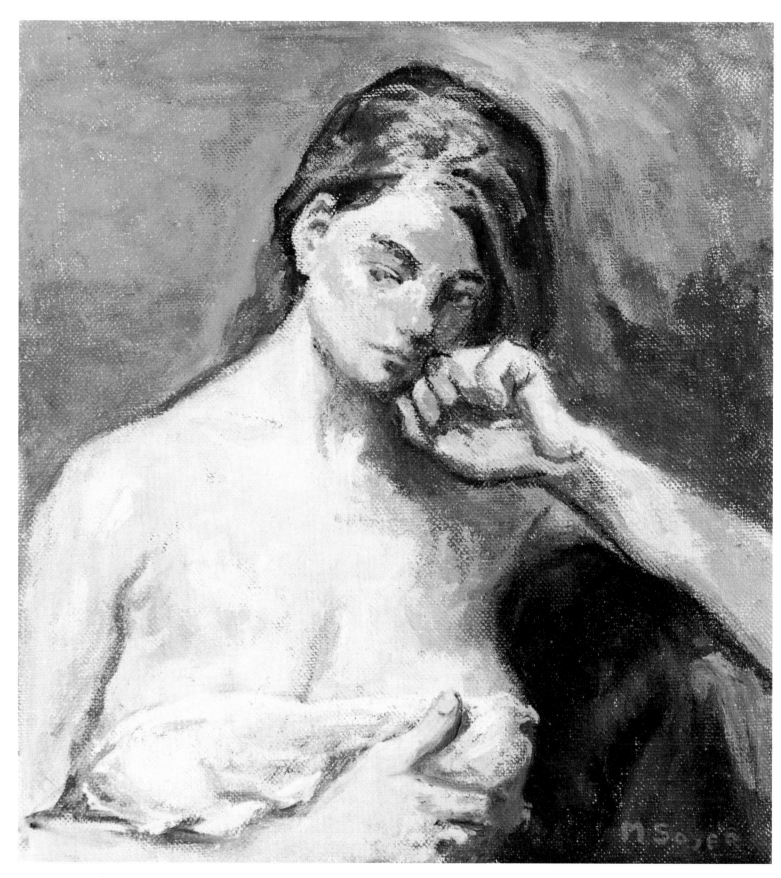

68. Young Girl. 1964. 16 x 14. Collection Dr. and Mrs. Martin Cherkasky

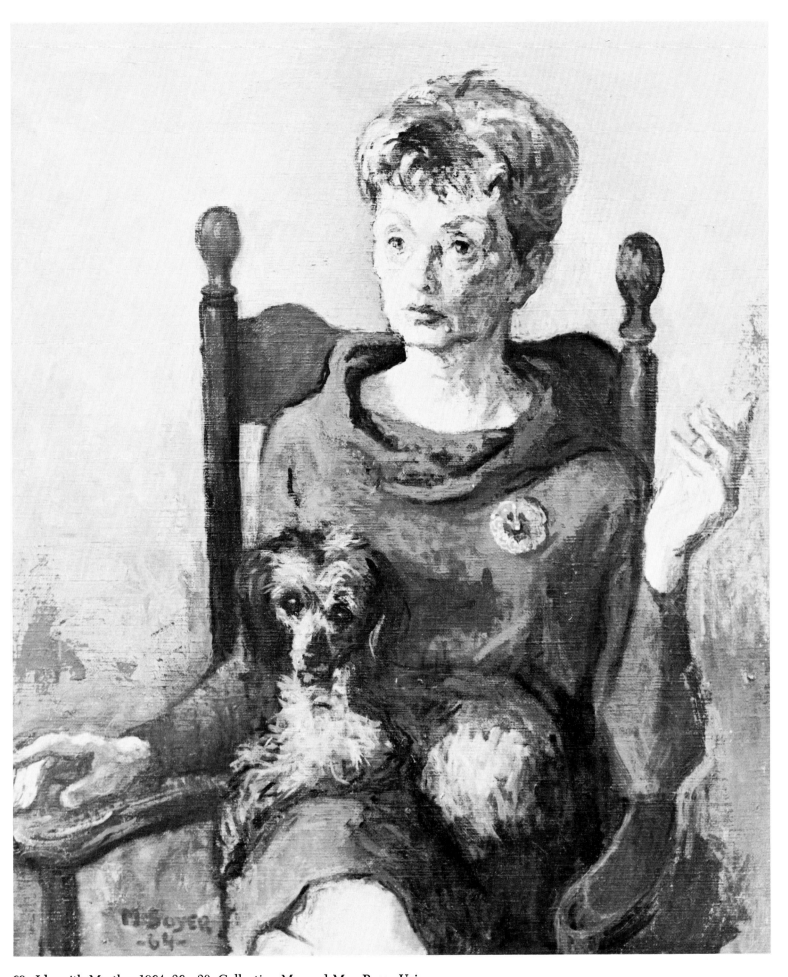

69. Ida with Martha. 1964. 36 x 30. Collection Mr. and Mrs. Percy Uris

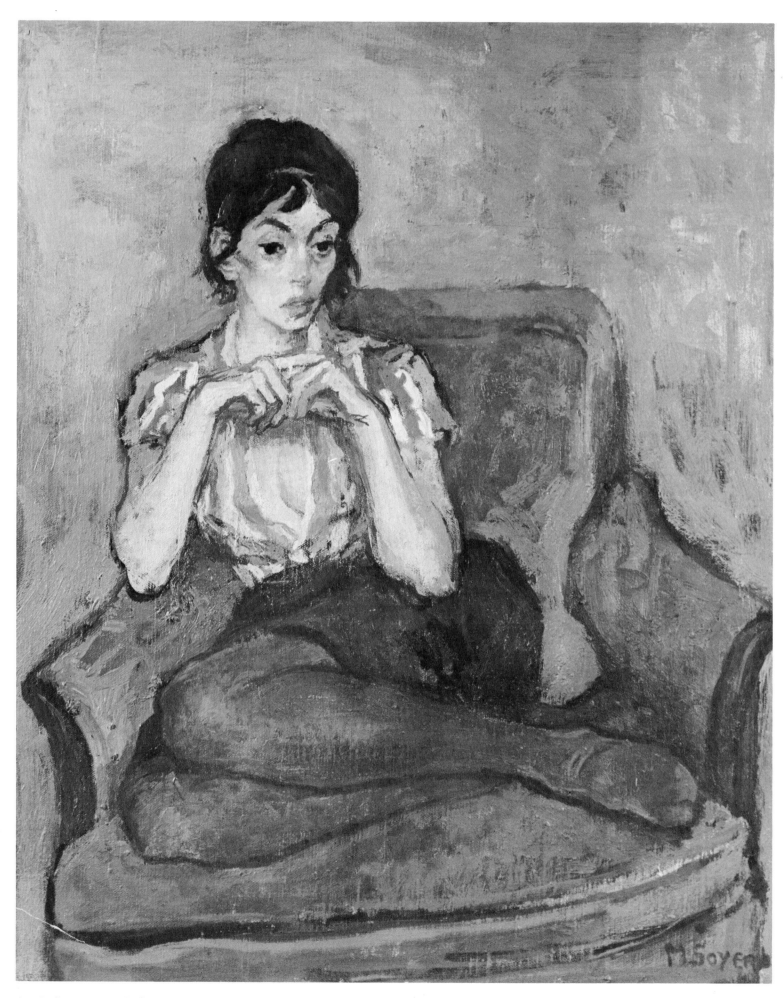

70. **Girl in a Striped Blouse.** 1964. 25 x 20. Collection Mr. and Mrs. Lawrence Harvey, Los Angeles, Calif.

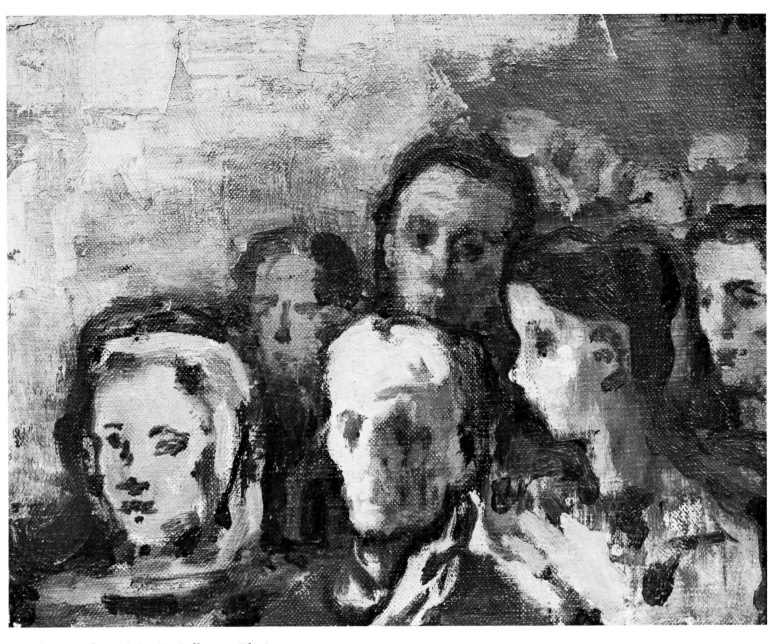

71. **The Crowd.** 1964. 8 x 10. Collection Ida Soyer

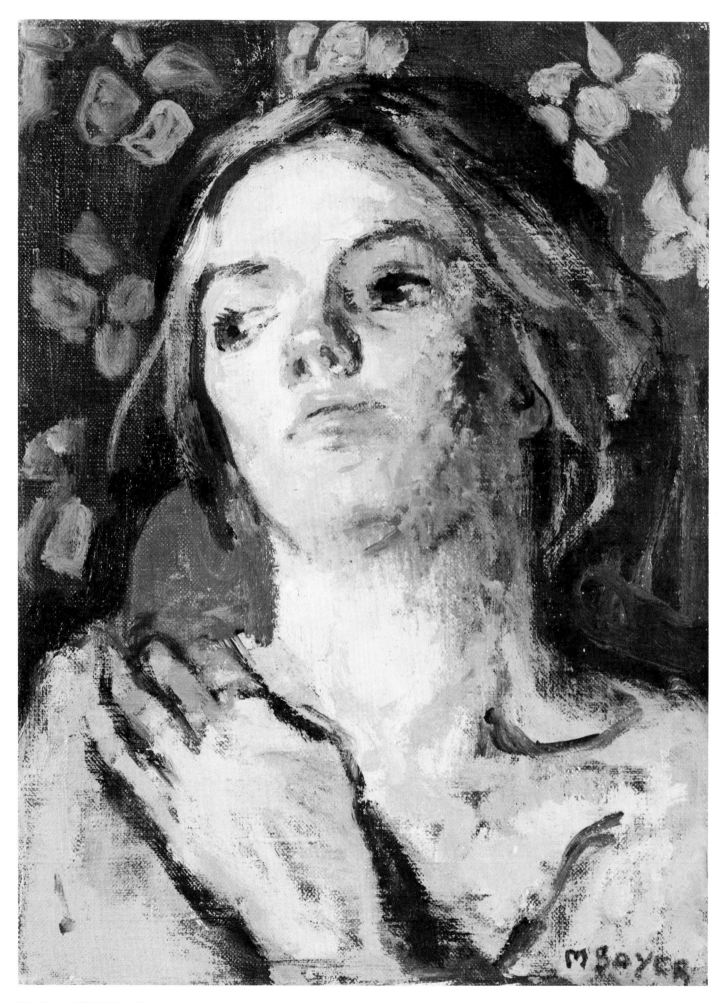

72. Cara. 1964. 16 x 12

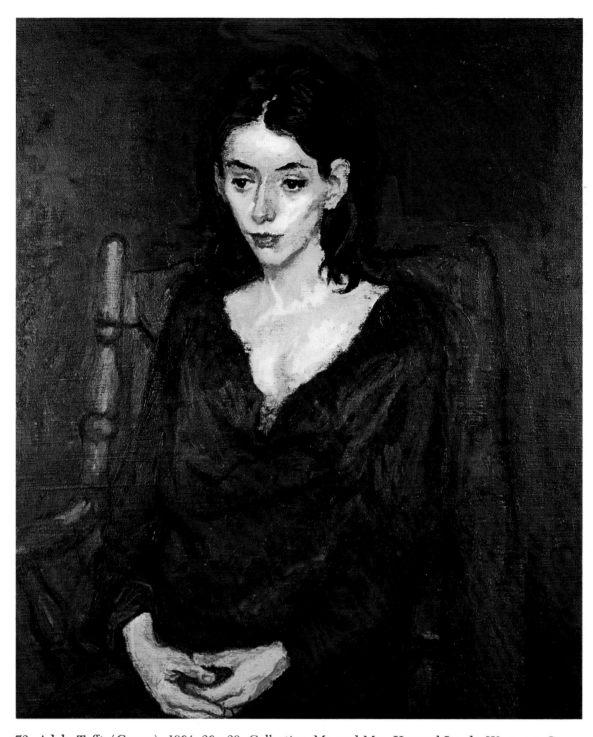

73. Adele Tefft (Gypsy). 1964. 36 x 30. Collection Mr. and Mrs. Howard Leeds, Westport, Conn.

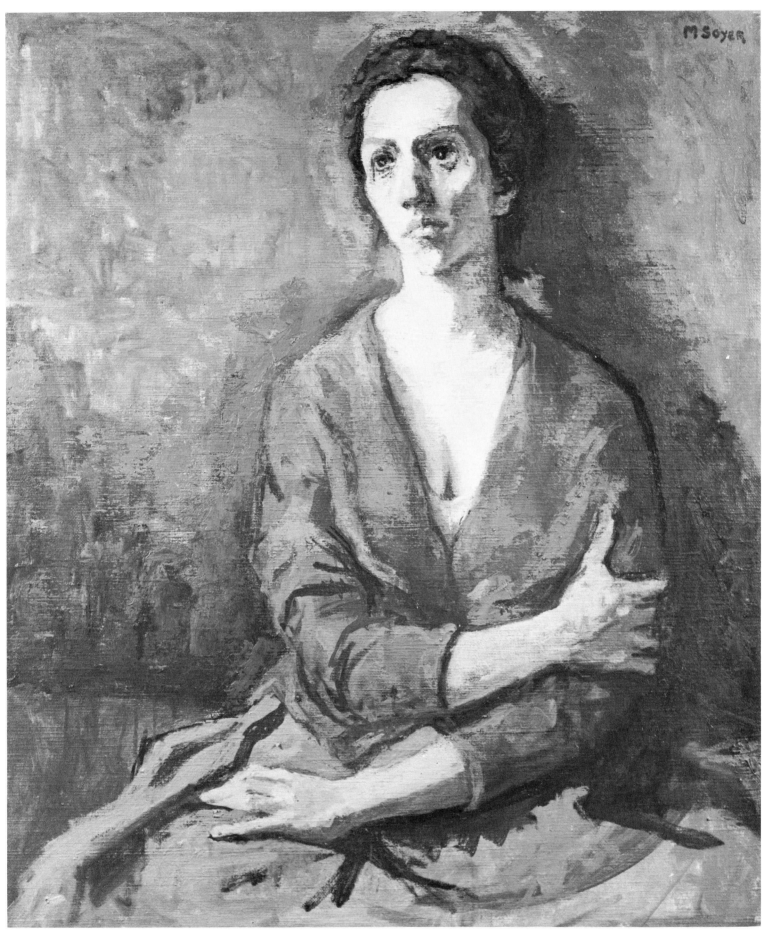

74. Diane di Prima. 1964. 36 x 30

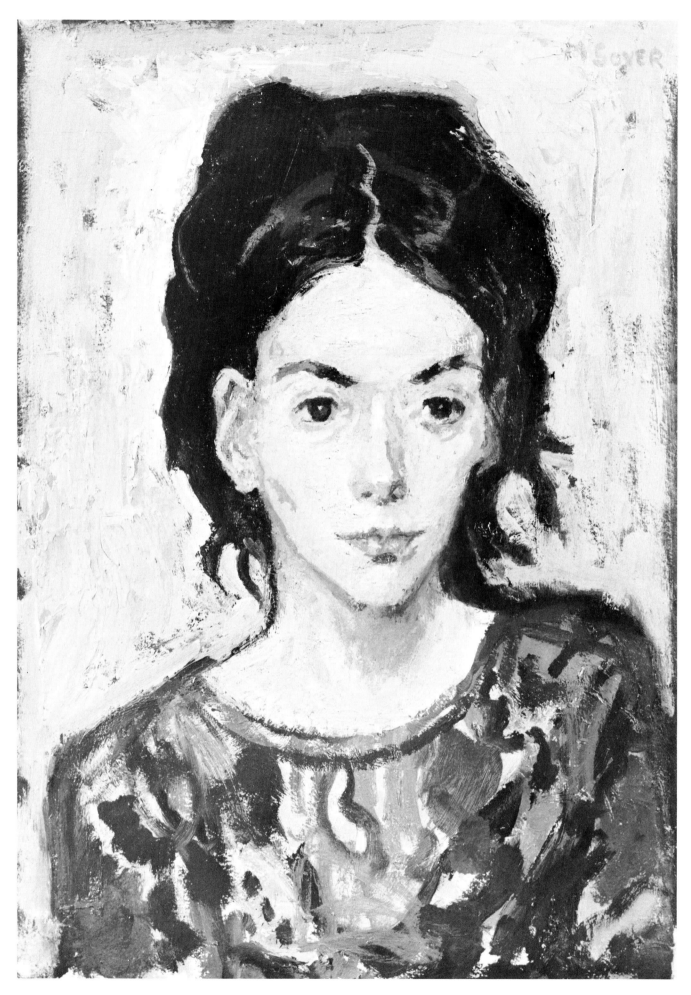

75. Gypsy. 1964. 16 x 12

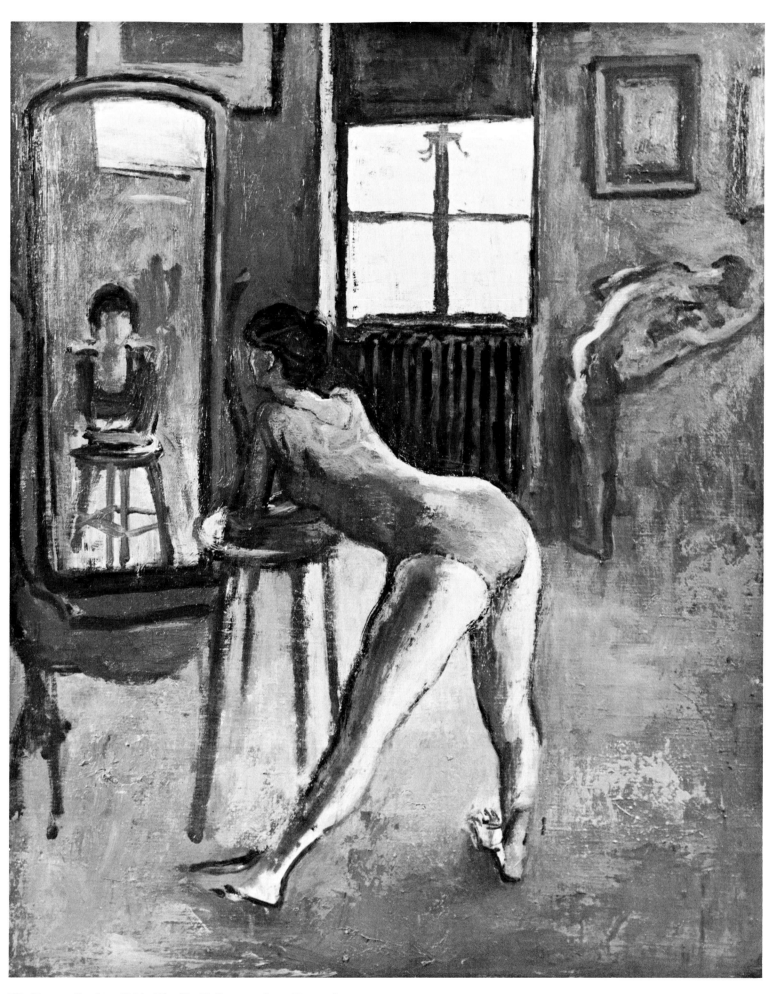

76. Dance Studio. 1964. 25 x 20. Collection Sara Deutsch

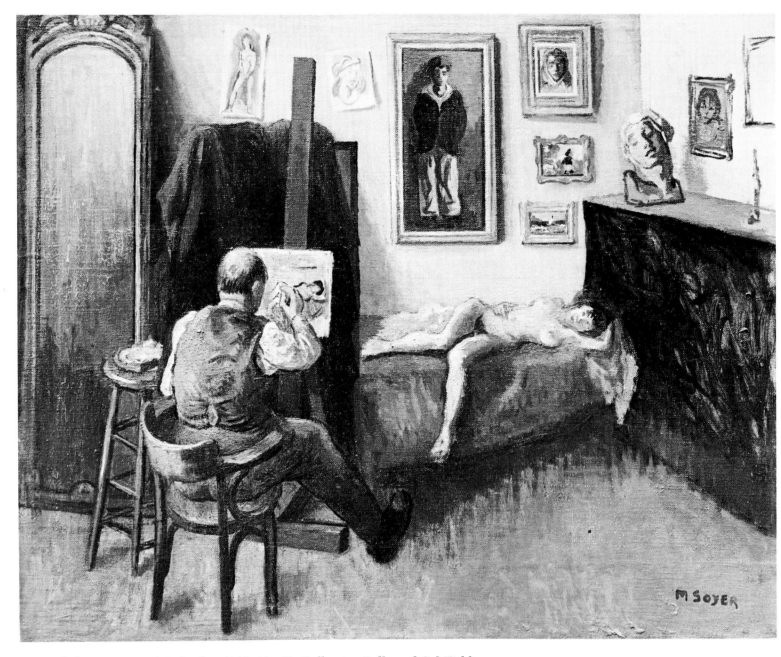

77. Burliuk Painting in My Studio. 1946. 16 x 20. Collection Bella and Sol Fishko

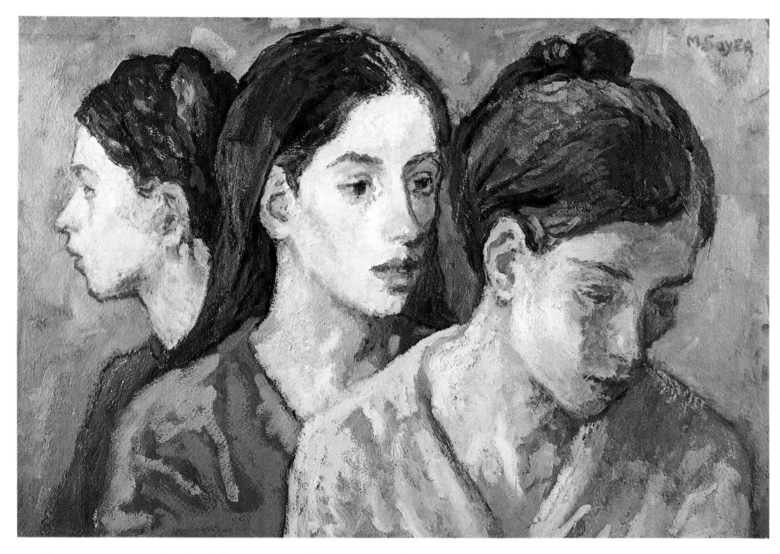

78. Three Sisters. 1966. 20 x 26. Collection Mr. and Mrs. Sam Denberg, Livingston, N. J.

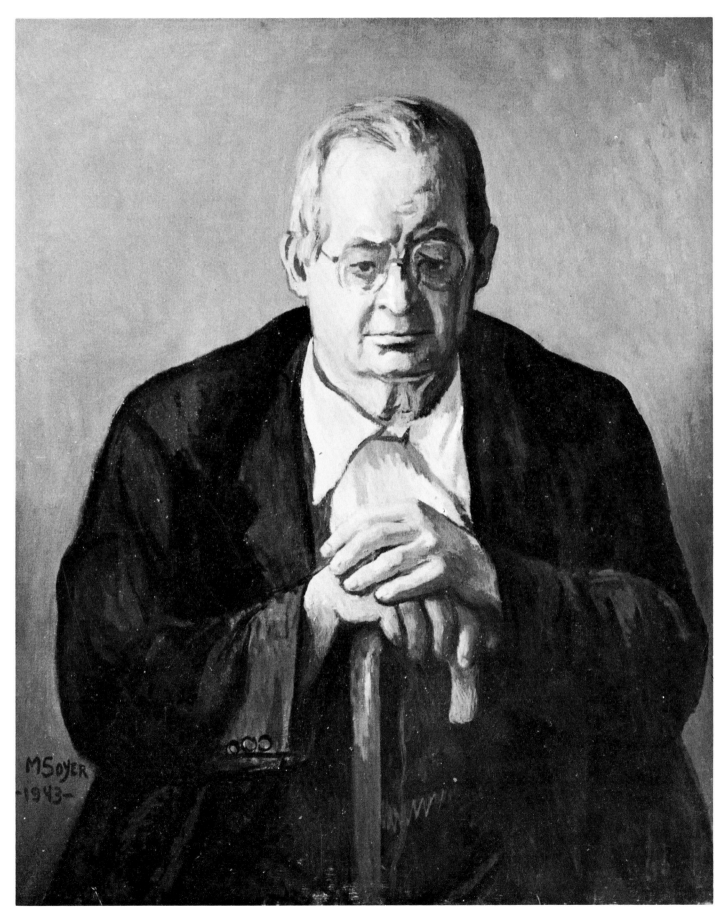

79. Joseph Stella. 1943. 29¾ x 24. Newark Museum Association, Newark, N. J.

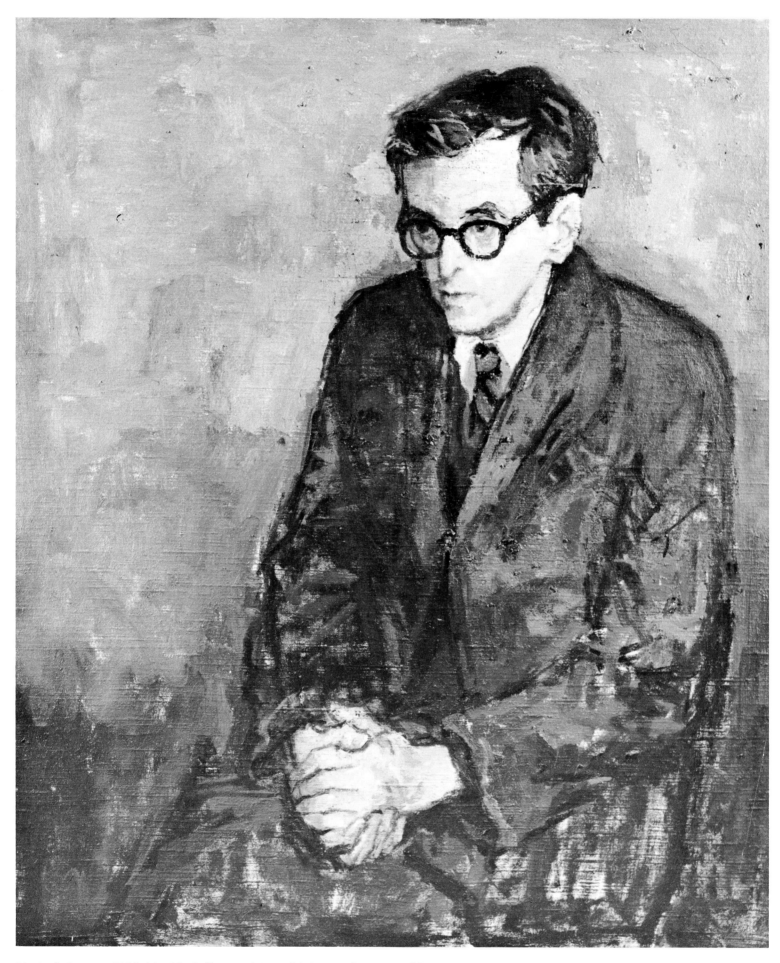

80. Jack Levine. 1964. 36 x 30. Collection Mr. and Mrs. Herbert A. Goldstone

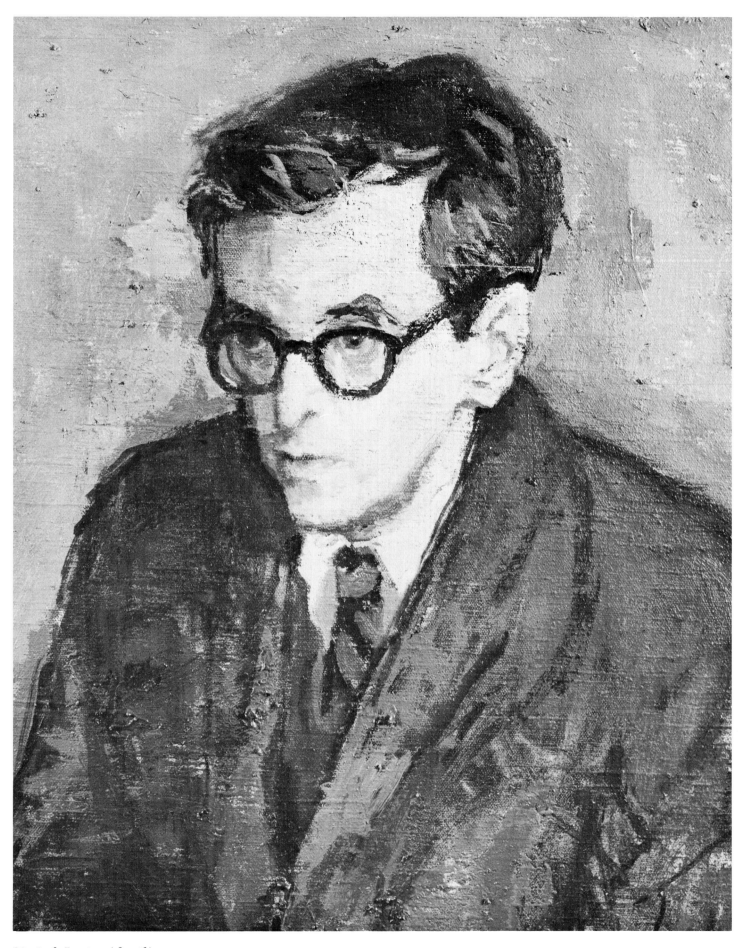

81. Jack Levine (detail)

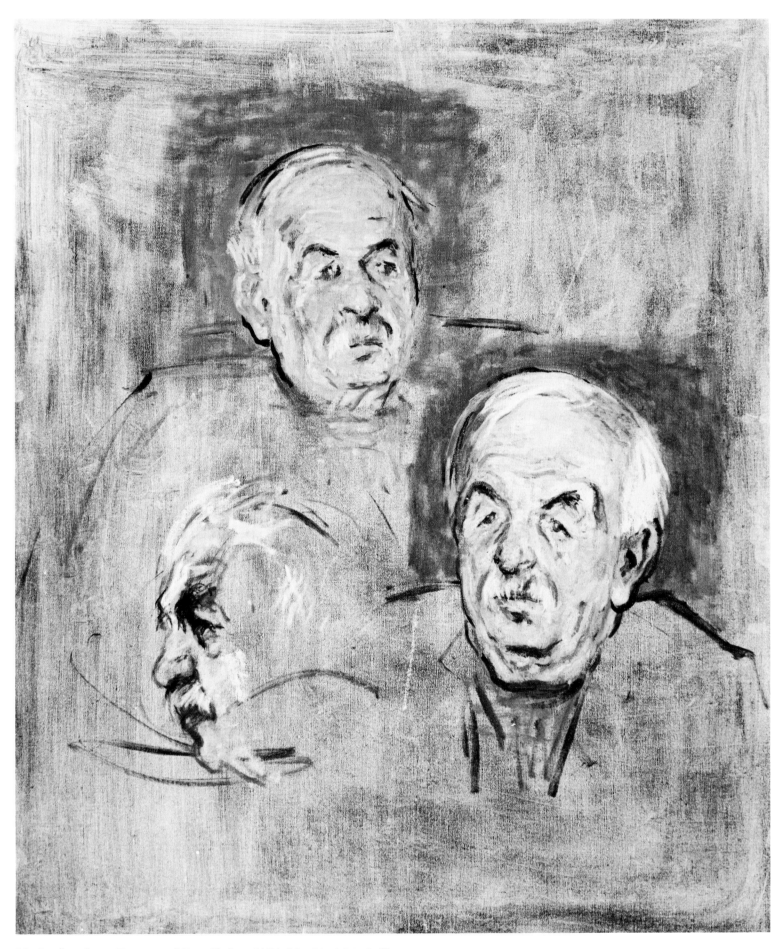

82. Studies for a Portrait of Ben Shahn. 1965. 36 x 30. ACA Gallery

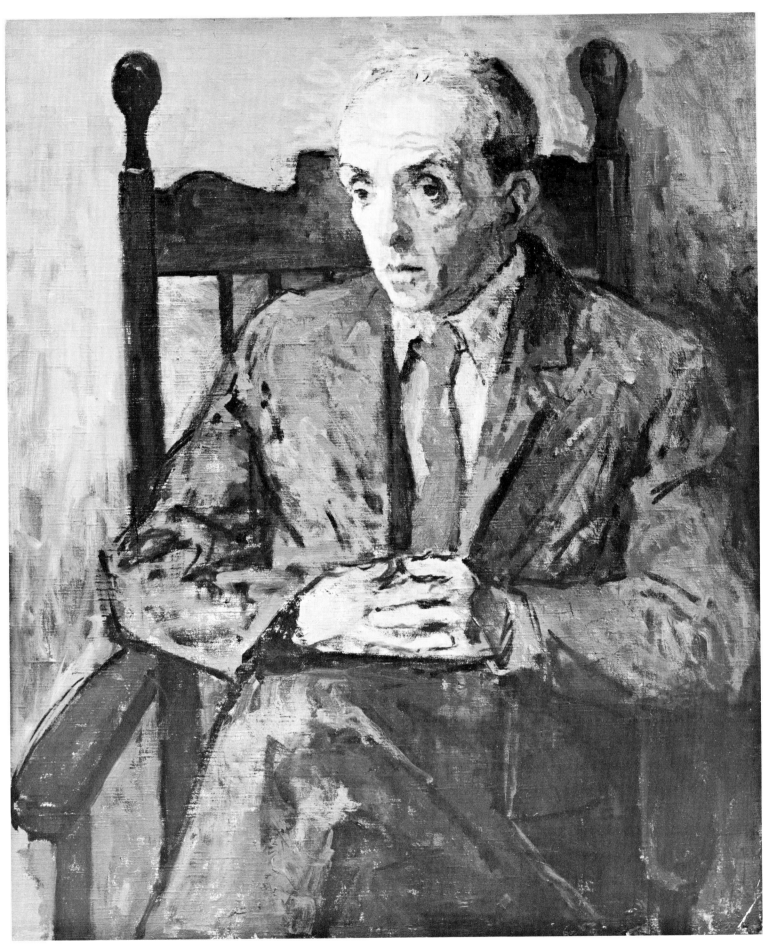

83. Portrait of Raphael Soyer. 1964. 36 x 30. Collection Sidney Lawrence, Kansas City, Mo.

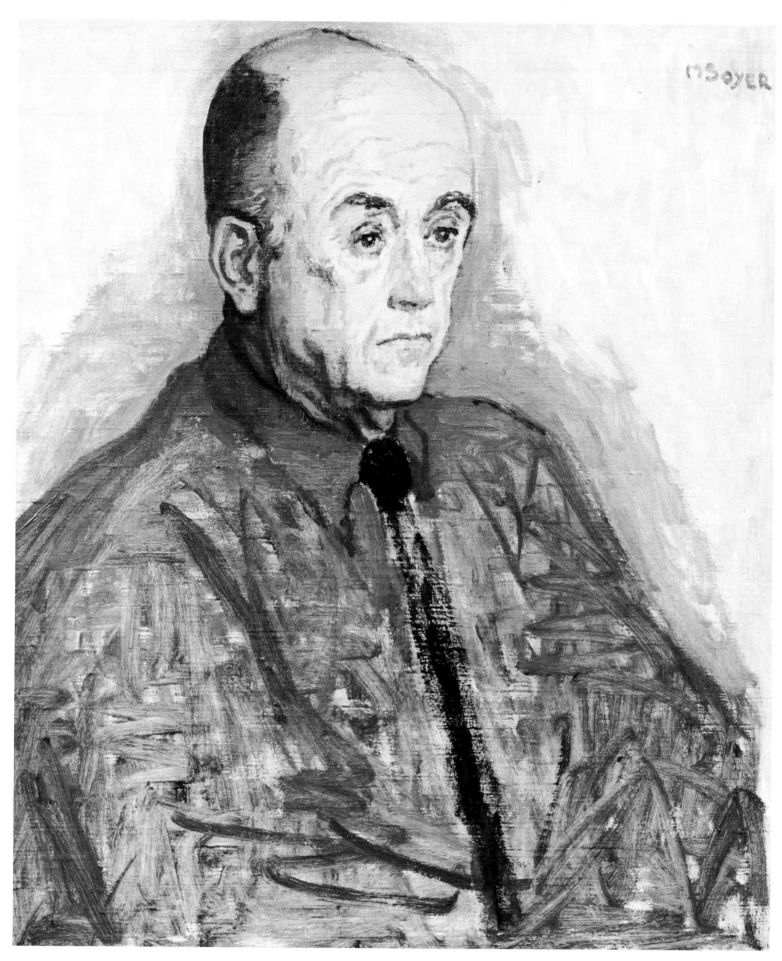

84. Portrait of Robert Gwathmey. 1965. 30 x 25. ACA Gallery

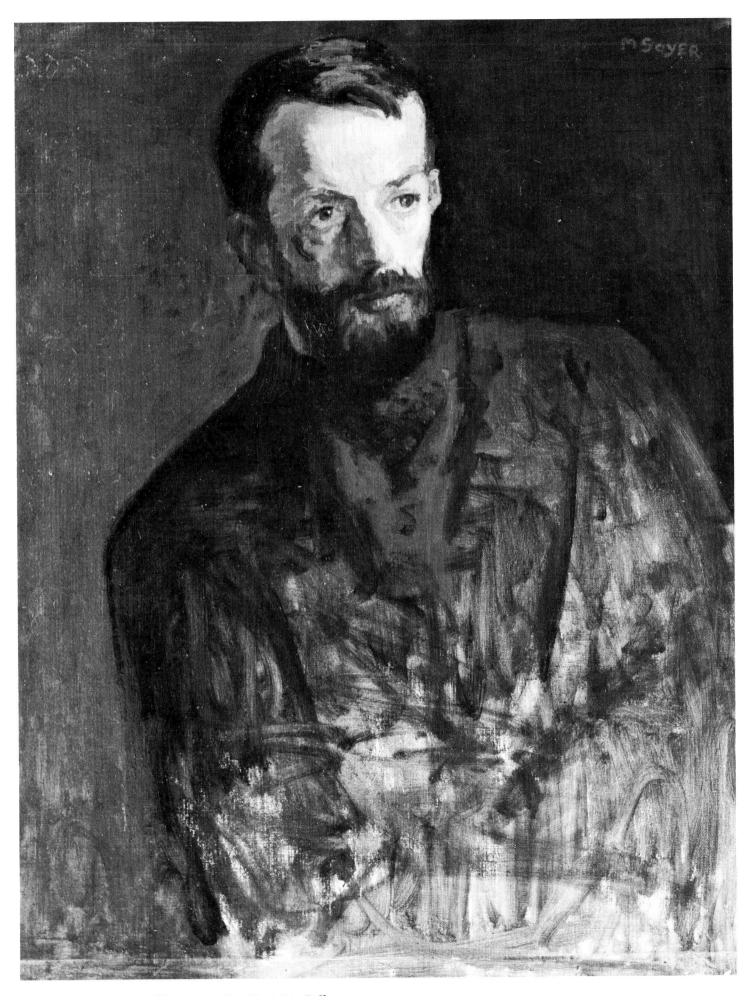

85. Portrait of John Dobbs. 1966. 32 x 25. ACA Gallery

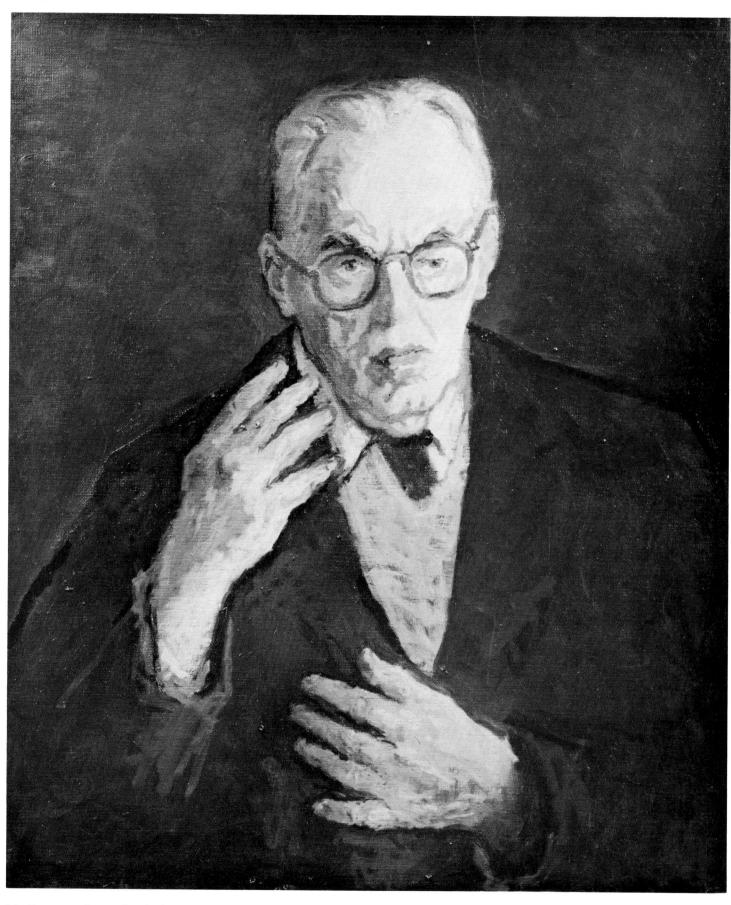

86. Portrait of Joseph Floch. 1967. 30 x 25. ACA Gallery

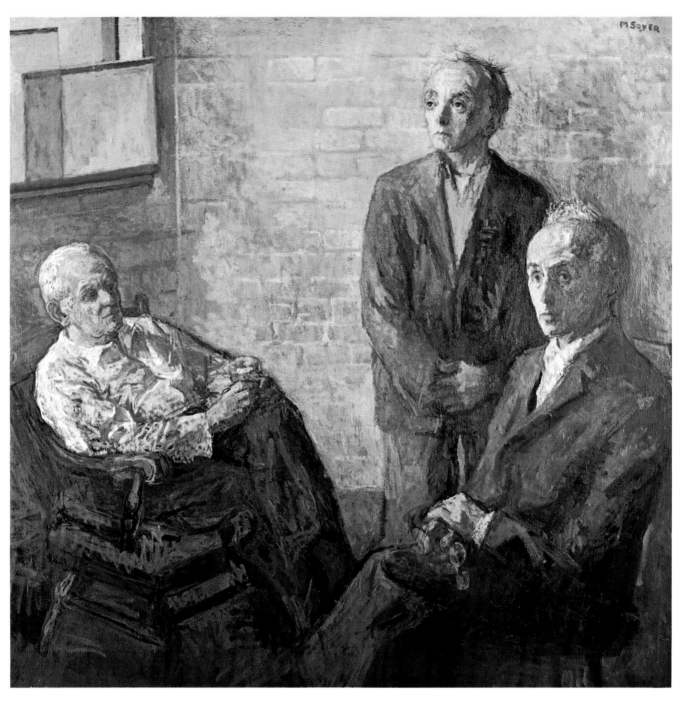

87. Three Brothers. 1963–64. 50 x 50. Brooklyn Museum, Brooklyn, N. Y.

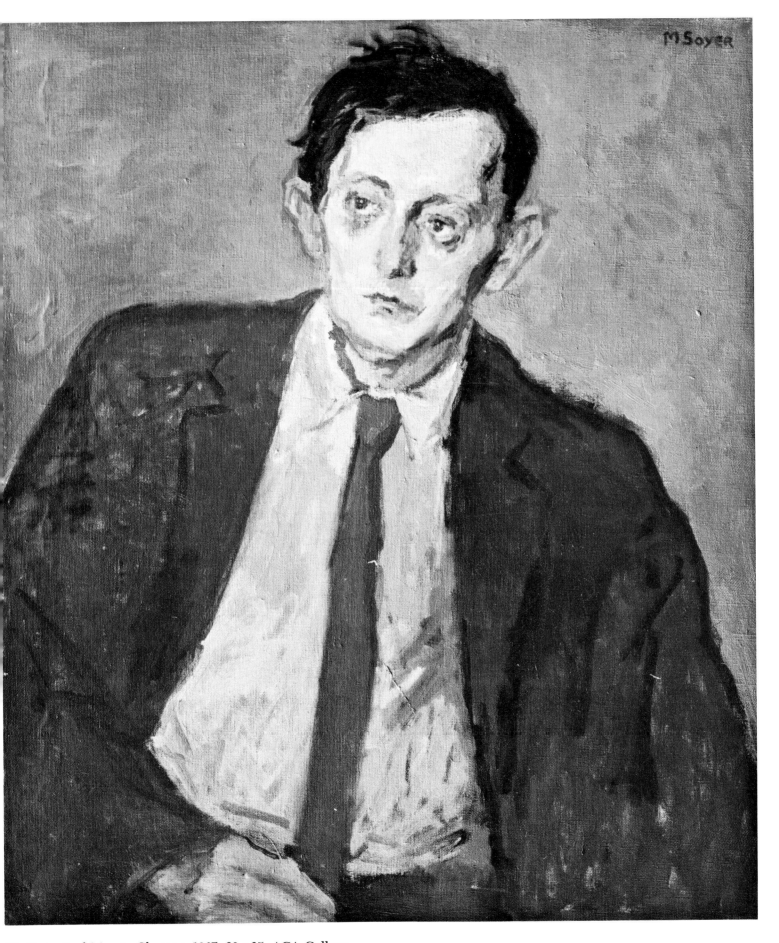

88. Portrait of Marvin Cherney. 1967. 30 x 25. ACA Gallery

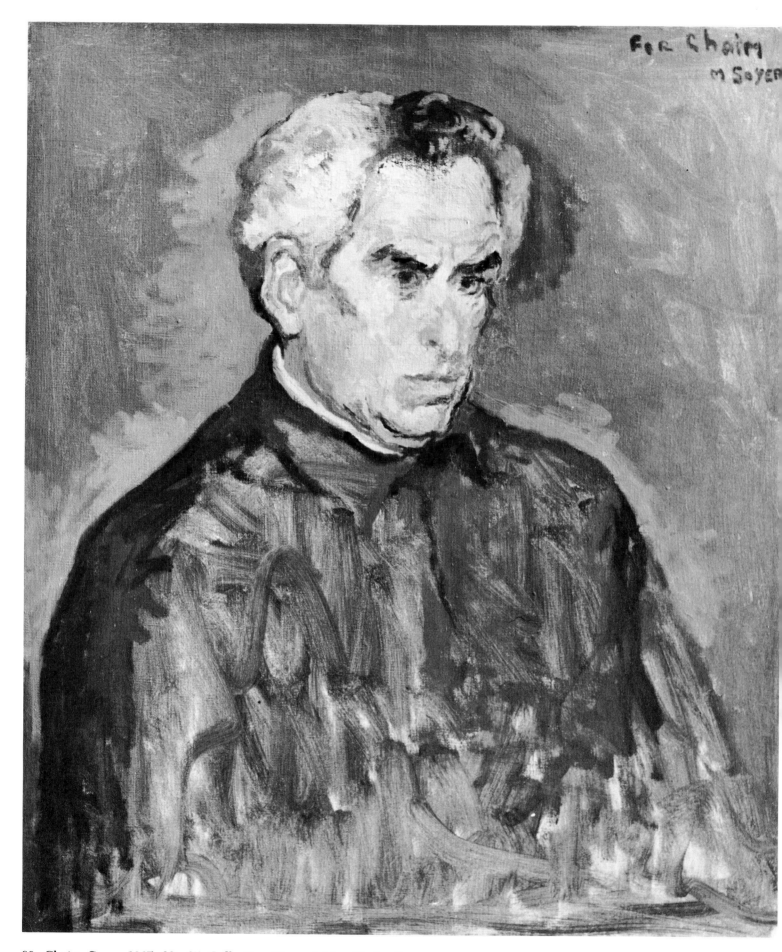

89. Chaim Gross. 1967. 30 x 25. Collection Mr. and Mrs. Chaim Gross

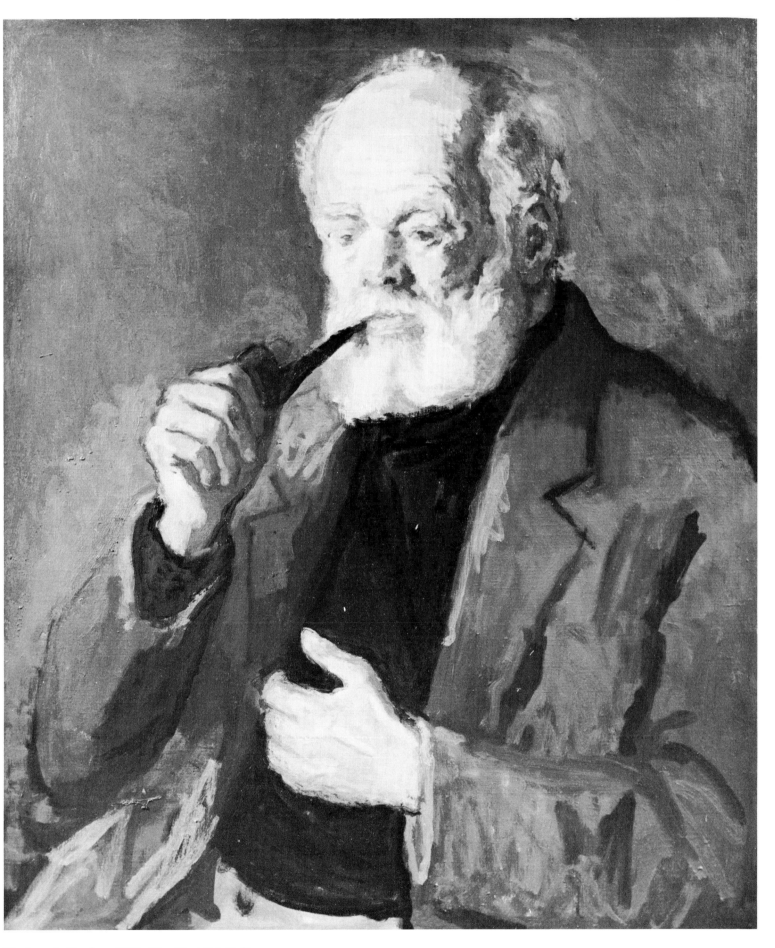

90. Joseph Kaplan. 1968. 30 x 25. ACA Gallery

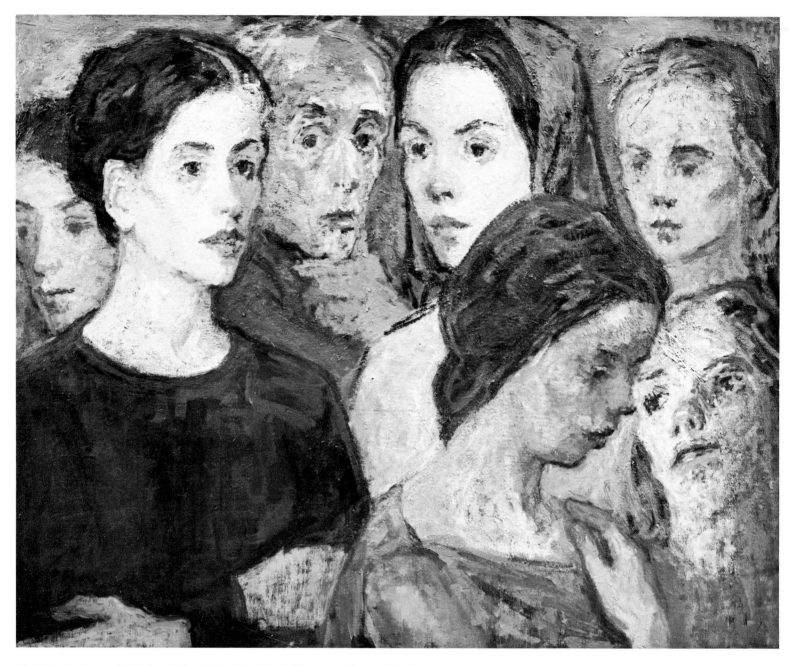

91. The Artist and His Models. 1965. 25 x 30. Collection Allen C. DuBois

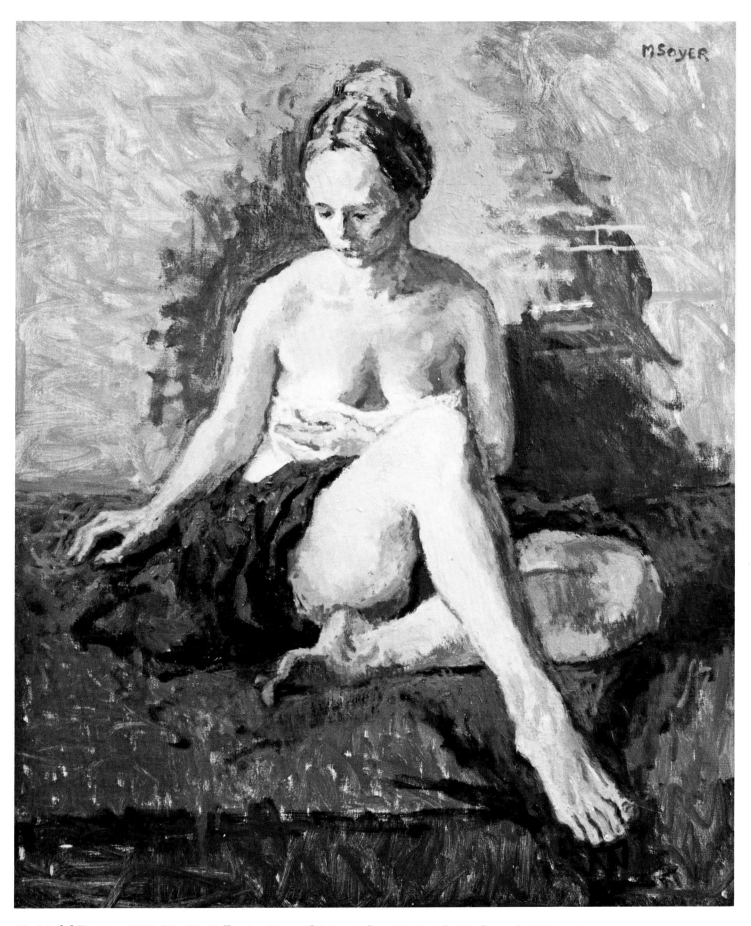

92. Model Resting. 1965. 30 x 25. Collection Dr. and Mrs. Arthur M. Tenick, Englewood, N. J.

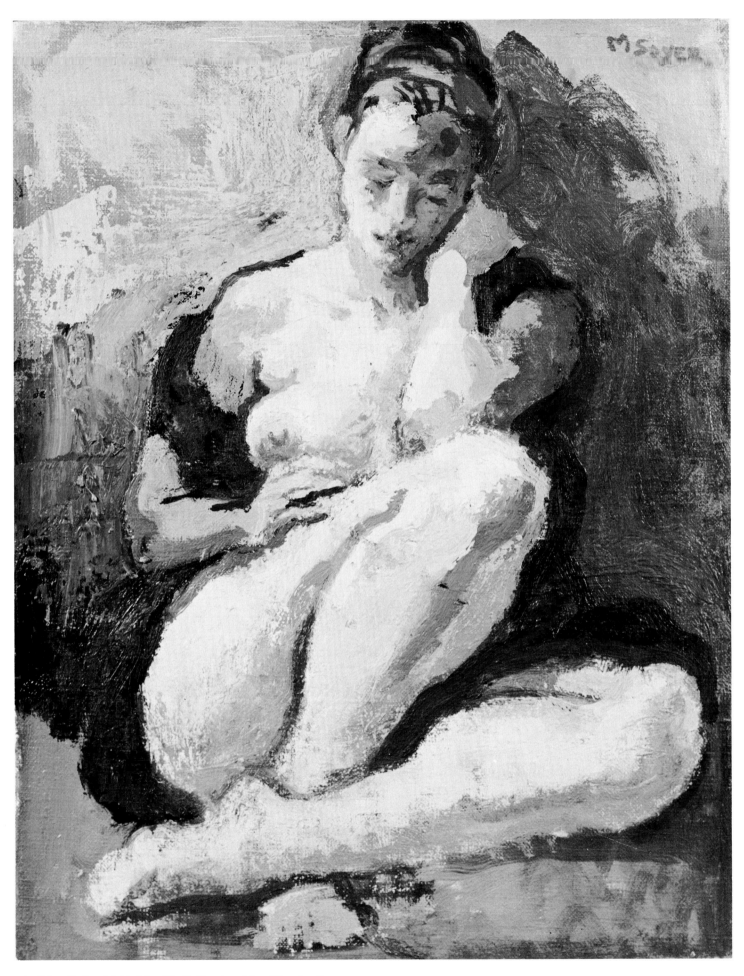

93. Blue Robe, 1964. 16 x 12. Collection Mrs. Harriet Perse

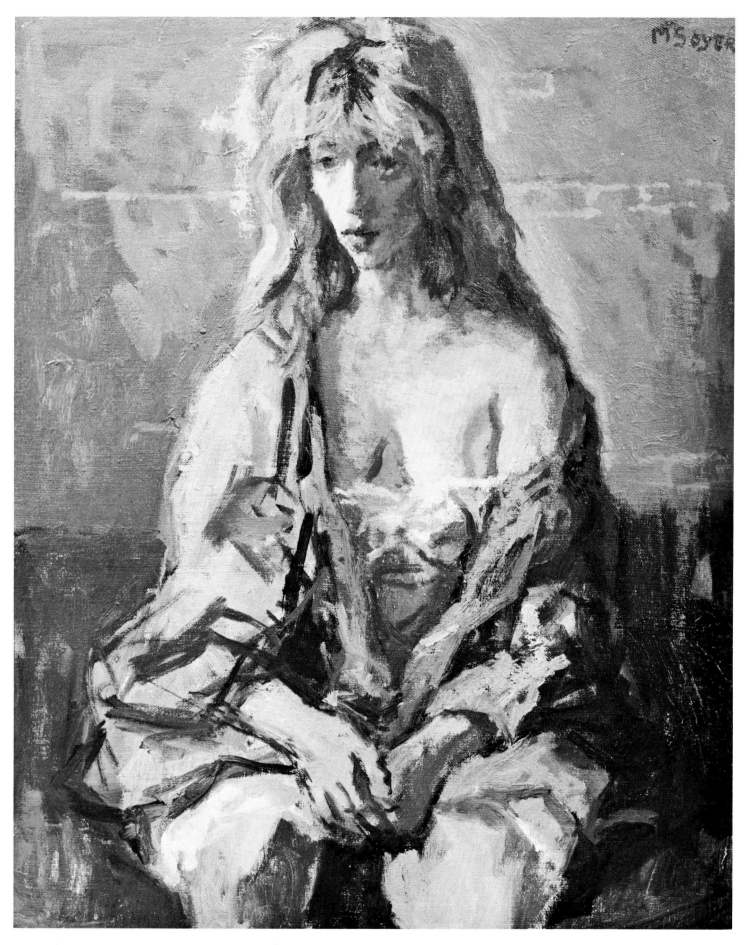

94. Girl in Green Kimono. 1965. 24 x 20. Collection Mr. and Mrs. Percy Uris

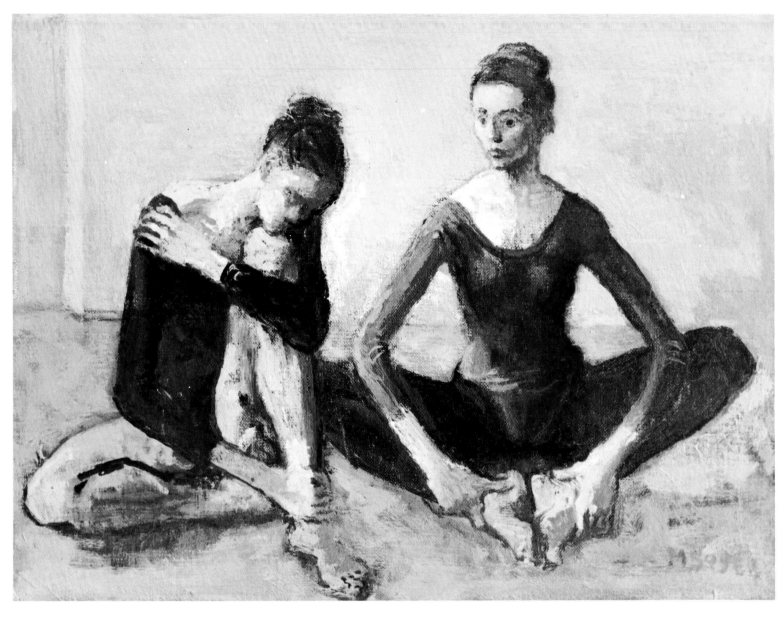

95. Two Dancers. 1965. 12 x 16

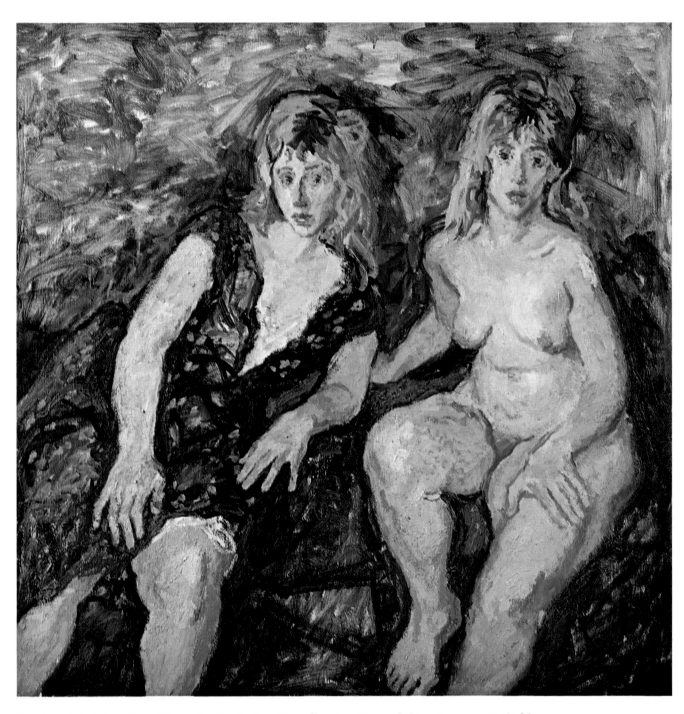

96. Bryn Vestida y Bryn Desnuda. 1965. 40 x 40. Collection Mr. and Mrs. Seymour J. Goldman

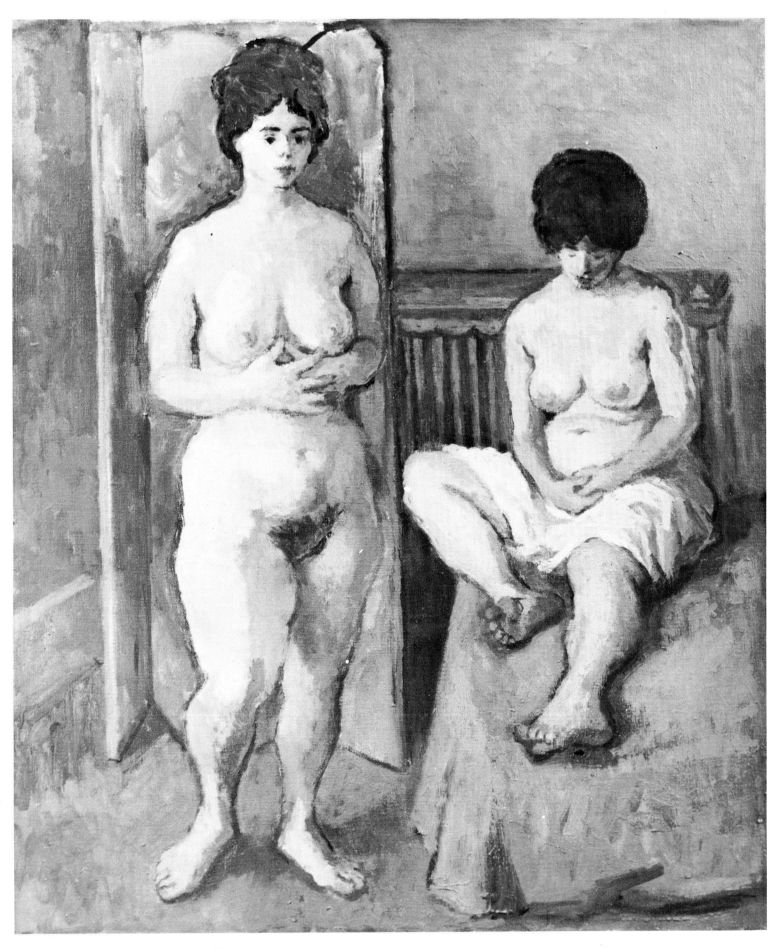

97. Models. 1968. 30 x 25. ACA Gallery

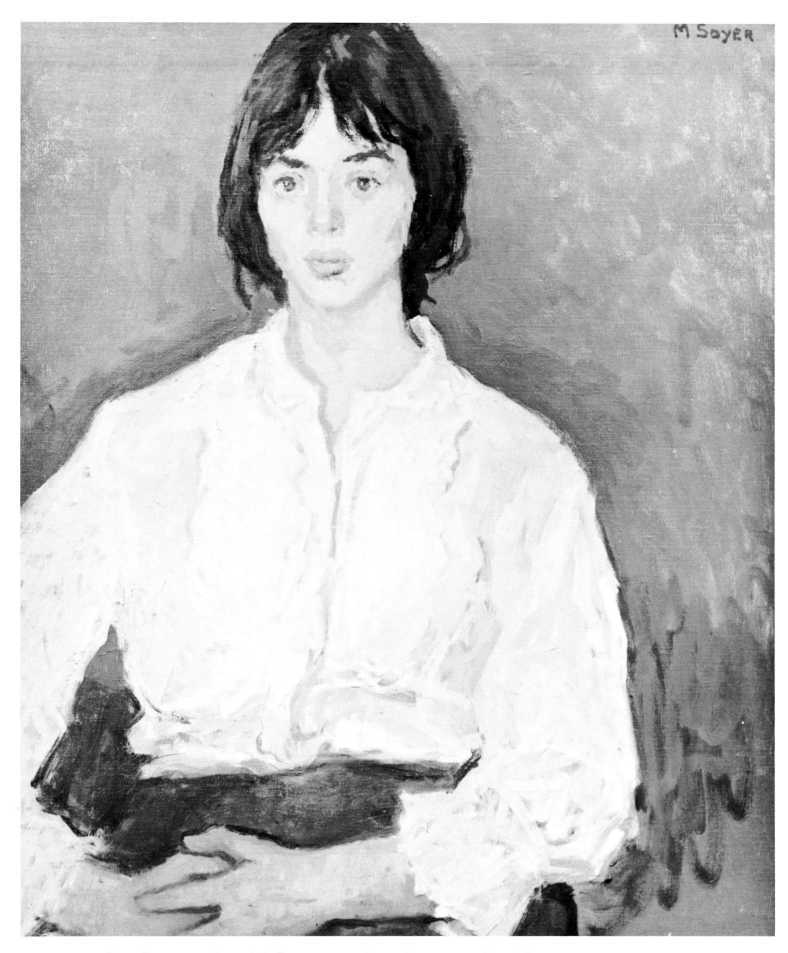

M SOYER

98. Katie in White Blouse. 1966. 30 x 25. Collection Mr. and Mrs. George Vargish, Saddle River, N. J.

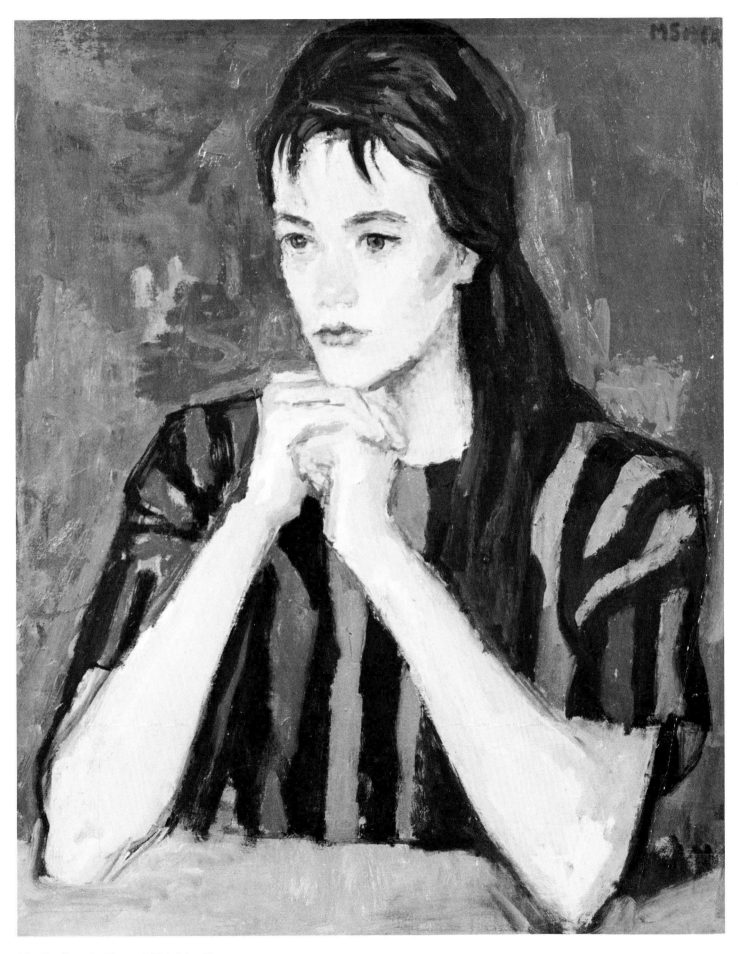

99. Pauline de Groot. 1964. 24 x 20

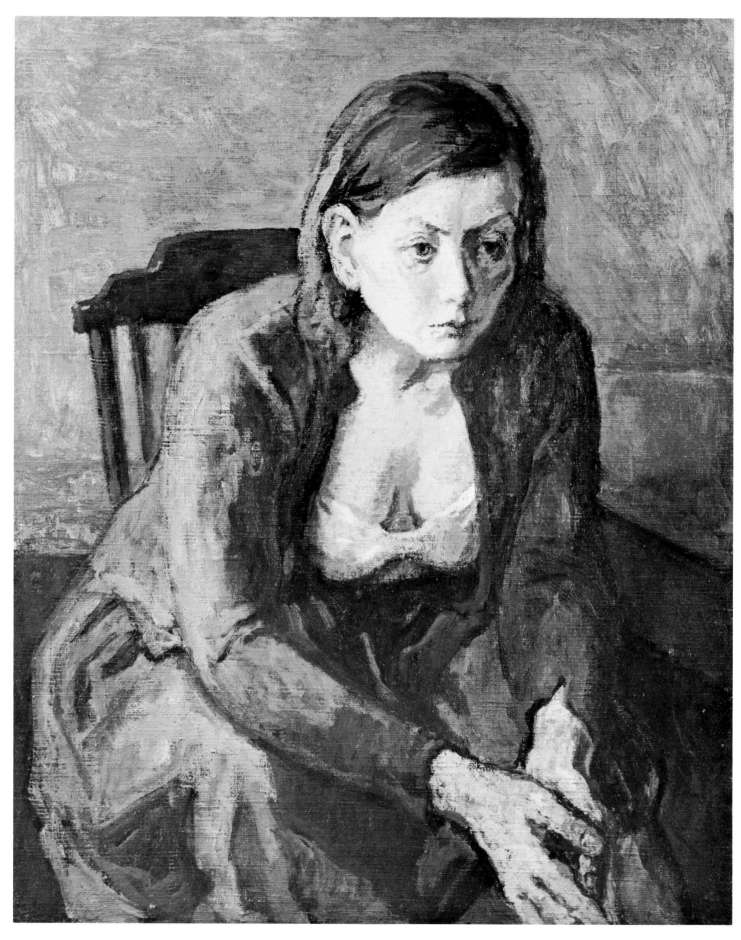

100. Dina. 1965. 30 x 25. Collection Alfred W. Kleinbaum

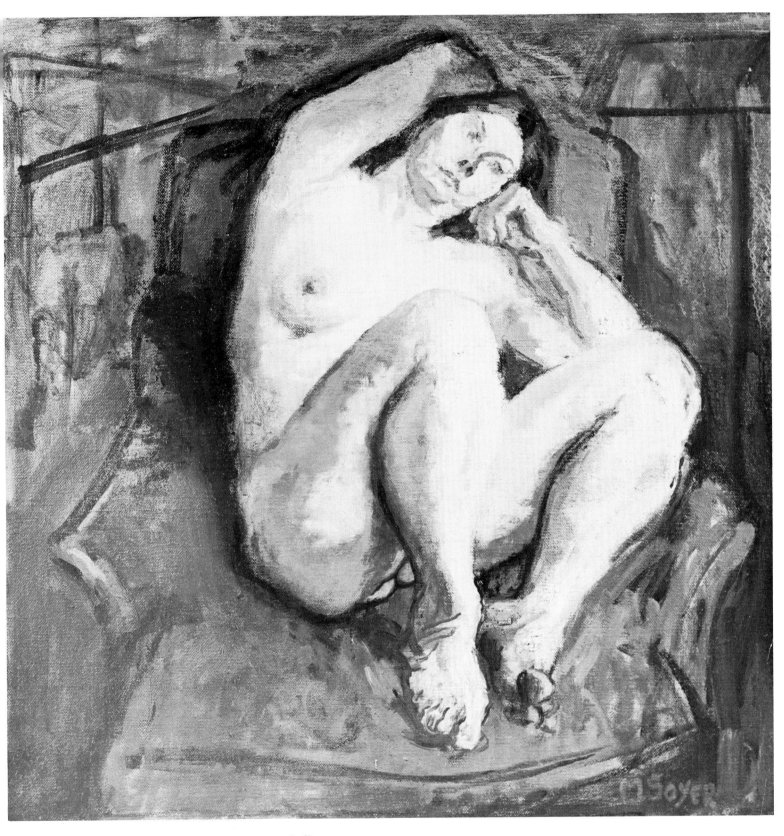

101. Nude in Green Chair. 1965. 25 x 24. ACA Gallery

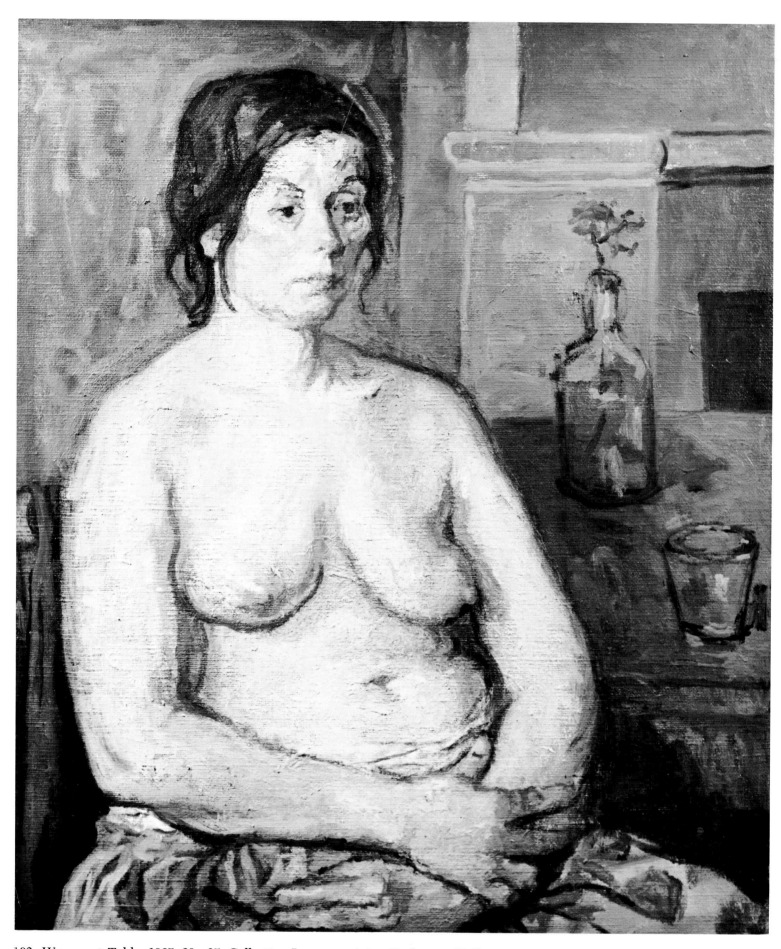

102. Woman at Table. 1965. 30 x 25. Collection Lawrence Arine, Rochester, N. Y.

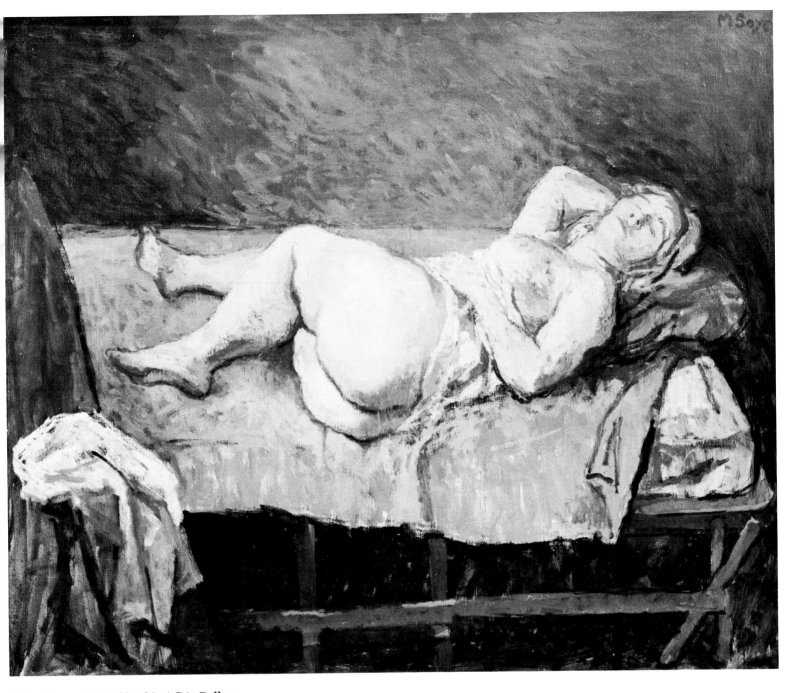

103. Asleep. 1964. 30 x 36. ACA Gallery

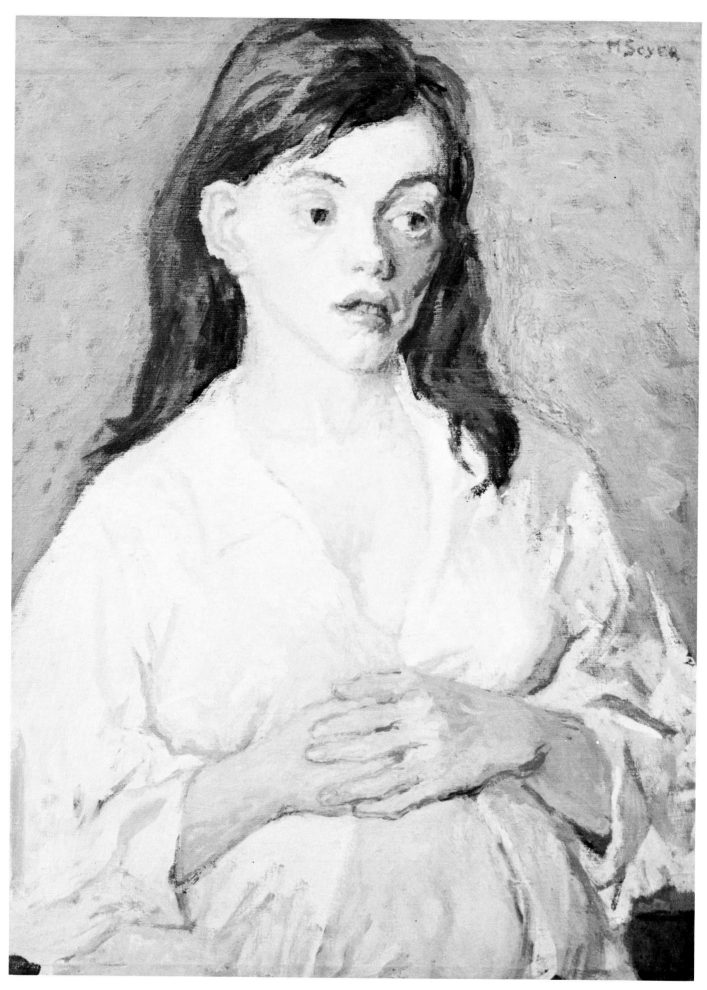

104. Pregnant Girl in White Blouse. 1965. 30 x 25. ACA Gallery

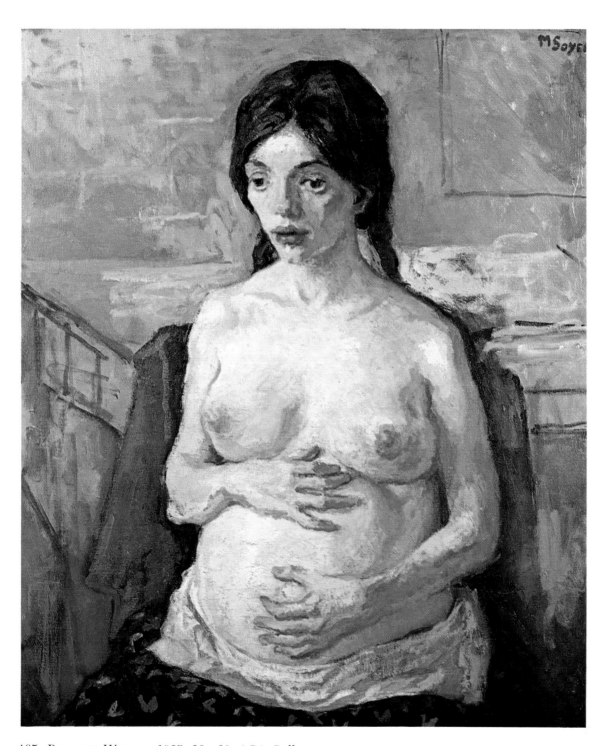

105. Pregnant Woman. 1965. 36 x 30. ACA Gallery

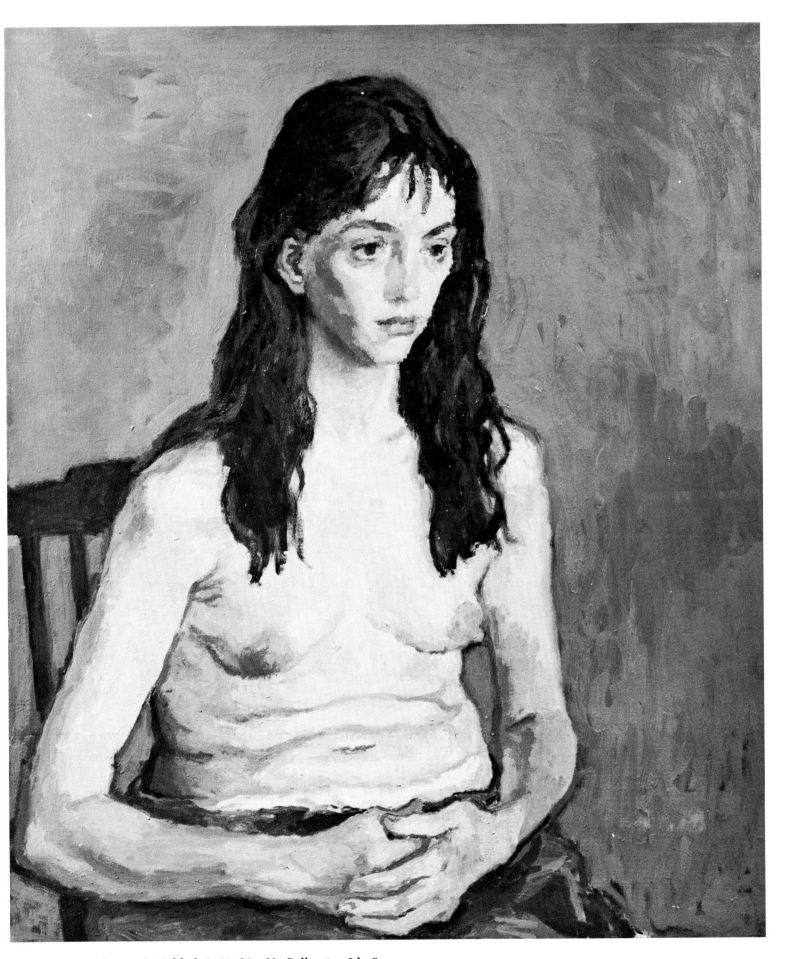

106. Woman with Hands Folded. 1969. 36 x 30. Collection Ida Soyer

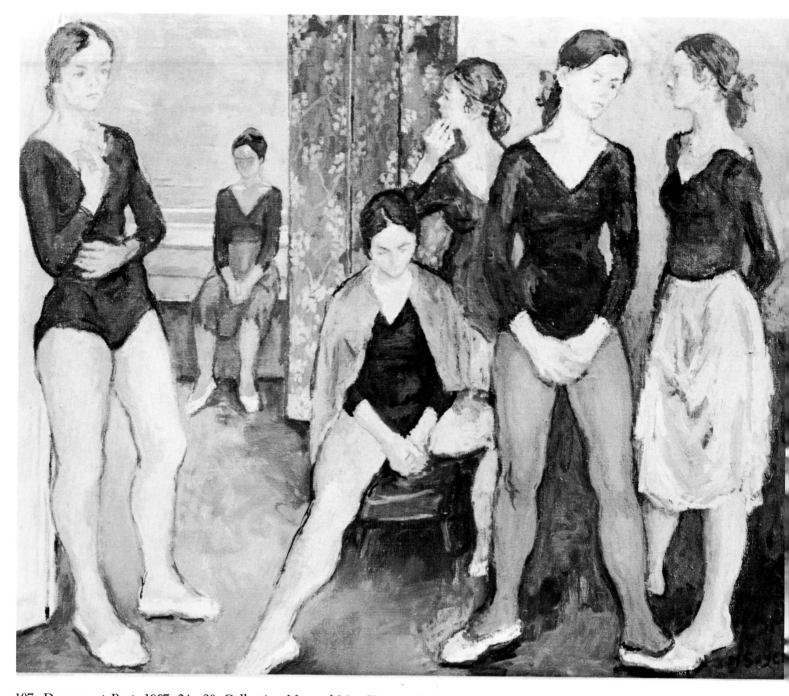

107. Dancers at Rest. 1967. 24 x 30. Collection Mr. and Mrs. Herman Sigman, Hewlett, N. Y.

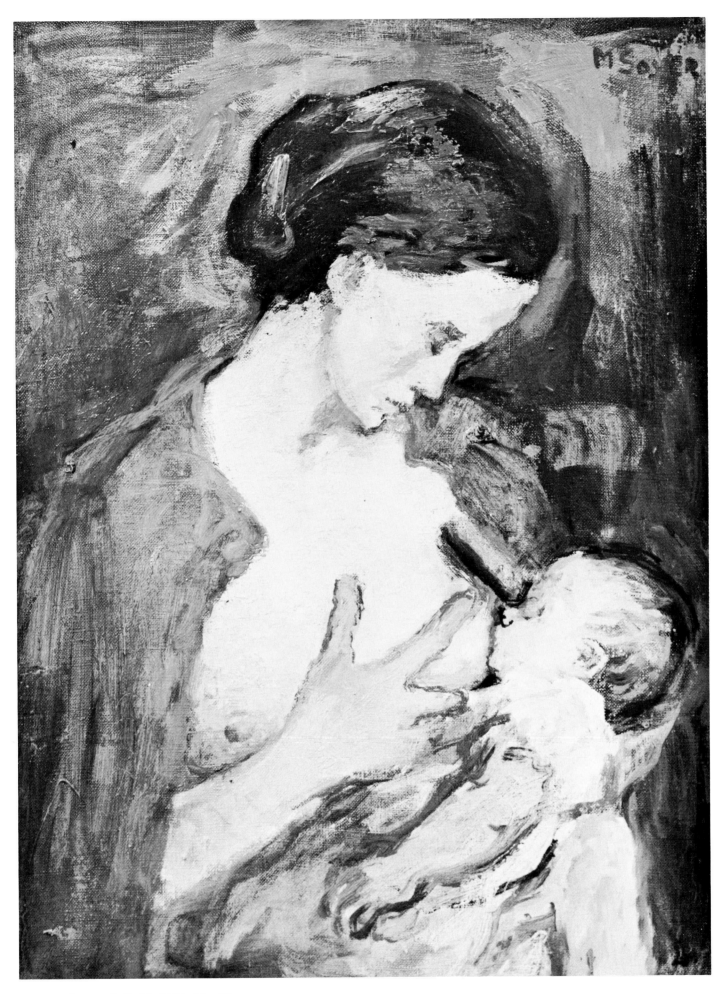

108. Mother and Child. 1965. 16 x 12

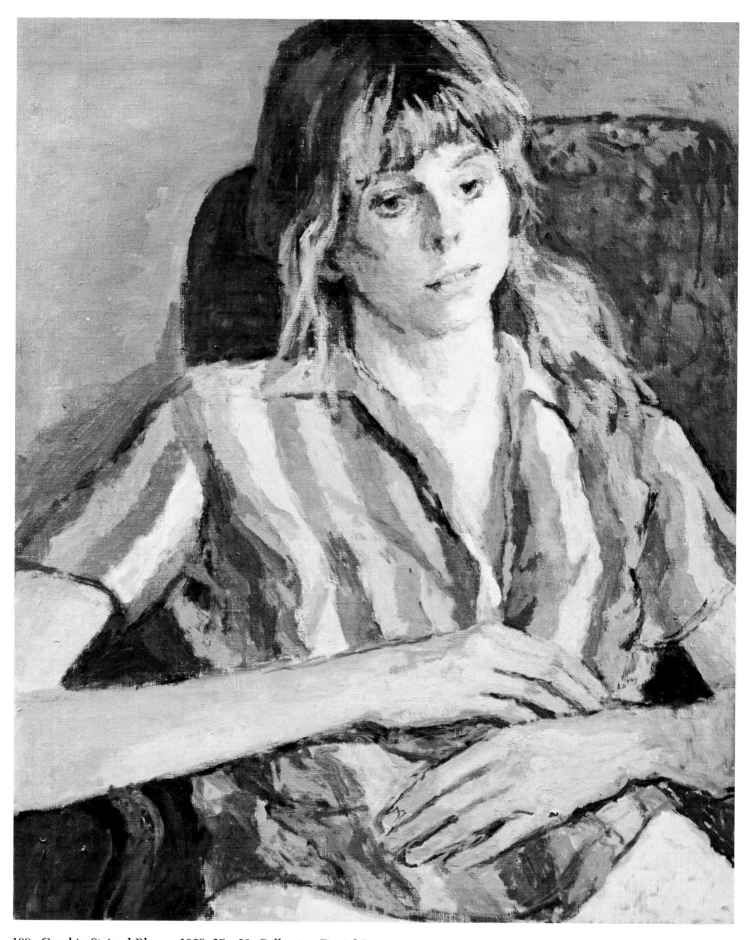

109. Carol in Striped Blouse. 1968. 25 x 20. Collection Daniel Soyer

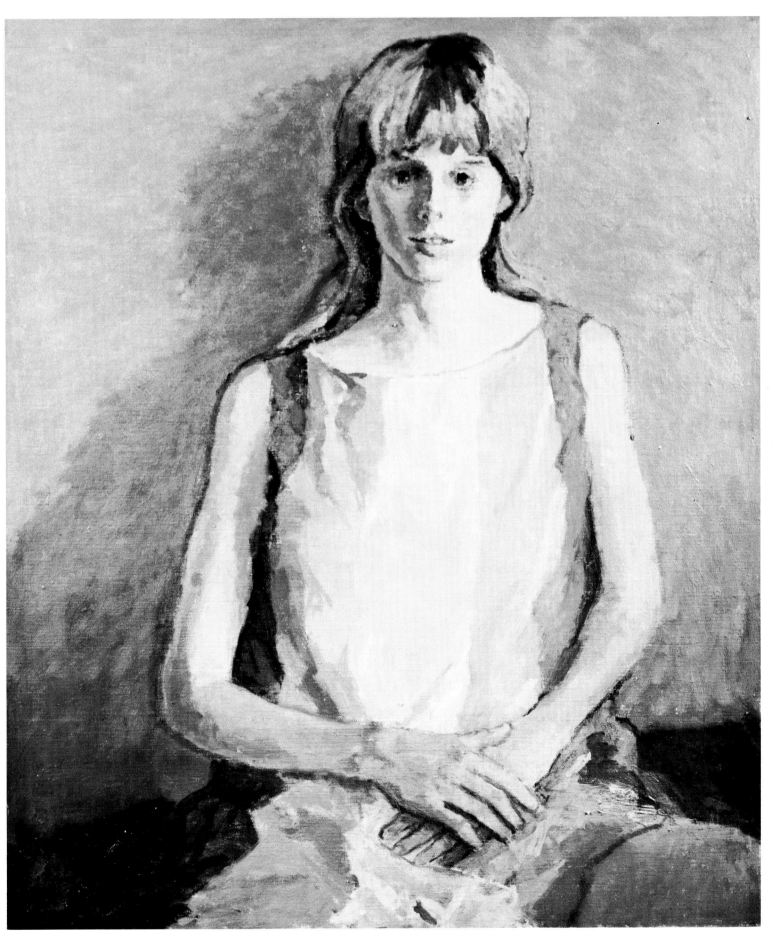

110. Carol. 1967. 36 x 30. ACA Gallery

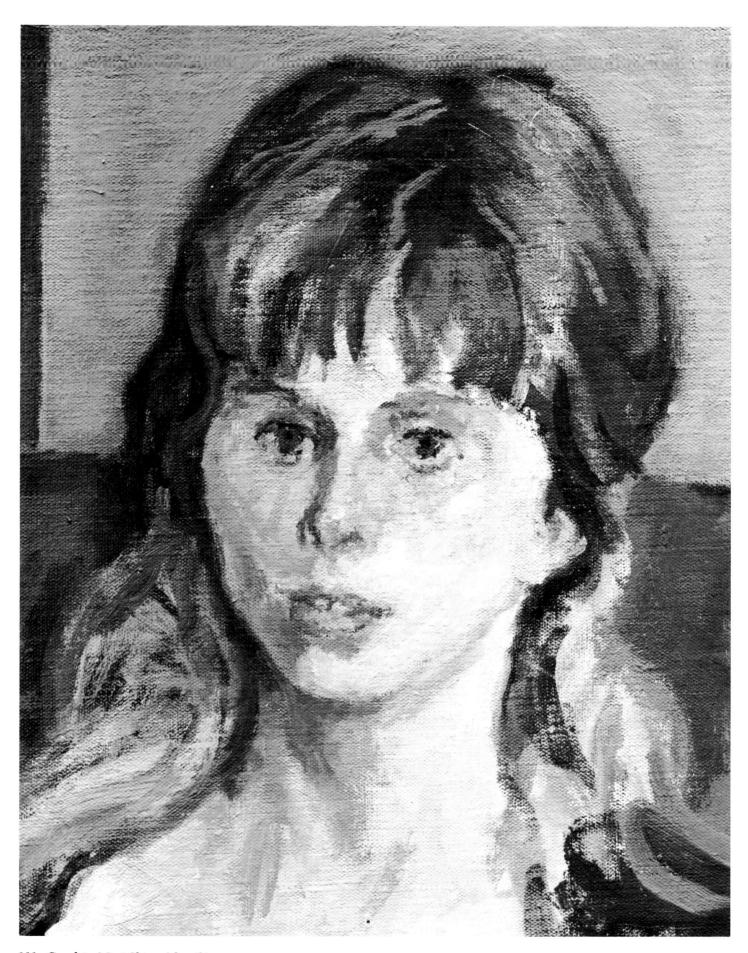

111. Carol in Mini-Skirt. (detail)

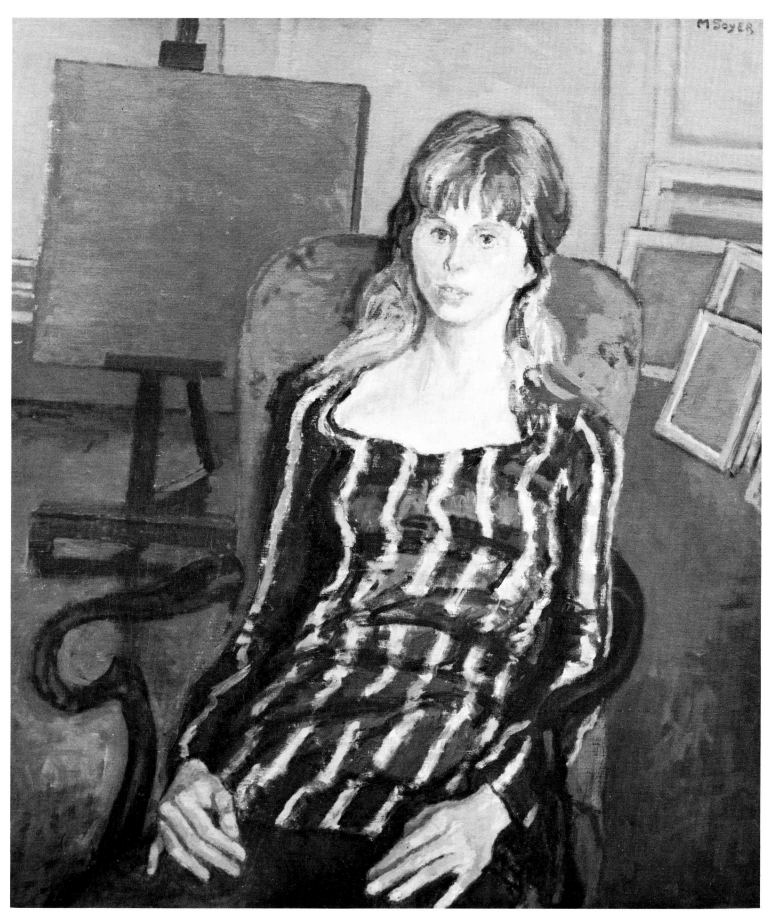

112. Carol in Mini-Skirt. 1968. 42 x 36. ACA Gallery

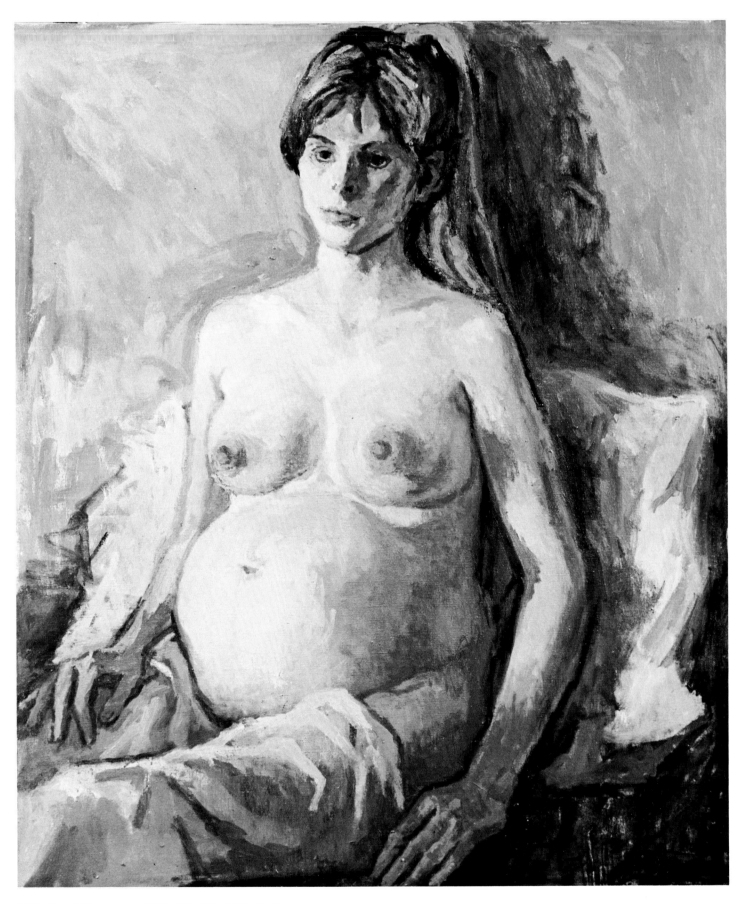

113. Carol Pregnant. 1969. 30 x 25. ACA Gallery

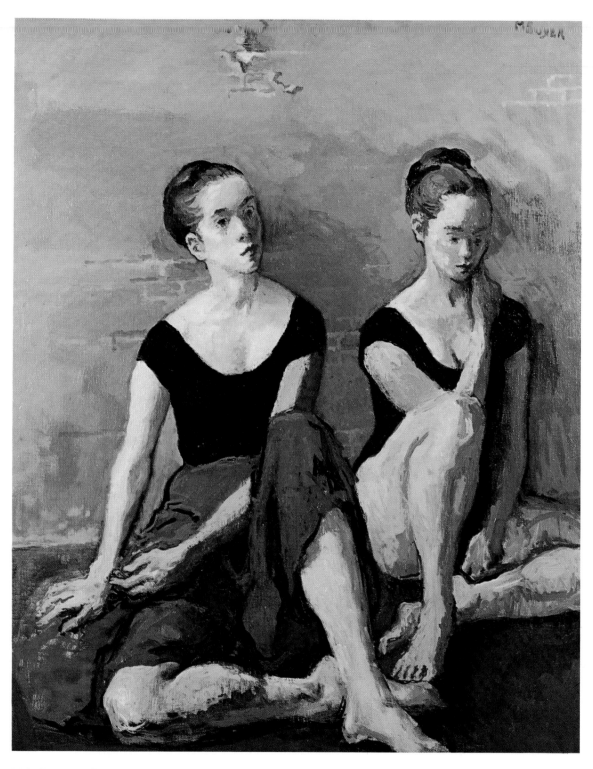

114. Dancers Resting. 1966. 20 x 16. Collection Dr. and Mrs. J. J. Vargish, River Edge, N. J.

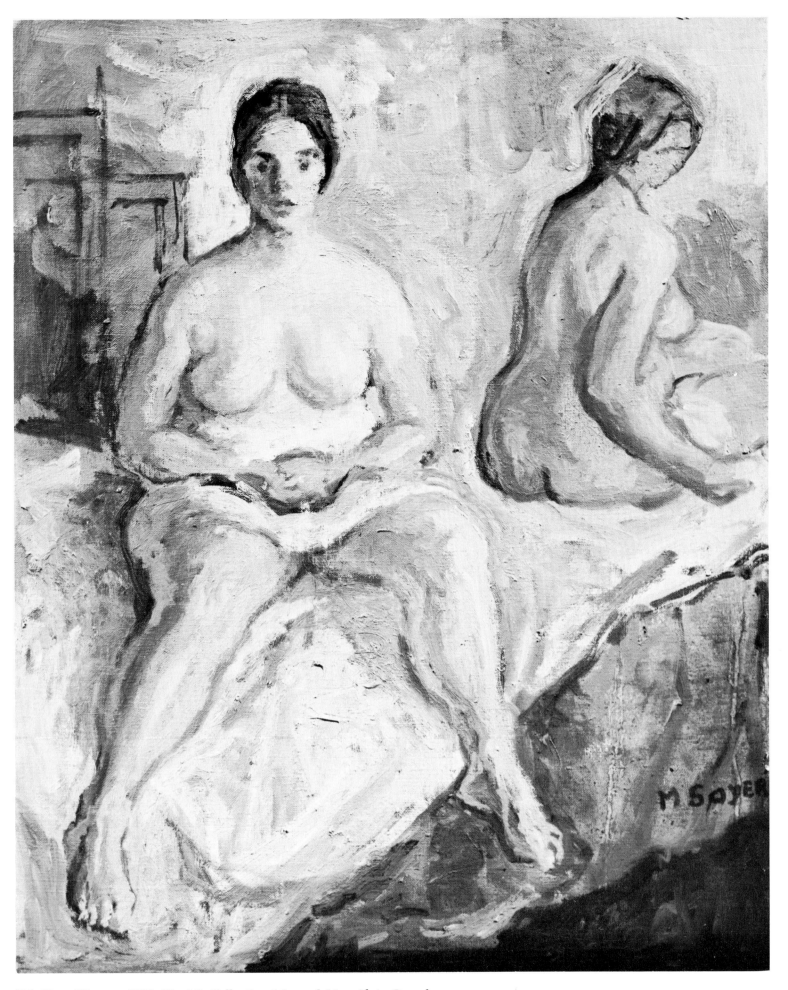

115. Two Women. 1968. 20 x 16. Collection Mr. and Mrs. Alvin Greenbaum

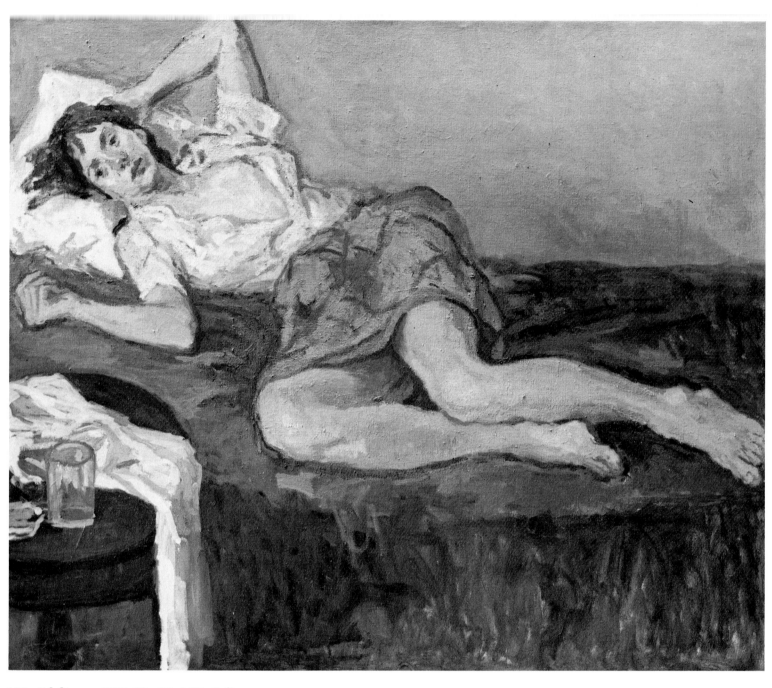

116. Odalisque, 1969. 30 x 36. ACA Gallery

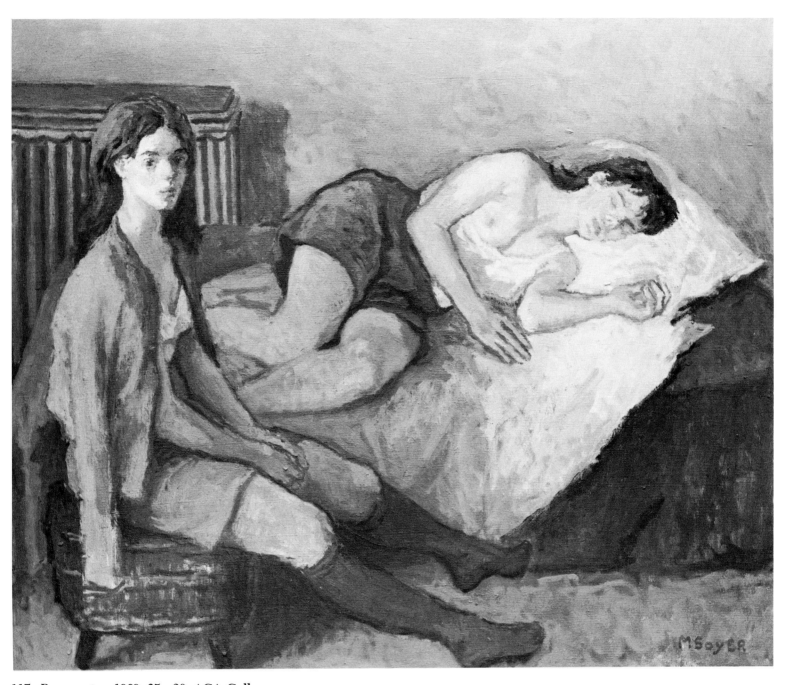

117. Roommates. 1969. 25 x 30. ACA Gallery

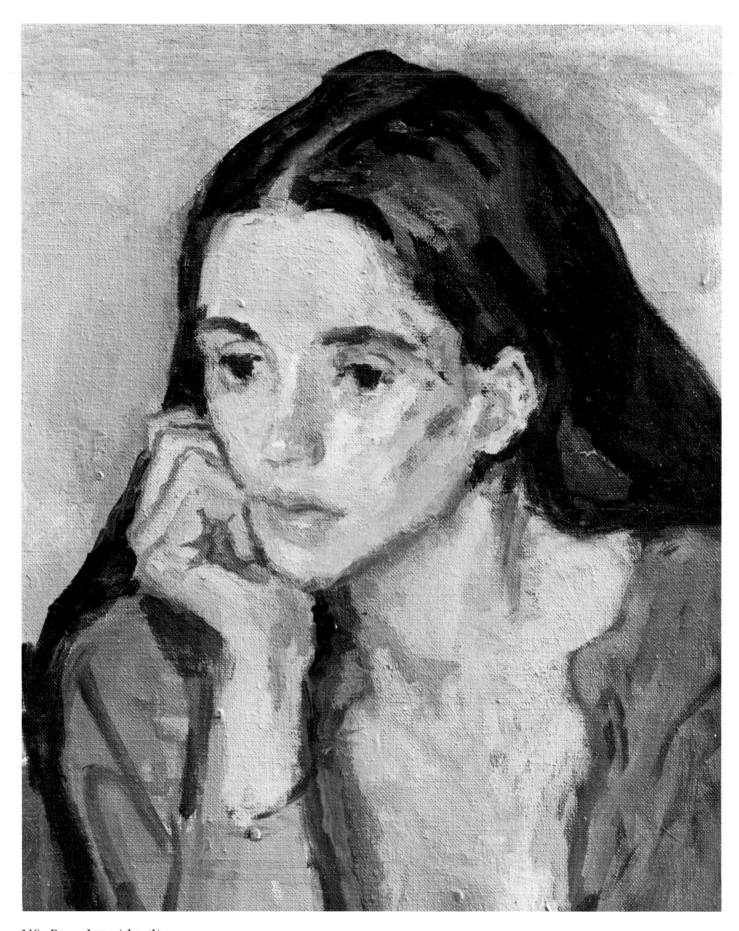

118. Bernadette (detail)

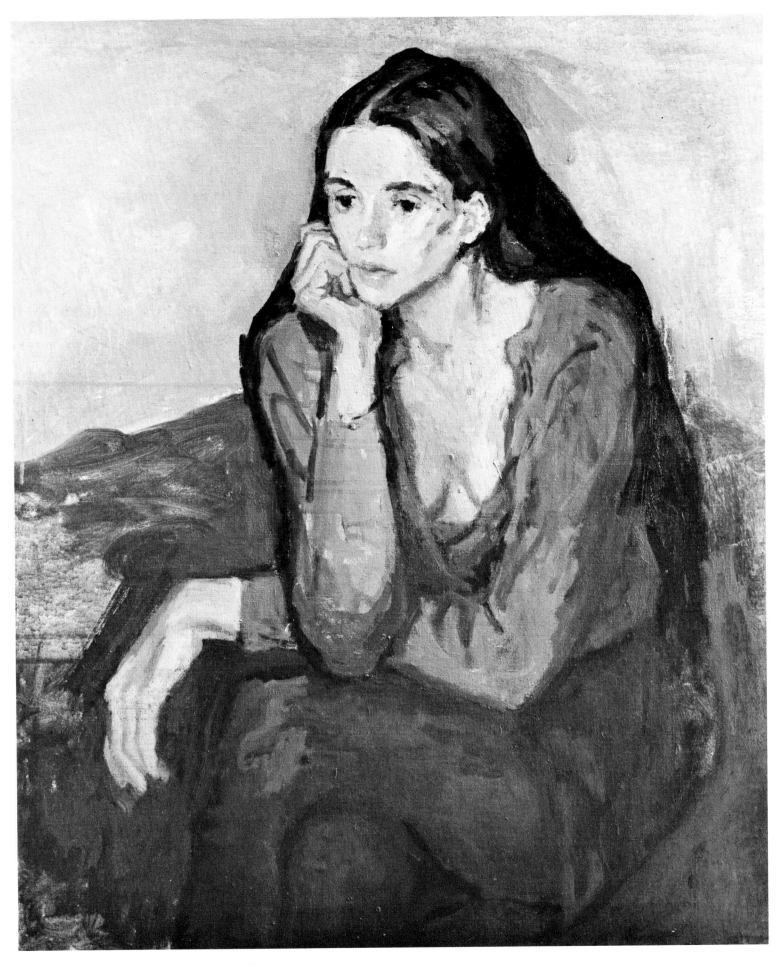

119. Bernadette. 1969. 30 x 25. ACA Gallery

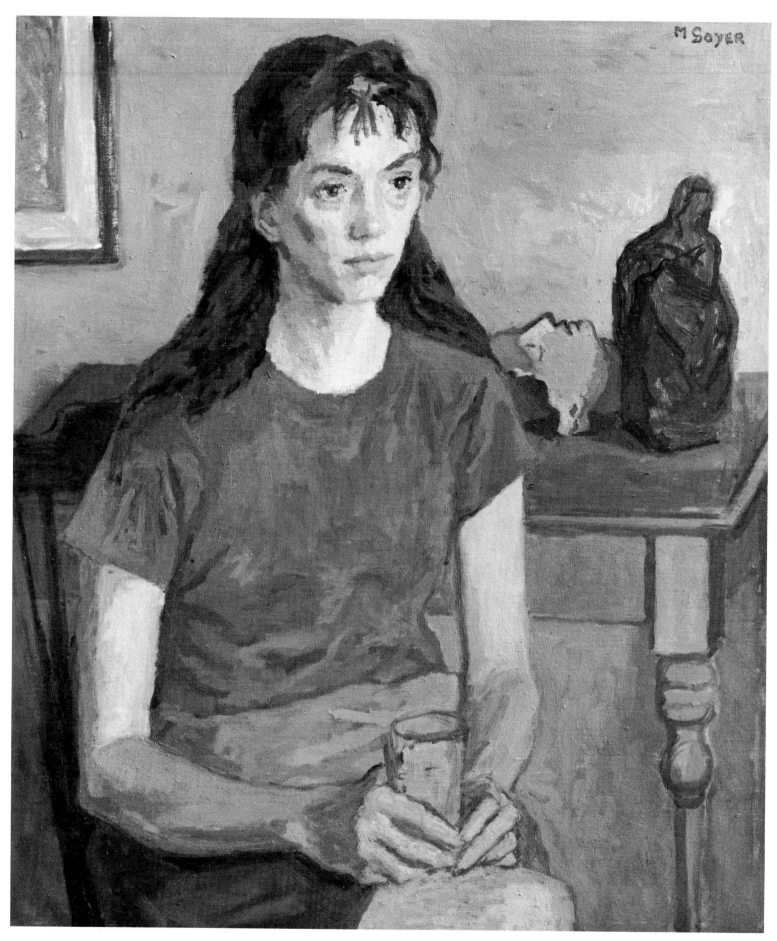

120. Cynthia with Wine Glass. 1969. 36 x 30. ACA Gallery

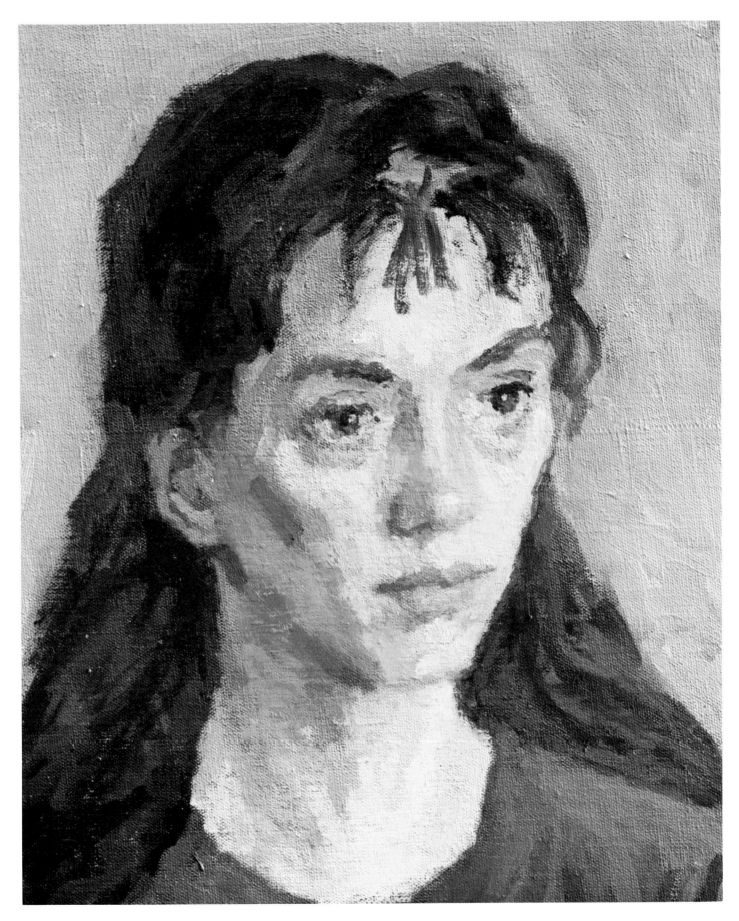

121. Cynthia (detail)

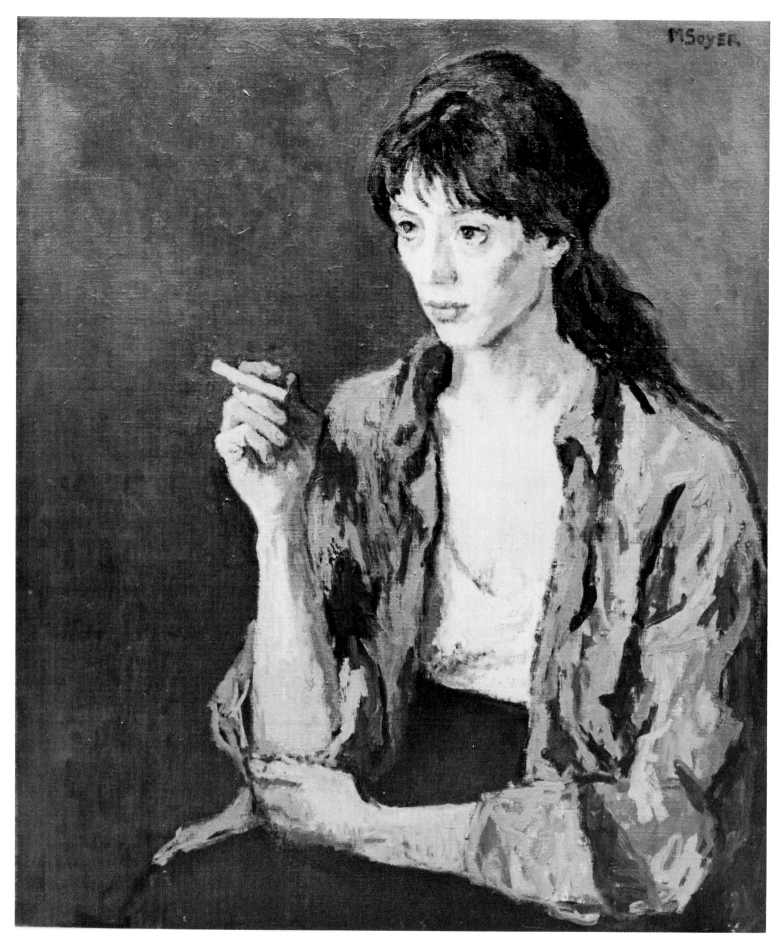

122. Woman with Cigarette. 1968. 36 x 30. Collection Mr. and Mrs. Charles H. Muhlenberg, Jr., Wyomissing, Pa.

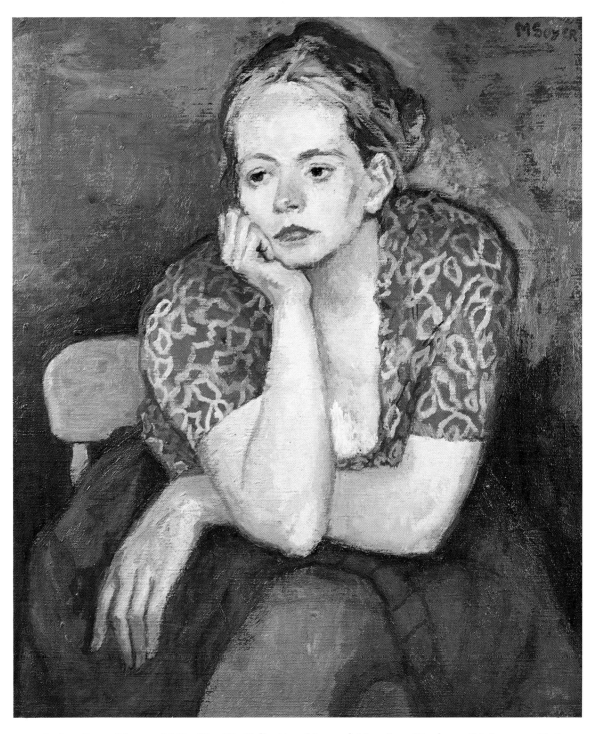

123. Girl in Print Blouse. 1963. 30 x 25. Collection Mr. and Mrs. Sam Denberg, Livingston, N. J.

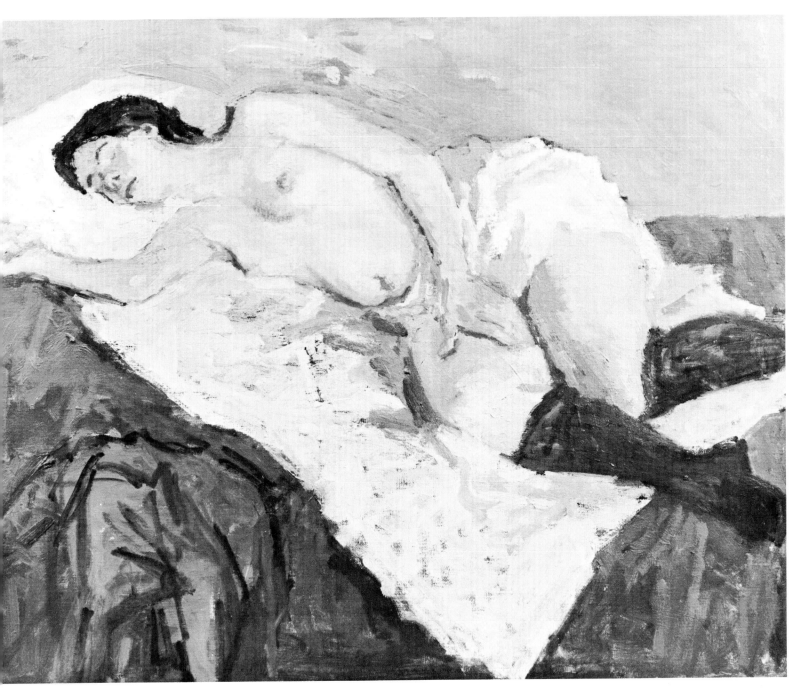

124. Girl Asleep. 1968. 20 x 25. Collection Abe Lerner

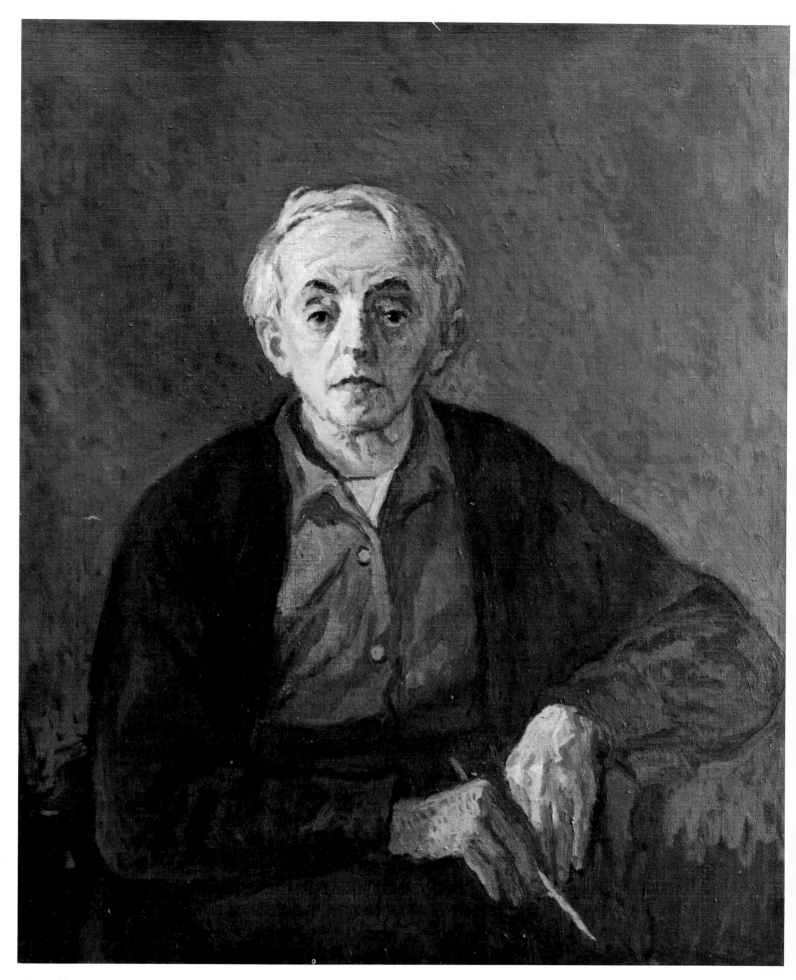

125. Self-Portrait. 1969. 36 x 30. ACA Gallery

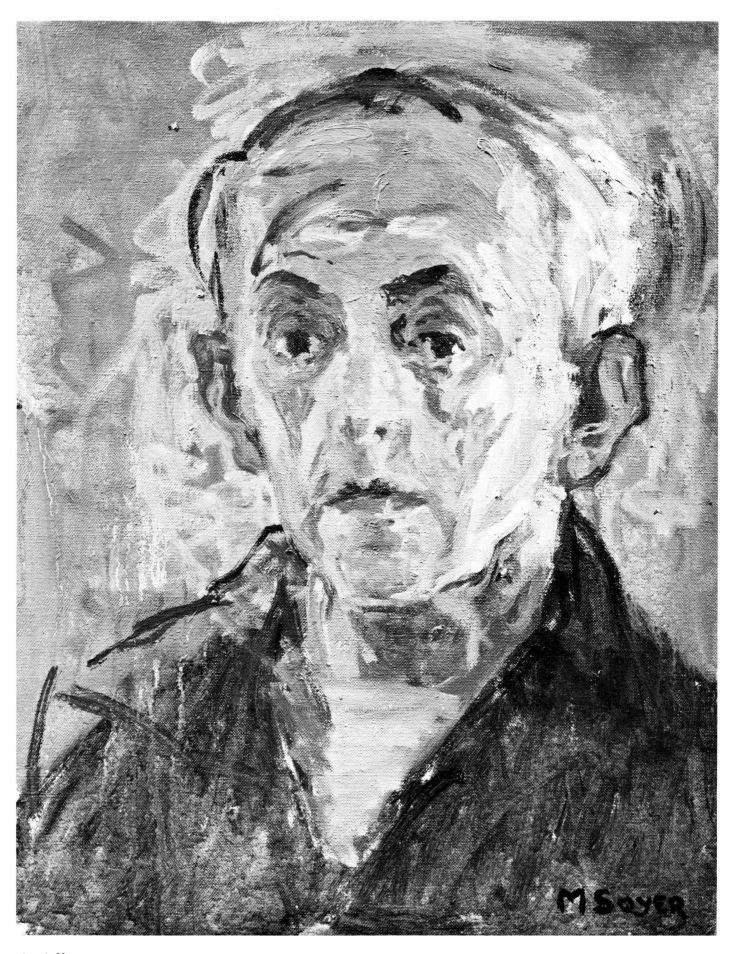

126. Self-Portrait. 1967. 18 x 14. ACA Gallery

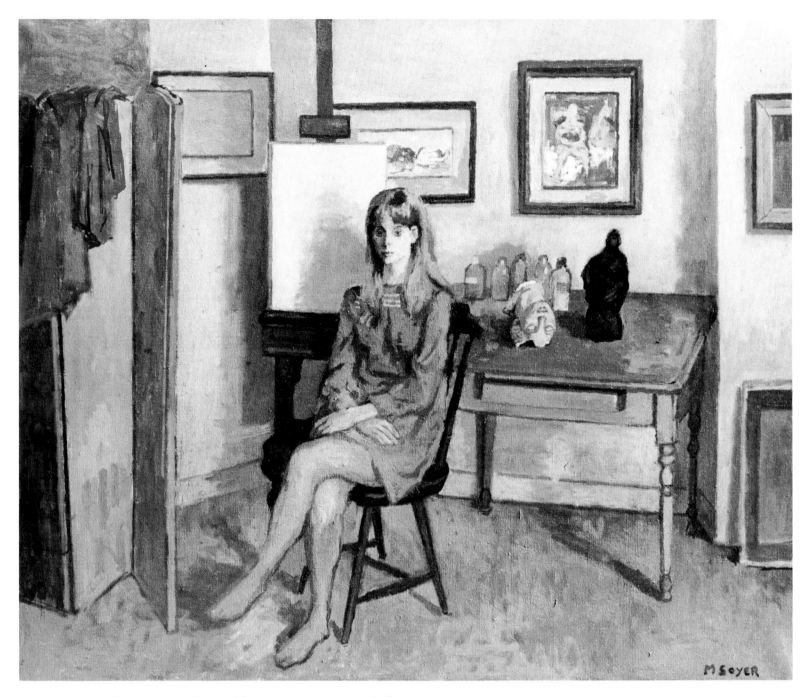

127. Studio Interior with Model. 1969. 36 x 30. ACA Gallery